SILENT HEROES

SILENT HEROES

The Bravery and Devotion of Animals in War

EVELYN LE CHÊNE

SOUVENIR PRESS

For

Adrian, my son
in salute to his (human) courage

First published 1994 by Souvenir Press Ltd,
43 Great Russell Street, London WC1B 3PA
and simultaneously in Canada

Reprinted 1995, 1996, 1997 (with corrections)

ISBN 0 285 63214 0

Photoset by Rowland Phototypesetting Ltd,
Bury St Edmunds, Suffolk

Printed in Great Britain by
The Bath Press

CONTENTS

ACKNOWLEDGEMENTS

By its nature a book like *Silent Heroes* relies heavily on researched material. I am therefore pleased to acknowledge the sources from which I have drawn and the people who have given so freely of their time and knowledge.

The extract from Queen Victoria's *Journal* and the photograph of Bobbie and his fellow survivors of the battle of Maiwand (Chapter One) from the Royal Archives are reproduced by Gracious Permission of Her Majesty The Queen.

I am grateful also to the following:

Colonel Rupert Mayne, whose ancestor survived his injuries at Maiwand and provided an unique report of the incident; Brigadier Calvert, Major Hallam and Mr G. S. Beaumont for information about Chindit Minnie drawn from their own works and, in the case of Mr Beaumont, from his RAF log book; Mr Otto Opstad of Norway for permission to draw on his records of Bamse the Sea Dog, and Mrs Nina Waehaug of Oslo who patiently translated for me; *Historia Magazine* of Paris for extracts concerning the battle of Monte Cassino, and in particular my gratitude to Mr W. A. Lasocki for making available such a large collection of photographs from which to choose, as well as for permission to use so much from his own work on the bear Voytek.

For the chapter on Irma I am especially indebted to the following for the amount and depth of material provided: Major Hogben's *Designed to Kill* which detailed the sites from which the V-1 and V-2 rockets flew, Mr Charles Fricker, MBE, who permitted unlimited access to his records of how to train dogs for emergency operations, and the staff of MoD Defence Animal Centre at Melton Mowbray, from whom I was able to obtain a copy of Mrs Margaret Griffin's diary of operations on which Irma was involved. I am grateful for their

permission to quote from it so freely.

For Gallipoli Murphy I relied greatly on the text of J. M. Winter in Hamlyn's Andromeda Oxford book *History of the 20th Century, World War I*, on the Australian Government's official history of the First World War, on Patsy Adam-Smith's *The Anzacs* and on Sir Irving Benson's *The Man with the Donkey*. I am also grateful to Mr John Parkin of Essex who holds the rights to all documentation concerning John Simpson and his donkey. For Sebastopol Tom I drew on official records of the campaign but also on Michael Barthorp's *Heroes of the Crimea*. Mary E. Thurston's article in *Military History* provided the inspiration for Stubby's story. For Rob, the SAS dog, I must thank Anthony Kemp and John Murray for allowing me to quote from *The SAS at War, 1941–45,* but my particular gratitude goes to Miss Heather Bayne whose family owned Rob. Miss Bayne grew up with him from her years as a toddler and hopes one day to write her own story of his heroic achievements. I wish her all success in that. She very generously permitted me access to her private documentation.

I have been fortunate to have had outstanding assistance and encouragement from Mr Rick Osman of *The Racing Pigeon* magazine. He permitted extracts from his own book on pigeons at war and also submitted a quantity of rare photographs for use in this book. Similar spontaneous help was given me by Phil Buss of Canterbury regarding the chapter on Rifleman Khan. I also owe a debt of gratitude to Ken Frost who patiently reproduced the maps for the book and took on the touchy job of first copy-reader.

Thanks to the Foreign Office, *Silent Heroes* has been able to reproduce certain unique information which, for the first time, tells the real story of how pigeons were used in secret intelligence operations during the Second World War.

Above all, it would be impossible not to feel especially grateful to the PDSA whose staff have been most helpful and whose organisation is at the very heart of the Dickin Medal.

Evelyn Le Chêne
August 1994

PREFACE

Few of us can be left untouched by stories involving animals. Even more emotive are those telling of acts of their great courage. Animal courage, like that of humans, comes in many forms. It may be simply by being there, uplifting the spirit and morale and turning a situation from darkest despair into one of driving will to survive. Or an animal, without any urging, may decide what to do in a moment of peril and save life or turn a situation for the better.

I have learned a great deal during the research and writing of *Silent Heroes*: about animals, their nature and thought processes; about the world in which we live and the history that has formed that world. All have been important, all have been enthralling and all will surely have the effect of humbling the human being who thinks of animals as dumb and useless creatures. The silence in which they strive to save life is a mark of their eternal greatness.

When I started this book, I had not thought it would relate particularly either to me or to my family. Yet two chapters at least touched upon the intelligence services in which my family served in the Second World War: in MI5, SOE and PWE. I have had the unique opportunity and privilege of being able to draw on several documents that had fallen under the Official Secrets Act, with release to the public banned for 50, 75 and even 100 years. As a result, in Chapter Nine we have an insight for the first time into the use by the intelligence services of pigeons and are able to give details of what lay behind those stories of courage in the shadows and under the constant threat from the dread Gestapo or SS.

There have been sad moments in describing certain stories, such as that of Chindit Minnie whose mother's fate we do not know; Bamse whose burial brings a lump to the throat even now, or Gallipoli

Murphy for the hideous war his tale recalls. There have been lighter moments too, even highly humorous ones, such as the story (told in Chapter Thirteen) of Mustard, the dog whose bravery award, ceremoniously presented and placed around his neck, was made of bone which he then buried. And there have been the moments of stirring history, such as the battle of Maiwand in Afghanistan and the story of Sebastopol Tom in the Crimea.

There have been two exhibitions at the Imperial War Museum on animals in combat, and countless books have been written on the subject. Yet, strangely enough, to collect in-depth information on the animals concerned has been anything but simple. They became legends but little was specifically written about them in official records, as opposed to memoirs by those who recalled an animal being with them. From this point of view the chapter on pigeons was exceptional: there is an abundance of free material on their contribution to man's survival.

Silent Heroes involves animals that have been awarded the Dickin Medal for Valour, that have received awards from other nations including the American Purple Heart and French Légion d'Honneur and those who received none. In the end the telling of their stories is my tribute to the undaunted spirit of them all.

THE DICKIN MEDAL

The Dickin Medal, instituted by Mrs Maria Dickin, founder of the People's Dispensary for Sick Animals, was popularly referred to as 'the animal's VC'. It was awarded to any animal displaying conspicuous gallantry and devotion to duty associated with, or under control of, any branch of the Armed Forces or Civil Defence units during World War II and its aftermath. The award was made only upon official recommendation and was exclusive to the animal kingdom.

The obverse of the medal, which is in bronze, bears the initials 'PDSA' at the top, the words 'For Gallantry' in the centre and 'We Also Serve' below, all within a wreath of laurel. The reverse is blank for inscribing with details of the recipient. The medal ribbon is green, dark brown and pale blue, representing water, earth and air to symbolise the naval, military, civil defence and air forces.

Of the 53 Dickin Medals awarded, 18 were presented to dogs, 3 to horses, 1 to a cat, and 31 to pigeons.

1

Bobbie and the Battle of Maiwand

They had been working hard all day, cutting the red velvet, lining it and sewing on a crown with chevrons in imitation pearls. Tomorrow the wearer of this splendid coat, put together with such collective urgency, would be meeting the sovereign, Queen Victoria. The object of all the joyous activity eyed them with interest from across the room, and permitted the trying on of the fruit of their labours. It was an excellent fit for Bobbie, the white short-haired terrier and only survivor of the last stand of the 66th Regiment of Foot at the Battle of Maiwand.

Small and greying around the muzzle, Bobbie had travelled on ship and train, and across arid, hostile desert; he had been at the centre of massacres by savage tribesmen, wounded and eventually alone. Yet he had found his way back to the unit after more than five weeks of dodging and weaving through enemy lines. Tomorrow would be his day, the day his extraordinary courage and devotion would enter military folklore and history.

* * *

Dogs were not unusual as pets within the ranks of the military during the Victorian era. Nor was it strange for families to follow in the wake of a regiment, even on the field of battle. Particularly was this the case during the expansion of the British Empire in Africa, India and the Far East. A pet would share the life and duty of its soldier master and inevitably an enduring bond developed between them, often extending to the whole platoon.

It was not an easy life for dogs in the army: they had to withstand the rigours of long marches in harsh climates, endure the terrifying noise of battle and the discharge of weapons, and face up to visible danger with calm. In case of injury, for animals as for their masters,

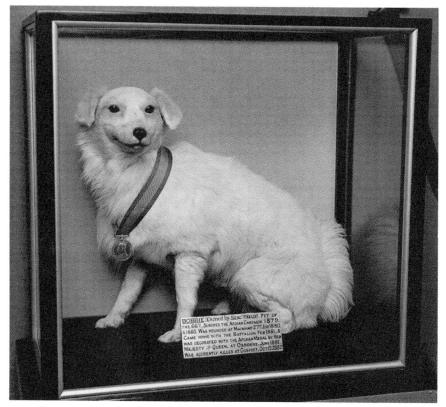

Bobbie, hero of the Battle of Maiwand, 1880, and mascot of the 66th Regiment of Foot. *Photo: Anthony Miles Ltd, courtesy the Duke of Edinburgh's Royal Regiment Museum, Salisbury, Wiltshire.*

medical care ranged from rudimentary to non-existent. Yet the dogs that will be described in this chapter were never trained to become canine soldiers as such. That was something that evolved, matured through love and care and being part of a family—in this case a whole regiment—even in mortal situations. Such a relationship was not taught, nor could it be demanded. It was given willingly.

Bobbie became a regimental mascot, and was frequently seen with

a ribbon and medallion around his neck, but he was not the only pet dog in the 66th Regiment of Foot. There was Nellie the mongrel and Billy the bull terrier, both of whom stayed with their masters to the bitter end. But Bobbie's story is exceptional. Alone, when all others had been killed or lay desperately injured, he continued to snap, bite and cause havoc to the enemy in a demonstration of individual courage that transcended all norms of fear.

Before telling his story, we need to look at the reason why Bobbie was with his regiment in Afghanistan, a barren and desolate land stricken with constant warring among factions, and how events that occurred in London, Malta and India had their role in what eventually became the Battle of Maiwand.

The disaster of Maiwand remains one of the gravest military defeats suffered by the British Army. It was certainly the most disastrous of the Victorian era. The British Empire was at the height of its power on land and at sea in Africa, the Indian Ocean, Canada and the Far East. Its trade links spanned the globe and encompassed more than a quarter of the world's population. Its economic and strategic strength were indivisible, one dependent upon the other. India was, without doubt, the Empire's largest asset, being rich in resources and controlling vital sea lanes. It was a nation difficult to control, however, and a sense of rebellion was always in the air. In fact the Bengal Army's sepoys, or native soldiers, had mutinied in the early 1860s and for the first time in the history of the Raj, as British rule in the subcontinent was known, the confidence of the military had been badly shaken and the question posed, 'If a rebellion happened again, could we put it down?'

As part answer to that problem, reinforcements were sent to India, where Lieutenant General Sir Frederick Roberts—who was later to play a key role in the Second Afghan War—had been a leading player in stifling the rebellion. Another feature of British political and military disquiet at the time—which featured in all strategic decisions—came from frequent conflicts occurring across the North-West Frontier in Afghanistan. Anything that happened in that wild country was of potential importance to India and its long common border.

For years both Russia and Persia (modern Iran) had sought to

13

expand their influence through Afghanistan to India, and both played one Afghan tribe off against the other in order to achieve that end. The British had enough on their plate, however, and did not wish to have any treaty committing them to either faction within Afghanistan. They preferred the role of honest broker, though they did require reassurance from the Afghan leaders on two points. First, that the influential East India Company have unrestricted trade with and through Afghanistan. Second, that there be a form of British presence, known as a residency, in the three main cities of Kabul, Kandahar and Herat. Such an accommodation had been signed with the ageing amir, generally referred to as the Wali, or governor, of Kabul, as early as 1855, and despite Russian and Persian aspirations there had been no particular problem with the arrangement until the amir's death in 1878. Now his son was in charge in Kabul, and he wanted change.

The new amir demanded massive British concessions if he was to renew the previous agreement. One of his demands was that Britain provide military support and equipment. The request was coolly received. The amir pressed his point, emphasising to the British envoy that he had already received generous offers from Persia and even more generous ones from Moscow, including help to raise an Afghan army. Indeed, he added, his brother Ayub Khan was at that moment in Russia.

Britain again rebuffed the suggestion. Relations with Kabul were allowed to drift and contact instead taken up with the pro-British Wali of Kandahar in the south, Sher Ali. When Ayub Khan heard of Britain's approach to Sher Ali—his brother's enemy—he returned from Russia and in retaliatory rage blew up the British residency in Kabul, killing both Sir Louis Cavagnari, the British consul, and his bodyguard.

This was an act that the Crown could not ignore. Shortly afterwards, in November 1879, Lieutenant General Sir Frederick Roberts (who had been in charge of the North-West Frontier expedition of 16 years earlier and knew the terrain well) led British forces across the Khyber Pass, attacked Kabul and overthrew the amir, who fled with his brother Ayub to Russia. Roberts installed Sher Ali in Kandahar. British authority in Afghanistan had been re-established.

This, then, was the state of affairs: the power and influence of trade and commerce; intrigue, rebellion and violence; political and strategic miscalculations and fearsome tribalism. Combined, such factors were to lead to Maiwand and the Second Afghan War.

* * *

When, early in the new year of 1879, Bobbie arrived at the garrison and transit camp in Karachi overlooking the Sea of Oman, he was already familiar with his surroundings. He had been there before. Bobbie had been in most places before with the regiment.

It all began when he was adopted by Sergeant Peter Kelly of the 66th Regiment of Foot. Had that not happened, he would probably have had a short and uneventful life as a stray in and around Malta's port of Valletta. It was there, nine years previously, that two troop-ships—the *Seraphis* and the *Crocodile*—put in to port *en route* for India. The soldiers on board, given shore leave while the ships took on fresh water, stores and more crew, marched down the gangplank in their red tunics and blue trousers and made for the taverns that dotted the shoreline. Valletta was a busy little town, a hive of activity. Fishing smacks bobbed on the water, weaving their way between the tall-masted schooners loading and discharging their cargoes. Music and the cries of vendors selling their wares filled the narrow streets descending towards the bay. Donkeys brayed, dogs barked—and a puppy yapped, scurrying forward in search of scraps that might be dropped.

The puppy was scooped off the ground by Sergeant Kelly and adopted on the spot. Kelly had quite a reputation for dogs. He was constantly bringing strays into camp, and caring for them. It had got him into trouble just before setting off from base in Athlone for India on the *Seraphis*. The culprit was a dog called Piggie. She was much loved and played with: the band boys painted her white fur with blue and red stripes and paraded her around as the Union Jack; not to be outdone, the target-range markers painted her with black circles. But Piggie frightened an officer's lady and that led to a reprimand for Kelly and Piggie's removal from camp.

It was therefore no surprise in Valletta when, by dodging the vigilant

military shore patrols, a bundle of white fur was smuggled aboard the *Seraphis* just before she sailed. The pup was given the name of Bobbie and cosseted throughout the voyage. The ball of fluff was passed from doting soldier to doting soldier. He was hand fed and slept with Kelly in the crowded troop quarters. He was to spend more than a month at sea, sailing via Alexandria and the Suez Canal—which had been open barely one month—before being transferred to the *Malabar* for the last leg of the journey to Bombay and from there travelling overland to garrison in Karachi. Three years later, in 1873, Bobbie and the 66th left Karachi for six years of constant movement, to Belgaum, Poona and Ahmednagar, again to Poona and finally back to Karachi.

At the quartermaster general's HQ in Simla, meanwhile, General Sir Frederick Roberts was preparing his campaign for restoring and reinforcing British authority on the North-West Frontier and in Afghanistan. Organising a Kandahar field force, he placed Lieutenant Colonel James Galbraith in command of the 66th Regiment of Foot and ordered it to move out from Karachi for Sibi, where Galbraith was to rendezvous with E battery of B Brigade of the Royal Horse Artillery (generally referred to as EB) and the field hospital unit controlled by Surgeon Major Preston.

When orders reached the regiment in January 1880, Bobbie was already a seasoned veteran of military life. He had learned fast what he must do on patrols, in guiding and guarding, in seeking out and warning of venomous snakes or of the approach of marauding enemies. He had developed a keen sense of impending peril and could spot quicksands and swamps, then find safe ways round them. He had learned how to cope with the huge assembly of pack animals—the donkeys, mules, horses and camels that towered over him—that were part of every military camp's life. He had an innate sense of duty and timing too and, most of all, a sense of belonging.

The journey to Sibi must surely have been one of the most pleasant Bobbie ever knew, for it took place in the roomy and well-ventilated carriages of the Indian Peninsula Railway, which passed through jungle and plain, over bridges and through villages with ornate temples, through lush verdure and changes in both climate and scene as it gained height towards the mountains. There were hundreds of

birds with beautiful plumage to be seen, parrots and jays, and monkeys that clambered up the tall palm and date trees, chattering at the approach of the train.

Sibi was a sombre end to such a journey, an inhospitable, dreary-looking plain of red sand and intense heat, subject to raging sand-storms that often lasted two or three days at a time. A storm could be seen miles away, like a thick cloud, rolling along the desert as one solid mass of sand. Within minutes of it hitting camp, all was engulfed beneath an inch of dust and the animals, terrified, scattered.

D detachment of the 66th was already at Sibi when the main force arrived in mid-February. It had been diverted earlier to Hyderabad to pick up six smooth-bore howitzers—four six-pounders and two 12-pounders—as a present to the Wali of Kandahar from the East India Company and government. They were heavy and cumbersome, and were destined to play a key role in events to come.

The Kandahar field force set off at the end of the month knowing the going would be slow, especially for the pack animals and for both EB and the 66th's D detachment, hauling their field guns. They marched at night to avoid the searing heat, but only at the cost of slipping and groping their way forward in the dark. During the day, as the column rested, there was no way in which the animals could be tethered in terrain so barren that only a few thorn bushes broke up the landscape. Many mules and donkeys wandered off to die from heat and exhaustion, while vultures circled above, marking the spot.

The route lay via Quetta, the Piskin Valley, Khoja Pass and Chaman and was punctuated with alerts and skirmishes as they fought off attacks from Indian hill tribes—stocky, fearsome-looking warriors armed with matchlock rifles, and with dirks and knives hanging from their belts. One such alert came when, as the columns approached the Piskin Valley, it was learned that two small British outposts at Gatai and Dubbrai had been attacked, looted and everyone killed. At Dubbrai, Galbraith's reconnaissance party found Major Wauby dead with his pet dog, severely wounded by sabre cuts, lying across him. (The dog was cared for, survived and was eventually handed over to Major Wauby's widow.)

Crossing the dread Piskin Valley with its banks of quicksand took

three days. Wheels bogged down, horses stumbled and pack animals shed their loads. Bobbie, sure of foot, ran ahead testing the way, then, retracing his steps, led the column through. The sun was unrelenting and not a tree was to be seen. The struggle continued up to the Khoja Pass where, at its summit and as if by magic, the way ahead suddenly opened on to a vast plain studded with distant hills. They were in sight of Kandahar. The journey had taken ten days from Sibi and there had been many sad losses on the way of men, stores and animals. Many suffered from severe sunburn, dehydration and dust congestion of the lungs.

The Wali of Kandahar, Sher Ali, was delighted with his gift of six guns and left almost immediately with his force of some 3,000 irregulars for the right bank of the Helmand River. From there, he said, he could monitor the groups of Ayub Khan's army filtering over the border, and cut off any enemy advance towards the Kandahar road.

The British military garrison in Kandahar, commanded by General Primrose, was situated just outside the citadel. Primrose had the advantage of a good intelligence network and a communications system that included the latest innovation in science—the telegraph. On several matters Primrose ceded authority in judgement to Colonel St John, his political officer. St John had never been convinced that Sher Ali's force could be as effective as Sher Ali thought, so he kept an astute and wary eye on reports coming in from the border sector. In early June, he received information that a considerable number of Ayub Khan's men had crossed the border at Herat, north of the Helmand, and appeared to be camping preparatory to moving southwards to the Kandahar road. He advised General Primrose to send out a brigade—which could now be mustered since the reinforcements had arrived—to join up with Sher Ali in a show of force.

General Primrose showed some reluctance to do this. Events of the previous war in Afghanistan made him wary of committing himself or overstretching his resources. Nevertheless, when St John confirmed Ayub Khan's movements on 21 June, Primrose agreed with him and telegraphed General Roberts in Kabul. He informed Roberts that he could move a brigade out *if* HQ sanctioned it. But, like General Primrose previously, now Roberts hesitated. He consulted the vice-

roy's officials and the East India Company, whose views were influential, and finally referred the whole question back to London to the secretary of state for war, Edward Cardwell.

It was not until 1 July that General Primrose finally received a reply authorising the brigade to move out. The instructions were specific and constraining. His troops were not to cross the Helmand, only to prevent Ayub Khan from doing so. More, he was not to strengthen Kandahar at the expense of the small garrison at Khalat-i-Gilzai, where two companies of the 66th Foot had been based for some time.

It must have been an impressive sight when the brigade left the garrison just as the sun rose on 4 July. In charge was Brigadier General Burrows, leading the cavalry of the 3rd Sind Horse and 3rd Bombay Light Cavalry; Major Blackwood was at the head of his EB of the Royal Horse Artillery drawing their six modern field guns; Lieutenant Colonel Galbraith led his 66th Regiment of Foot and Surgeon Major Preston followed with his field hospital. There were units of the 1st Bombay Grenadiers, the 30th Bombay Infantry, otherwise known as the Jacob's Rifles, and half a company of Bombay Sappers and Miners under the command of Lieutenant Henn, Royal Engineers. In all, there were 3,453 men of all ranks, of which the 66th Foot had 19 officers and 497 other ranks. Bobbie, ribbon and medallion round his neck, now more than ten years old, trotted out in front as the mascot, with Nellie and Billy not far behind him.

They left to the music of the drummers and in a blaze of colour—khaki, blue, red and green—with long, slightly curved sabres at their sides and spurs at the heel; the infantry were armed with four-foot long (five feet with bayonet attached) Martini-Henry rifles. Behind them came the pack animals—almost 2,000 camels, 500 ponies, 100 mules and 350 donkeys, in addition to more than a hundred bullocks—with ammunition, stores and tents loaded across their backs. The vast column extended for more than three miles, churning up a permanent cloud of hot red sand.

They rested up during the heat of the day and marched mostly by night, which brought its own hazards. In the dark the troops were greatly dependent upon the dogs for their eyes and ears, and to find solid footing through crevices and over rocks. Pack animals were lost

all the same, crashing down under their loads, gun and trailer wheels snaring between stones. Added to these challenges was the continual oppressive heat, which increased relentlessly as the column descended into the desert 1,500 feet below the level of Kandahar. For seven days they continued across the hills that cut the Maiwand road, forded the Argandab River and ploughed once more into the desert before reaching their objective at Girishk on the Helmand. There they pitched camp on the left bank beside the refreshing sight of clear, running water. The junction with Sher Ali's forces on the right bank had been made.

Throughout that night came the noise of fighting from across the river, of movement there and unrest among Sher Ali's followers. Early in the morning, General Burrows agreed with the Afghan that the following day, 14 July, his rebels would be brought over to the left bank and disarmed by the British. The rebels moved first, however. During that night, 2,000 of the 3,000-strong force fled, taking ammunition, stores, pack animals and all six guns with them to join forces with Ayub Khan.

The cavalry, the EB and five of the six 66th Foot companies gave chase. Way out in front in the pursuit was Bobbie, running in perfect line with the troop. The disorganised rebels panicked and fled towards the hills, leaving all they had taken behind them. Lieutenant Maclean snatched the Wali's six guns and hauled them back to camp, but there were only 51 rounds of ammunition left per gun. A crestfallen Wali joined Burrows' force on the left bank with what remained of his supporters. There was now no question of his guns being returned to him. Instead, several EB gunners spent the next ten days teaching the 66th's infantrymen how to lay down fire.

The experience of the rebellion in the Wali's camp caused General Burrows to reflect on the security of his own position. The Helmand, while flowing well in places, was fordable elsewhere. A more defensible site was at Khusk-i-Nakund, but within a few days of arriving there the camp was moved again to an old fort three miles farther north at Mahmudabad. Each move was a colossal and fatiguing effort, with hostile local tribesmen shadowing the convoy and striking when they could.

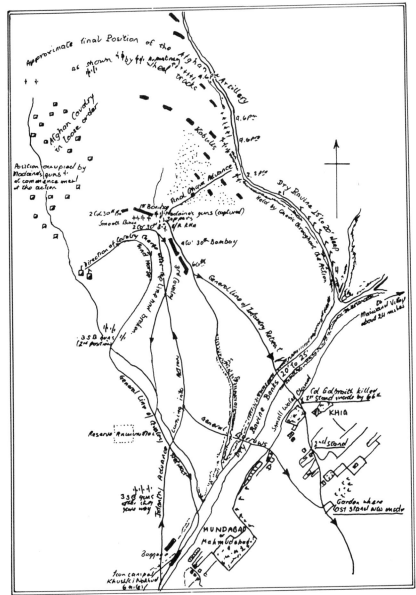

The Afghan advance towards Kandahar and the last stand of the 66th Regiment.
From *The Second Afghan War, 1878–1880*, Official Account.

Mahmudabad stood on the edge of a deep, dry watercourse that curved northwards, 15 to 20 feet in depth. The plain beyond was flanked in the distance by mountains through which Ayub Khan's army must come if they were to lay siege to Kandahar.

The brigade made camp on 26 July at the southernmost point of the watercourse. There, as in all moves since leaving Girishk, tents were furled and stacked horizontally to form a breastwork over which the troops could fire if need be. The night was full of tension. No one slept. The pack mules sheltering within the banks of the watercourse were restless and the horses, spooked, thrashed around. In the distance, lit against the night sky, hundreds of flickering fires testified to the presence of the enemy.

Dawn on the 27th was calm. There was little movement to be seen from the enemy camp in the shadow of the mountains. Then, suddenly, as the sun rose higher, came an awesome sight, an awesome sound. Advancing through the mountain pass in a huge cloud of dust drummed up by thousands of feet and hooves, and with a noise of chanting that carried and vibrated on the air, was Ayub Khan's army, a far, far greater army than General Burrows had been led to expect. It was an army of 4,000 cavalry—some on horse, some on camel— 8,000 infantry, 30 guns (of which six were the latest breech-loading 12-pounder Armstrongs) and thousands of pack animals. Added to this were 20,000 irregulars, composed of Moslem religious fanatics called Ghazis and the Wali's deserters, now bent on revenge.

The course of the Afghan advance was towards the Kandahar road, from which they had to be diverted at all cost. Lieutenant Maclean went off immediately with two of his six-pounders and an escort from the 66th, halting about 300 yards into the plain. There he sighted the guns and fired. The slow-moving mass continued as if unaffected, the sound of the explosion lost in the deafening din of their push forwards. Maclean resighted on 2,900 yards. This time the shots found their mark. The Afghans halted, hesitated and turned away from the Kandahar road to face Burrows' field force.

During Maclean's diversionary action, and in what must have seemed an eternity though it spanned only a quarter of an hour or so, frantic efforts were made by Burrows to strike camp, regroup his forces

and haul the guns, supplies and cavalry across the obstacle of the watercourse onto the plain. Once there, he advanced parallel to Maclean's guns and set up his line of defence. The 66th was situated on the right with the Wali's six smooth-bore guns in the centre and the Indian Infantry to the left. The opposing forces were unevenly matched from a numerical point of view. Ayub's army was colossal (its field strength was confirmed after the battle and the subsequent relief of Kandahar), yet it was untried, undisciplined and subject to internal squabblings, whereas Burrows' brigade was highly trained, disciplined and dedicated. Burrows was certain the strength of his force would prevail. The day's events might well have vindicated his faith—at least partially—had not unforeseen developments taken a hand.

Ayub Khan took his time. With his overwhelming superiority in numbers—at least 10 to 1—he felt he could afford to consider strategy. He decided on an outflanking manoeuvre in which the Ghazis would push forward on the right flank, hidden from view by the high banks of the watercourse, while his cavalry would take on the Indian formations on the left flank.

In a feint, scores of Ghazis on horse and camelback, white robes floating in the breeze, charged forward fluttering little flags in the hope of distracting the 66th's attention from the outflanking movement proceeding close to them in the watercourse. The ruse was spotted by alert eyes and the barking of a dog. It is not known from the records whether this was Bobbie raising his first challenge, although Sergeant Kelly was certainly in the proximity of the watercourse at the time. The battle was joined: sabres arched into the air, their blades flashing in the light of the sun. There was pandemonium as the enemy took heavy losses within the restricted area of the watercourse. There was hardly a lull before the Ghazis mounted a second attempt to infiltrate along the watercourse. This one almost succeeded, only being repulsed by Major Ready's stores escorts as far down the watercourse as Khig.

There was little point in the Ghazis continuing to hide in the watercourse once their position was known. They poured over the top onto the plain in one shrieking, pounding mass. For the first time the brigade saw the magnitude of what they must face. Burrows' cavalry ranks

were now dangerously exposed and the Afghan artillery was withering, their salvos landing accurately within the British lines. Gunners with the 66th's smooth-bore howitzers fired until their barrels were hot and there was no more shot. Eyes streamed from gunpowder fumes and swirling dust. Hands blistered as riflemen wrapped rags or paper around barrels too hot to hold. Fingers, cut and burning, fumbled painfully into pouches to dig out ammunition. Ears rang from the detonation of shell, shot and bullet, from the screams of the injured and the piteous cries of the hideously injured animals.

There was no time to stop to think of water as the sun beat down and parched tongues began to swell. The 66th hauled the six guns, now without shot, to the rear, where the injured were loaded across the barrel supports. Anything that could move was being used to evacuate the wounded to the rear and then on the long and perilous retreat to Kandahar. The weight of their load bore down heavily on the backs of the hard-pressed horses as they struggled, petrified, to pull the injured away from the battle.

The Afghans charged again. Horses, camels, guns and sabres descended on the brigade's lines in a wild and deafening mass, and a sea of dust rose high into the sky. Yet they were repelled once again, leaving the field strewn with their dead and dying. Then came an eerie and uneasy lull as the dust settled once more in the mid-day heat.

Ayub changed tactics. This time he concentrated on the left of the defensive line—on the Indian infantry. As the Ghazis emerged from the heat haze and thundered down on the defenders, the Indians panicked. Their line broke almost immediately. They scattered, fleeing towards the rear in such a haphazard manner that they collided into the rear of the 66th's lines, who were firing solidly into the ranks of Ayub's horsemen. The impact of the Indians momentarily broke the 66th's lines too, and there was desperate confusion before they reformed, badly mauled. Two EB guns were overrun and hauled off by the Ghazis, whooping in delight. Major Blackwood, still on horseback, was hit in the thigh, then in the shoulder, and disappeared in the engulfing waves of enemy. A bullet struck Lieutenant Aslett's helmet, spinning it round. Another ricocheted off a sword, killing the next man.

It was probably now that Sergeant Kelly was wounded in the head. Bobbie sprang to his defence, jumping onto him and covering him, yapping and snapping protectively. Bobbie's coat was heavy with dust and grime, and his eyes were red. He followed his master as he was lifted from the ground and taken to the rear for evacuation on an ammunition limber. Bobbie hesitated, then turned and sped off back to his company, taking up his place at the heart of the dwindling group.

The Indian cavalry were ordered into line. Captain Mayne, a young officer and scion of an illustrious family, sought desperately to clarify the situation with the force commander, but failing to receive any response to his messages, he temporised in a desperate effort to hold the fast-disintegrating line. Over on the right flank, the 66th now numbered no more than 100 men. Regrouping with the remaining EB gunners, the remnants of the 66th made for the watercourse in the hope of retrenching on the other side. Crossing the watercourse was a nightmare. Men fell onto the swords of those preceding them, crashing into the fleeing sepoys and hurtling into animals demented by noise and pain. Yet most of them reached the other side where, 800 yards farther on, they took up defensive positions in the ruins of Khig.

For a further hour the battle raged, the injured being hastily withdrawn, evacuated on anything that moved. But the end was in sight, and those remaining had no illusions as to their fate.

Still Ayub's army would not fully close with the defenders, preferring a hail of shot and bullets in a policy of attrition until the tiny band of troops, now reduced to just 11 men and two dogs—Bobbie and Nellie—retired 200 yards to the walled garden of Maiwand to make their last stand. There was another lull. The few left fell silent, each locked in their own last thoughts, pondering their end. Hands went out tenderly to caress the two creatures snuggling up to them in silent devotion in this most dire of moments.

To the stunned silence of the enemy, no more than 20 yards away, 11 figures and two dogs emerged from behind the ruined walls. The tiny group marched forward some yards and in perfect order took up a box defence formation. They calmly loaded rifles, aimed and fired into the milling hordes. Colonel Galbraith and Captain Macmath died almost immediately in a hail of Afghan bullets. Nellie was killed along

25

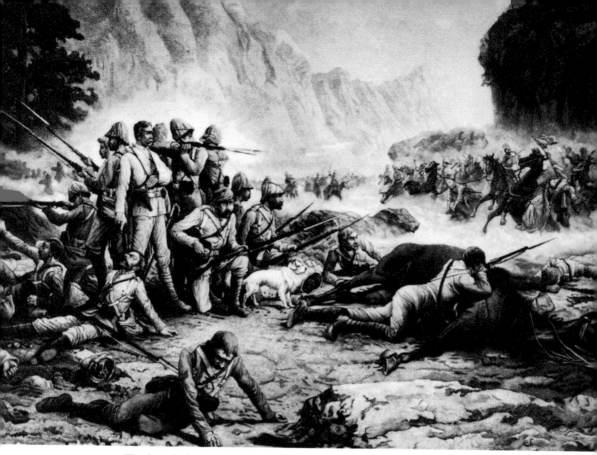

The Stand of the Last Eleven, the Battle of Maiwand, 27 July, 1880. *Photo: Anthony Miles Ltd, courtesy the Duke of Edinburgh's Royal Regiment Museum, Salisbury, Wiltshire.*

with her master. Right at the end, the only creature left standing, feet splayed, teeth snapping at horses' fetlocks, growling, biting and scratching in defiance, was Bobbie. The sight of the white, barking speck in front of the enemy as the position was overrun was the last image that the retreating wounded took back to Kandahar.

It was almost two days before the ramshackle convoy of litters laden with wounded reached the relative safety of Kandahar. The garrison moved immediately inside the citadel and prepared fortifications for the siege that could not be long in coming. Ayub's army stayed on the scene of the battle for two days, however, looting and celebrating,

totally oblivious of the ranks of British wounded escaping to relative safety.

<p style="text-align:center">* * *</p>

News of the defeat at Maiwand reached London within hours of its occurrence. In the House of Commons the next day, 28 July, 1880, the prime minister announced the disaster to a hushed assembly. The news sent such shock waves throughout the nation and Empire that the official record of the disaster would not be published until 27 years later. Even before the facts were known, blame for the disaster was being apportioned and demands for an inquiry made.

The losses were of size. Of the 66th, barely a third—all injured— returned. Among the huge assortment of animals that had left the garrison on the outward journey three weeks earlier, the losses were: five officers' horses killed and two wounded; 62 battery horses killed, with a further five dying of wounds; 11 horses shot due to wounds or exhaustion; 83 horses shot in Kandahar due to their wounds. Transport losses were even heavier: 1,676 camels, 355 ponies, 24 mules, 291 donkeys and 79 bullocks.

Action was demanded in London. Immediately, Roberts set off on an epic march from Kabul to Kandahar at the head of a relief force. He pressed his men hard, for they covered the 300-mile distance in barely six weeks—an average of 50 miles a week in nearly impossible conditions—before sighting the Ayub's army encamped in siege formation outside the citadel. Ayub was unprepared for the sudden appearance of such a force, probably not believing it could arrive in such short time, and was himself within seconds of being caught inside his own command tent when it was overrun by a British advance unit. So unexpectedly did General Roberts' forces arrive that the coffee cup from which the Ayub was drinking at the time was still hot. The relief of Kandahar made General Sir Frederick Roberts a national hero; he was promoted to commander-in-chief, India, and created Lord Roberts in recognition.

The evening the siege was lifted, an event occurred that stunned the garrison. A white-haired dog, exhausted and with his coat covered in matted blood, limped into camp and calmly sought out his beloved

<p style="text-align:center">27</p>

master. He went up to Sergeant Kelly, sitting on the side of his bunk-bed. Bobbie was home where he belonged, with the 66th. His wound was severe but was healing: a shot had gouged a rut down his spine. He was the final casualty and the only survivor of 'The Stand of the Last Eleven'.

How Bobbie managed to survive remains conjecture. His first hurdle must have been when the last 11 were killed and the position overrun. Shot, he probably lay unconscious for some time among the bodies of the slain. Perhaps he was cared for by a compassionate Afghan, for they were a people who respected courage, but their renowned cruelty would have made such tenderness highly unlikely. It is much more probable that Bobbie, keeping close to a water supply all the time, made his way back to camp alone.

At the end of October, the 66th left Kandahar to return to India and Bombay *en route* for repatriation to England. They set sail with Bobbie on 20 January, 1881, arriving in Portsmouth on 18 February. Disembarking the following morning they went immediately to Park-hurst on the Isle of Wight, where they were billeted. The return journey had not been without sadness. The regiment had lost three more men and one child, all of whom were buried at sea.

The 66th Regiment of Foot, in existence since 1756, was destined for change. This came not so much from its terrible decimation in Afghanistan as from reorganisation of the entire British Army by the secretary of state for war, Edward Cardwell, in 1881. The 66th had enjoyed a long and proud history and seen service in the Peninsula War, in the Pyrenees, Nepal, against the Canadian rebels in 1841 and, along with the 20th Company, had guarded the Emperor Napoleon on St Helena and eventually borne his coffin to his grave. Now news came in the summer that the 66th would be incorporated into a new regiment and become the Berkshire, later the Royal Berkshire, Regiment.

It was under this new banner that the survivors of Maiwand were to be presented to Queen Victoria to receive military awards and take new regimental colours. The date was set for 17 August and the invitation was extended to Bobbie, the canine hero who had caught the imagination of the queen of an empire. With pride and affection

the wives of the former 66th set about ensuring that Bobbie was nicely attired for his memorable day. He would need a smart coat: work began on it immediately and by the evening of the 16th it was finished, complete with the regimental blazon.

On the morning of 17 August Bobbie was introduced to the Queen at Osborne, her favourite summer holiday home, on the Isle of Wight. She showed intense interest in the now-ageing terrier, and asked one of the men about to receive his Afghan medal to lift the dog's coat in order that she might see his wound. Bobbie was lifted onto a table and in a ceremony that in no manner differed from other presentations,

Bobbie with his fellow survivors of the Battle of Maiwand, after receiving the Distinguished Conduct Medal from Queen Victoria at Osborne on 17 August, 1881. Left to right: Private Clayton (Berkshire), Private Battle (Berkshire), Colour Sergeant Woods (Northumberland Fusiliers), Bobbie, Corporal Lovell (Berkshire), Sergeant Williams (Berkshire), Lance Corporal Martin (Berkshire). *Photo: The Royal Archives* © *Her Majesty The Queen.*

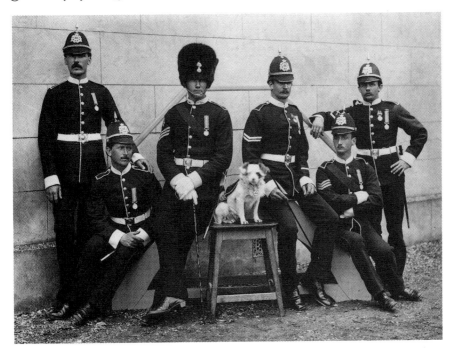

the Queen placed the red-and-green ribbon and medal of the Afghan campaign around his neck. Privates Clayton and Battle (Berkshire Regiment), Colour Sergeant Woods (Northumberland Fusiliers), Lance Corporal Martin, Corporal Lovell and Sergeant Williams (Berkshire Regiment) all received the Distinguished Conduct Medal, and were photographed in the grounds of Osborne with Bobbie at the centre. For his part, Bobbie was conscious of the greatness of the occasion, and kept himself in dignified line throughout.

Later that day, as was customary with the Queen, she recorded the day in her diary, mistakenly referring to Bobbie as a 'Pomeranian':

At 11, I gave 6 good conduct medals to Sergeants and Corporals who had, all but one, been in the 66th Regiment in the dreadful retreat after Maiwand, and had shown great gallantry. I stood in front of the house with my back to the portico, a Sergeant with the colours next to me, and 200 of the 66th Regiment (now called Berkshire, with white facings instead of green) under the command of Colonel Hogge, were formed up in a square, facing me. They had their little dog, a sort of Pomeranian, with them, which had been with them through the campaign and is quite devoted to the men. It disappeared after Maiwand but came back with Sir F. Roberts when he entered Kandahar, and instantly recognised the remaining men of the Regiment. Bobby, as he is called, is a great pet and had a velvet coat on embroidered with pearls and two good conduct stripes and other devices and orders tied round his neck. It was wounded in the back but had quite recovered. The men marched past; Lieutenant Lynch was presented who was badly wounded at Maiwand and is almost the only officer of the Regiment who came back alive!

So, Bobbie entered history. His remains have been preserved and are now in the Duke of Edinburgh's Royal Regiment Museum in Salisbury, along with many other items brought back from the battlefield of Maiwand and two famous paintings of the Last Stand. To this day, Bobbie has the unique distinction of being the only animal of combat ever to have been decorated by a reigning monarch.

2

CHINDIT MINNIE

The situation was bad in White City, the Chindit stronghold more than 150 miles behind enemy Japanese lines. For a while it was touch and go as the Japanese pressure increased. If they could demolish the Chindit 'phantom army' which had operated against them so effectively, they would be able to march on Imphal and into India. Chindit casualties mounted. The injured were evacuated by light aircraft which zoomed in low above the dense jungle. Reinforcements were dropped by air and Mustang fighters, serving as ground-support planes, tore into the enemy less than 100 yards from the defenders. Yet, despite the tension of the moment and the enormous strategic importance of the operation then taking its course, Lieutenant Colonel Mike Calvert, White City's commander, had news on the progress of their dear Minnie passed throughout the unit.

Minnie must surely have been the most unlikely of heroines. A fragile pony foal, she had captivated the hearts of the 12,000 men in the steamy, fever-ridden jungle of Burma. When they withdrew from the area there was no question of Minnie being abandoned, left behind. She was smuggled out by plane and remained with the Chindits from the Lancashire Fusiliers 20th Column as their beloved mascot. With them she travelled from India to England and on to their next posting in Egypt, marching at their head on parade. She was presented to royalty and the highest officials. Her story is one of awesome endurance, and of the spirit of affection and compassion that exists between man and beast even in the most critical times of combat.

Minnie was unique. She should never have been in Burma, never have participated in the war that was to rage with terrible ferocity around her. By one of those flukes of circumstance in which the exception always slips through the control process, the Veterinary Corps

31

Minnie, mascot of the Lancashire Fusiliers 20th Column, on parade after the war. *Photo: courtesy Bury Times.*

officers in charge of selecting up to 2,000 mules and ponies for the operation had not noticed that one of the pony mares was pregnant. The mare, whose name too has slipped through the net and is unknown, was flown into occupied territory as a beast of burden and into a battle on which so much was to hinge. Minnie has often been referred to as a mule. This is unlikely to be the case. Indeed, records refer to her as a small pony. Ponies found in India, from where Minnie's mother was certainly recruited, did tend to be smaller than

the European variety. They had longer pointed ears, too, which would have added to the confusion. And the use of the word mule in military parlance had traditionally meant anything that carried a load: in army circles, even an elephant was referred to as such!

To a large extent, this is the story of the undaunted strength of character of Minnie's mother as much as Minnie. Their fates were interlocked throughout the height of the battle that risked engulfing them. Together, they provide one of the most powerful and moving animal stories to emerge from the Second World War.

Mules in particular have been used as load carriers in war and peace since time began and have, generally, a most unflattering reputation. 'As stupid as a mule' or 'as stubborn as a mule' reflect the qualities often ascribed to them. Yet this is far from the truth: they are rugged in strength, intelligent and determined, and these factors are often confused with stubbornness. They are in their element in difficult situations, such as in the mountain, jungle, or any terrain in which transport is difficult or impossible. They are not inclined to panic and have a remarkable stoicism. They do have a fearful temper, however, and will lash out with their hindquarters or nip at legs with their long, often brown, teeth. They are able to carry up to 25 per cent of their body weight in load, and by this means transport heavy weapons, ammunition supplies, radio transmitters and medical equipment. For all these reasons, the mule was an urgent requirement in the military operation against the Japanese in Burma. Although Minnie and her mother were ponies, and ponies were in a minority among the mules, they were destined to endure exactly the same hardships, and the loads they had to carry were no less heavy to bear.

* * *

The miracle was that Japanese reconnaissance never noticed the huge, almost unparalleled, build-up of forces taking place just 80 miles across the Burmese border in Assam. There, high in the mountains, some peaking at about 8,000 feet, two military bases were hewn out of the dense undergrowth and semi-jungle, Sylchar and Lalighat. Each was more than a square mile in size and included airstrips capable of sustaining heavy loads. Tents had been pitched to house up to 15,000

33

men—troops, aircrews and support staff. Huge storehouses were stacked with food supplies, ammunition, anti-aircraft guns, heavy weapons, mines, barbed wire, radio transmitters, medical equipment, clothing, bulldozers and a few jeeps. High-octane fuel tanks catered for the needs of 50 Mustang fighters, a squadron of B52s, a squadron of Douglas C47s—not to be confused with the better known DC3— and about 80 light aircraft. Shared between the two bases were 100 wide-winged, 60-foot-long gliders parked nose-to-tail in a seemingly unending line. Field kitchens worked round the clock to provide for the troops about to go into action against a relentless and frequently cruel foe. And in the transport section, close to water and any available shade, hundreds of mules and ponies were under examination and certification for the task that lay ahead. Every day their numbers increased as hundreds more were brought up from the valley below.

What was in preparation was visibly an airborne operation. Had the Japanese seen it, they would have been alarmed at its size and rate of build-up. Their concern would have been double had they been able to identify the senior command officers standing round a map spread on a portable table in an open-sided tent: General Slim, later to be Field Marshal Lord Slim, Commander of the British Indian 14th Army; Air Vice-Marshal Williams; General Orde Wingate, creator of the famed Chindits; Lieutenant Colonel (later Brigadier) Mike Calvert with his number two, Colonel Claud Rome; and from the United States, the already famous Colonel Cochran. Cochran's force, known as the American Air Commandos, was staffed by volunteers. Like 'Merrill's Marauders', the long range penetration group with which the force were to link up later, Cochran's air commandos' skill and daring were to make military history. Almost all the aircraft, flown by Americans and pilots from 146 Squadron Royal Air Force, and certainly all the gliders had been provided by Cochran and the USAAF.

The impressive group had much to discuss, for the operation about to take place was intended to turn the tide of the battle in the Far East in the Allies' favour. Last-minute plans had to be confirmed, last-minute instructions given. Yet as they waited for dusk to turn into darkness and take-off, there was surely talk, reminiscence, of how hard the struggle had been to get that far.

The joint American-Chinese forces under US General Stilwell were facing 25 experienced Japanese divisions across the China–Burmese border and were blocking Stilwell's push south. In south-west Burma, more Japanese forces were pressing hard to reach, and take, the vital Imphal Plain, gateway to India. The enemy exercised a stranglehold, a deadlock for Allied strategy. It had to be broken. Only something really novel, unexpected, could change the situation and provide Stilwell with an opportunity to proceed south and open the road for an Allied victory.

There were daunting physical problems largely not encountered in the European theatre of war. Japanese-occupied territory in the Far East covered thousands of square miles. Not miles with clearly defined roads or easily accessible railways, nor even clearly defined tracks. The region covered dense, often impenetrable, hot, steamy, fever- and insect-ridden jungle, where the enemy enjoyed a mastery of disguise; their echoing of bird-calls adding to the eeriness that came, directionless, from the undergrowth. There were mountains and gullies and monsoon rains, and the way ahead could only be achieved by hacking through the undergrowth with sharp-edged machetes.

If the considerable enemy forces, well entrenched, were to be dislodged and beaten, it would take a massive injection of expert, hardy troops, well equipped, to get the process under way. How to transport all that would be required hundreds of miles behind enemy lines and still maintain the element of surprise? There could be only one way: by air. But such a massive lift, which would have to include thousands of pack animals, had never been even contemplated before, let alone made into a practical operation, and certainly not in a terrain of wild and limitless jungle. Even were this possible, who could form such a force and lead it on such a vital mission? It would have to be someone quite unique and with a proven track record. It had to be Orde Wingate and his Chindits.

The idea that it would be possible with only a few well-trained men to hit the enemy in its rear base, disrupting their communications, had been suggested several months earlier. It was met with a blank refusal from the army chiefs of staff, suspicious of unorthodox methods. Orde Wingate knew he had to prove his point, to prove his theories could

Field Marshal Wavell and General Orde Wingate oversee the preparations to airlift 2,000 mules and ponies into the Burmese jungle. Among the animals was one pregnant mare. *Photo: Imperial War Museum.*

work. A team of volunteers was assembled. Carrying loads of up to 60 pounds on their backs, and using mules to transport heavy weapons and stores, Wingate's first Chindit unit crossed the Chindwin, from which it derived its name, and marched 150 miles behind enemy lines. There they cut the Mandalay–Myitkyina railway line in several places before being obliged to withdraw. Wingate learned much from that experience. One lesson was that you cannot expect to have real success unless you have considerable forces, and you cannot get considerable forces all that way behind enemy lines without being noticed. And, importantly, completing the venture on foot in such hostile territory means that you are unlikely to bring your wounded out. The next attempt would have to have considerable air support.

Despite the hard lessons of that first expedition, it served its pur-

pose. Wingate had proved his point. (Wingate had not been the only victim of the army chiefs of staff scepticism. It was the same with the SOE, the Special Operations Executive, which went on to thrive in Europe, dropping its agents behind enemy lines to organise resistance; so it had been with the Long Range Desert Group which was to revolutionise desert warfare and largely cripple Rommel's ability to manoeuvre; so it was with Colonel, later Sir, David Stirling's brilliant SAS, the Special Air Service.) But as Wingate stood that evening chatting with senior colleagues and the commander of the force about to go into Burma, Lieutenant Colonel Mike Calvert, even he must have been awed at the sheer scale of the operation.

The plan was simple enough. Calvert had chosen two sites about 150 miles behind enemy lines. Dubbed 'Piccadilly' and 'Broadway', they were little more than clearings in the jungle. They would be strongholds for stores and supplies, and an airstrip would be hurriedly created for casualty evacuation. Once down, the main force would strike in three directions, to blockade the road and railway between Mawlu and Hopin, deny use of the River Irrawaddy to the Japanese and cut the enemy's routes northwards on the Bhamo–Myitkyina road.

The Chindits, members of the 'phantom army', clambered aboard the gliders that were already attached to the C47s assembled on the runway and apron. They were a mixed team now welded together from the 1st King's (Liverpool) Regiment, the 3/6 Gurkhas, the 1st Staffords and the 20th and 50th columns of the 1st battalion of the Lancashire Fusiliers—and a Nigerian unit. Practically none had been on an aircraft before, and certainly not in a fragile-looking engineless glider.

Suddenly all was put on hold. An aerial reconnaissance photograph taken barely three hours before revealed trees blocking the tiny access into Piccadilly. If they waited for the next moon, the chances of their build-up being noticed would be high and the monsoon season would be upon them before the operation could be rescheduled. Wingate suggested an alternative but little-known site at Chowringhee. Calvert decided against that, for it would mean splitting his forces both sides of the Irrawaddy River. He opted to proceed as planned and concen-

trate all the landings on the one strip at Broadway. He just hoped
he could get sufficient men and supplies down before the Japanese
reacted.

It was Sunday 5 March, 1943, when the Dakotas roared off into the
darkening sky, the gliders jolting and dipping behind them before
stabilising in the air stream. From the portholes the passengers could
see the Imphal Plain and the mountains beyond bathed in moonlight.
They crossed the Chindwin, turned north and there, wending its way
like a sparkling snake, was the Irrawaddy. Suddenly the minuscule
landing-strip appeared below. The tows were cut. The Dakotas gained
height, turned tightly and set course to return to base for the next
sortie. There was sudden silence in the gliders: only the hiss of air as
they drifted down. Chaos was but a few moments away. Two trees
stood in the middle of their landing-path, unseen from the aerial photo-
graph. Unexpected ditches ripped out the gliders' undercarriages.
Glider ploughed into glider. The men, mostly Staffordshires, poured
out, desperate to clear the path for the follow-up gliders that could
not be long in arriving. But before they could do so, the second wave
smashed into the first. The strip was quickly jammed with broken
gliders. Thirty men were killed and 21 wounded. Of the 54 gliders
that took off, 37 landed at Broadway. Despite the loss of men and
equipment, the heaviest pieces landed safely—two bulldozers, a jeep
and seven men of Lieutenant Brockett's engineering team. 'Enough,'
he said, 'to get the Dakota landing-strip completed' for the next
evening, when the mules of the transport section and the remainder
of the men were due to be brought in.

The C47s were not easy to board, even for a human being. For
mules and ponies it must have been murder. The whole of the aircraft
is on a sharp incline, its nose at least 12 feet above its tail. Bamboo
struts, each about 12 inches in circumference, were anchored from
behind the pilot's cabin to the rear. Coconut matting on the floor was
covered in straw. Four, sometimes five, animals were harnessed
inside the structure. It would take a minimum of 400 flights to get all
2,000 mules and ponies on to the ground at Broadway and later at
'Aberdeen', another airstrip built to the west.

The animals, already spooked by the tension and activity of the

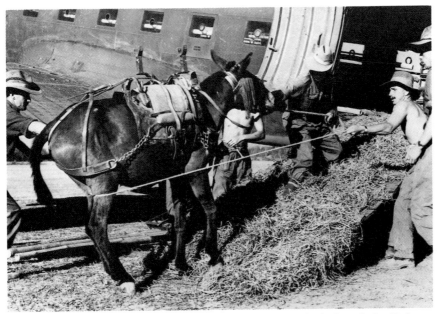

The reluctant animals had to be coaxed, pulled and pushed aboard the Dakotas. *Photo: Imperial War Museum.*

moment, were reluctant to go aboard and resisted energetically. They had to be coaxed, pulled, hauled and pushed from behind. As the pilots and navigators tried to clamber over them to get to the cockpit, the animals vented their feelings and nipped their legs. The Dakotas rumbled along the runway, their engines deafening, the framework vibrating. Yet strangely enough, once the animals were aboard and attached to the restraint bars, they were passive; in the hundreds of flights that were to follow, only four had to be destroyed because of breaking free or kicking the aircraft in a manner that risked putting it in danger. They were quiet, too. Their vocal cords had already been severed painlessly for fear that their braying would betray the Chindits' presence to the enemy.

In the seven nights of clear sky on which the Allies were relying for the aerial armada, 650 Dakota and glider sorties would deliver 9,000 men, 1,350 animals, 250 tons of stores, anti-aircraft artillery, bull-

dozers and barbed wire: all without enemy opposition. Within a fortnight, those figures were to rise to 12,000 men and just over 2,000 animals, leading Orde Wingate to declare, 'We are now in the guts of the enemy'. The impossible had been achieved and a new course set in the war.

* * *

It had taken almost five days to get to from 'Broadway' to Henu, north of Mawlu, where the block was to be made on the road and railway which ran in parallel there. And it had been agony every inch of the 80-mile journey. The route had been along rough tracks or tracks hacked through the undergrowth. Leeches clung to the pack animals' ears and legs, drawing blood. Twigs and branches stung them as they snapped against heads and fetlocks, catching in the heavy loads across their backs and pulling them off balance. The heat had been intense and sticky. Thousands of midges and mosquitoes added to the torment that reached its height as the caravan climbed across the uncharted Gangaw Hills, which peaked at 4,000 feet. More than 400 pack animals and 3,000 men had wended their way along the tortuous route, still without encountering the enemy or even local inhabitants. But that was a luxury that Calvert knew would not last for long. He radioed his position at Henu back to base. They would have to dig in fast, create a defensible stronghold, bring all the supplies and equipment inside it and prepare for the inevitable and imminent Japanese attack to try and dislodge them.

Engines droned. The Dakotas and B52s circled and pinpointed Calvert's force, officially named the 77th Brigade. Their despatch doors yawned open. White parachutes billowed out, floating down like a sheet of mushrooms across the night sky, the silks snagging in the tall trees, the cargoes swinging in the air. So white did the jungle become that Calvert dubbed the block White City. Hundreds of tons of supplies were dropped, including bulldozers to clear the undergrowth for the stronghold and barbed wire to form a perimeter fencing. The work continued in a frenzy: even the torment of the mosquitoes was forgotten in the urgency of the moment. Mortar and machine-gun posts were established, each with its own identification name. Water

lines were assured, telephone lines buried and the parachute containers filled with earth churned up by the bulldozers to make a wall behind which to shelter the animals.

While Calvert concentrated on the installation of White City, two floater columns were sent out to the north and south of the block. Colonel Christie's 50th Column of the Lancashire Fusiliers were to mine the road and railhead close to Mawhun and Kadu, while Major Shuttleworth's 20th Column were to do likewise at Pinwe and Mawlu. It was as the columns were successfully completing their missions, after having had several skirmishes with the enemy, that they heard the sounds of a heavy attack on White City.

Dusk was gathering. The mules and ponies that had been left behind when the Lancashire columns departed scuffed at the ground around them, pulling at their tethers, spooked. Shadows were falling across the trees and undergrowth beyond the perimeter, changing its aspect. Night birds and crickets were taking over from those that had kept up an incessant din throughout the day. Everyone's nerves were on edge. Suddenly, from the northern sector, figures emerged from behind the trees, running forward, shouting urgently 'Hi, Johnny,' 'Don't shoot! It's me!', 'OK, Bill, I'm coming,' hoping that their lilting accent would be confused with that of the Gurkhas.

The Chindits opened up with their heavy machine-guns, mortars and grenades. The enemy seemed to appear from everywhere, charging down towards the perimeter screaming their war cry, spectres in the fading light. The fighting continued for almost nine hours in waves and lulls, the white, yellows and reds of explosions lighting up the night sky. Bullets ricocheted off tree trunks and found their marks— on both sides. In the southern sector the Japanese forced a way through close to the casualty centre, but were thrown back in a counter-attack. The din of warfare at close quarters was deafening: the air, hot and sticky from the day's interminable heat, was stifling. A mortar landed in the animal compound. It exploded, and huge chunks of flesh flew through the air. Hooves were blown off and stomachs blown apart. The anguish of the animals must have been fearful.

The Japanese chiefs of staff had clearly recognised, too late, the

enormous problem that the airborne armada was to pose in their rear. They switched several regiments from their 18th and 56th divisions, the former facing Stilwell's joint forces, and ordered the elimination of Broadway, which they saw as the central point of the Allied operation. Broadway was heavily attacked on 21 and 22 March, coinciding with the White City attack, preceded by heavy airstrikes—the first time that aircraft had been in action against the Chindits since their operation began. The attack was only repulsed several days later after a determined counter-attack by the Gurkhas. The Japanese withdrew having lost up to a third of their strength.

On 27 March, the Japanese high command ordered an all-out attack on White City. Nine days later, it began. At 22.00 hours the skies were suddenly lit up by the intensive shelling of Mawlu, the Dakota strip at Aberdeen and the bastion of White City. The ground attack was this time concentrated on the south-east sector of the block, manned by Shuttleworth's Lancashire Fusiliers, a Gurkha company and the 6th Nigerians, who were laying down a withering response from Vickers machine-guns and three-inch mortars. But the Japanese had a new weapon this time. Called the 'Bangalore Torpedo', it was made of bamboo or steel tubes about 12 feet in length, filled with explosives and detonated by a trigger mechanism. These tore into the block, exploding with ear-splitting impact and sending everything in their path spiralling into the air in pieces. The combat continued throughout the night, for five or more long and painful hours, before Calvert called base in India and asked urgently for Mustang back-up.

Just two and a half hours later, as dawn was breaking, six Mustangs attacked the Japanese forming-up areas, where they were regrouping preparatory to following up their perceived advantage. The Mustangs' accuracy, however, was so awesome and effective that the Japanese broke off the attack. About four hours later, at a height of some 3,000 feet, 27 bombers from the Japanese 5th Air Division bombed White City. Their accuracy could not be measured with that of Cochran's pilots nor the RAF's. Some damage was suffered. Being bombed is not conducive to good morale, but by far the most troublesome effect of the raid was that it prevented the Chindits restoring order to the scarred block and getting any rest. The next day shelling began late

in the afternoon and continued until nightfall. There was a brief lull, then enemy assault troops moved up. Their voices could be heard coming from all directions of the jungle. There was no attempt to hide their presence. On the contrary, the calls to Jimmy, Frank and Bill continued with mocking and strident frequency.

The Japanese had a huge six-inch mortar with them this time, which, as Calvert was later to describe, was designed for the bombardment of Singapore. Just under five feet in length, its shells landed on White City in a whirring crash. Shrapnel from the explosions sliced through foot-thick trees as if they were made of paper. Large chunks of equipment were cut through with deadly efficiency by this weapon, which became the most feared of all by the defending Chindits. The battle raged without respite. The ammunition supply, once plentiful, had taken an alarming dip and had reached a very low level. Calvert called for urgent supply drops: 'We can do without food if we have to,' he said, 'but we can't do without ammunition.' (During the siege, no fewer than 700,000 more rounds of ammunition were dropped into the block without any falling into the hands of the enemy.) By now Calvert's reconnaissance teams had identified the units and strength of the enemy opposing them. They were outnumbered by at least four to one by the six battalions under the command of the Japanese General Hyashi.

Two tiny tanks broke through the thicket in an attempt to crash through the perimeter wiring. But their manoeuvrability was impaired by the density of the jungle. One was taken out almost immediately, and the other prudently withdrew. No longer was there any lull in the combat, and the losses were heavy on both sides. So bad had the situation become, with hand-to-hand fighting in some areas, that the perimeter wiring was covered with rapidly decomposing Japanese bodies, the stench from which lingered over the block. Light planes were called in to dust the bodies with quicklime, but this only partially succeeded and getting rid of the bodies remained a problem. More successful were the daily Mustang ground-support strafing forays. So accurate had the pilots become that Calvert could feel the ground vibrate beneath his stomach as he lay on the ground watching the enemy being hit no more than a hundred yards from the perimeter.

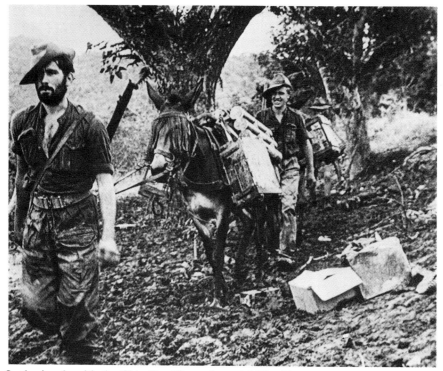

In the jungle with the Chindits. *Photo: Imperial War Museum.*

Light aircraft assigned for casualty evacuation wove through the shelling in an almost unending stream to pick up their charges.

The ferocity of the battle peaked during the third week in April. The sun, the steamy mosquito-laden air, the onset of the monsoon rains and the numbers of casualties combined to make matters worse inside the block which had, nonetheless, withstood all that the enemy, with their superior numbers, could throw at it. Once again the Japanese attacked with mortar fire and Bangalore salvoes, but Sergeant Lee of the 20th Lancashire Fusiliers had reason to be distracted. A pony in the transport paddock was visibly in trouble. Getting closer, he could not believe what he was seeing. The mare was lying on her side. Among all the mayhem and exploding shells, she was in labour. Her

eyes rolled round when he came near to her, and she slightly lifted her head. Her eyes were huge, full of pain and fear. He stroked her gently between her ears and murmured soothingly to her. She must have endured right to the end with the heavy backpacks. A team of midwives was hurriedly organised. The mare was cosseted, encouraged and stroked, and had water siphoned through her teeth to quench her thirst. Faces from all parts of the block looked over the barrier to where she had made her bed. When the time came, amid the bursting of mortar bombs, eager and gentle hands helped her give birth to a tender and fragile foal. The animal, which struggled to get to its spindly matchstick legs, its eyes still closed, was received with a burst of joy from the battle-weary Chindits. It was as if, for this moment if for no other, the war was in suspension, for this little thing was there in spite of it. A phenomenon. A miracle. The newcomer was christened Minnie on the spot, in recognition of the guardpost of that name at which she had been born.

News of Minnie's birth flashed throughout the garrison. She immediately became the sole focus of attention whenever a lull came along. The men would stroll down to the transport section to see her, to stroke her and talk to her and about her. Minnie had become more than a foal that would grow up to be just another pack animal. She was something special, and they all felt a responsibility for her survival and well-being, difficult as that might be in the middle of a siege in the jungle.

Minnie was a clever pony. She knew she could get special treats like sugar lumps. But nothing pleased her so much as when she was allowed to drink tea from a pot, knowing it would bring roars of approval from the faces of everyone crowded round her. Nor was she afraid of the interminable noise of battle and explosion of bombs; at least not overly, for she had been born into it, was part of it, knew no other way of life. This was her world, and the people around her were kind and loving and attentive; she in her turn played with them in her fashion, hopping on her dainty legs and turning her head coyly to the side whenever they approached.

We do not know if Minnie was afraid when an artillery shell landed right inside the transport section's mule paddock where she was

tethered. The explosion instantly killed several mules and stampeded the rest, who tugged in terror at their ropes, breaking free. As one broke out, it kicked its hind legs high in the air with all the force it could muster. Its hoof caught Minnie just above the eye, forging a deep, open and ugly gash across the socket. It was an extremely serious injury. Minnie was knocked into the air by the impact. She landed heavily, unconscious. Sergeant Lee was devastated and spent hours sitting with her, tending her injury. News of the occurrence and that it could mean that Minnie would lose her sight was, like her birth announcement, flashed throughout the garrison. The sense of sadness was almost perceptible, there in everyone's thoughts. Concern was expressed for her from as far away as the columns sent to the Irrawaddy. The effect that Minnie had had on those who knew her, and even on those who had only heard of her, was such that Calvert issued orders that every unit be kept informed of the foal's progress. The Chindits had been fighting a non-stop battle of the harshest kind for more than three months now; they were tired. The news that Sergeant Lee's devoted nursing had saved Minnie's sight absorbed air time in official communications and led to whoops of delight from the very heart of the jungle. Minnie was now an indispensable part of the Chindits. As Major Hallam, the Fusiliers' historian, later put it, 'The news was almost as welcome as a major victory'.

While the Chindits were indisputedly in control of the Irrawaddy Valley, the Japanese had pressed their advantage westwards across the Chindwin and were threatening more than ever the Imphal Plain and the 4th Indian Corps grouped there. Reinforcements by air were no longer possible for White City and the 77th Brigade, the Chindits, were reassigned. They were to strike out northwards on foot to make a junction with Stilwell's joint forces with the Chinese moving south. It sounded simple but was not. The journey lay over hundreds of miles, a nightmare for the Chindits already exhausted by the battles for White City. Nevertheless, on the move north through some of the most difficult jungle conditions they had ever encountered, made worse by the drenching monsoon rains, they were to notch up some singularly notable successes. One that had a bizarre conclusion was the fight for Mogaung. There the Chindits, including the Gurkhas,

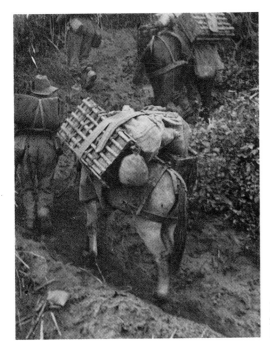

Minnie was too fragile to go
north with the Chindits.
Photo: Imperial War Museum.

had a difficult hand-to-hand fight to dislodge the Japanese defenders,
only to be joined by the Chinese detachments when the objective
had been taken. A few days later, when the BBC and British press
announced the Chinese success, Calvert signalled Stilwell's HQ 'The
Chinese have taken Mogaung, 77 Brigade is proceeding to take
umbrage'. Stilwell's staff officer replied, 'Please indicate map reference
for Umbrage.'

But Minnie was to know nothing of that. All she was aware of was
that her beloved Sergeant Lee and all the other men who came every
day to see her were no longer there at White City. Indeed, the garrison
was now in the hands of the 14th Brigade and the Nigerians, who had
orders to evacuate. Minnie was far too fragile to have gone north with
the Chindits. She was too fragile even to walk back to Broadway. A
conspiracy of silence descended as plans for her departure for safety
were laid. Everyone would know about it—had to know about it—
yet no one would admit that they were about to break every law in

the book rather than leave their beloved Minnie in the jungle at the mercy of the enemy. Minnie had become the symbol of survival.

She would have to be flown out. But the tiny airstrip near the garrison was extremely open and vulnerable, sectors of it changing hands several times. It would have to be cleared before a plane could safely land. Yet so strong was the affection for Minnie that even this happened. The 14th Brigade and the Nigerians mounted a special attack on the runway to get it cleared. Officers of all ranks in White City, Broadway and Sylchar turned a blind eye as an aircraft was scheduled for White City. Within a few hours of the airstrip being cleared, a plane swooped down and Minnie was put on board. The aircraft took off, circled and set course for India. Anxious eyes followed its course until it disappeared from view. Minnie was received at landing and passed from hand to hand as a celebrity, and when the Lancashire Fusilliers returned to their base of Dehra Dun in India a few months later, Minnie was reunited with her overjoyed 'family'.

Minnie was a highly privileged person who had the freedom of the garrison and freedom of the mess. She was particularly fond of frequenting the sergeants' mess, no doubt because of Sergeant Lee's presence, where she would cause hilarious uproar by eating the table-cloths, nibbling at the food, or demanding milky tea. Once, the whole column was on parade—adjutant's parade, an important ceremony and one that demands extreme excellence of presentation. Not even then would Minnie be separated from Sergeant Lee. She trotted after him, found his position in the line and nudged him repeatedly in the back. There was no way of containing her. She pushed him out of the line altogether. But what could have been dismay turned to joy. The adjutant cancelled the parade.

The 77th Brigade, the official name of the Chindits, was disbanded in December 1944, eight months before the Japanese surrender on the American battleship *Missouri*. The brigade had served its purpose, completed its task even more successfully than was then realised, and had proved Wingate's claims right for posterity. A high-level discussion took place on the question of Minnie and what was to be done with her. She was, after all, a Chindit, and Chindits were drawn from several regiments. Yet it was not a difficult decision to make. Minnie's

home would remain with the soldiers she knew the best, the Lancashire Fusiliers. When they in their turn left India in 1947, permission had to be sought to take her to England. Even that was granted. She travelled aboard the troopship *Georgic*, tethered on its afterdeck. Once again she was the source of limitless interest and admiration. She seemed to suffer no ill effects on the long sea journey and willingly ate all the food offered her, from Spam to condensed milk.

In England it was decided that Minnie would become the official regimental mascot. This animal, with its frail legs, had been with the regiment through some of the hardest fighting known in the Second World War and had emerged alive: the bond was deep and enduring. For the first time in her life, Minnie had to undergo training—to stand still on parade, to lead from the front. A ceremonial bridle and shabrack, or back cover, were bought for her and the xx of the 20th Column was etched in gold thread in the cover's corner. She proudly and correctly led ceremonies commemorating Gallipoli at Bury, trooping the colour on Minden Day and the farewell parade as the battalion left for service in the Middle East. This was now to be her life, leading and representing her battalion with foreign dignitaries and royalty, and on official occasions.

There is no record of the fate of Minnie's mother. Both of them were destined to have more adventure in a few years than many humans have in a lifetime. Minnie became beloved because she provided something special, the joy of life, at a moment when life itself was the least thing that could be assured.

In 1994, as the 50th anniversary of the battle for White City approached, a Japanese television company filmed an interview in London with Brigadier Calvert. Asked what he felt the elements were that assured his victory and the turn of the tide against the Japanese, he replied, 'Air transport and ground cover and the evacuation of the wounded.' The Japanese had not provided troop support of this nature and had felt that it was unlikely to succeed in such terrain. At the back of his mind, too, must have been the thought 'and thousands of pack animals,' for they were a silent and loyal lifeline. Among them, one adult animal and one foal were to etch their role in the history of the Chindits.

3

SEA DOG BAMSE

The tall, slim figure of King Haakon of Norway, in full naval uniform, mounted the gangplank of the British cruiser *Devonshire*. With him were his family and government. The cruiser put to sea escorted by Royal Navy destroyers, leaving the northern port of Tromso behind them. Bobbing on the light waves in the cruiser's wake were scores of small ships of all categories, manned by civilian and naval personnel who could no longer remain now that their country had fallen. The sad armada ploughed its way southwards for haven in the British Isles, where it would join with the Royal Navy in the bitter sea battles that were to come—in particular, the Battle of the Atlantic. One of those ships was the coastal surveillance vessel *Thorodd*, built 21 years earlier in the USA, bought by the French navy and then acquired by the Norwegians. It had only one 76-mm cannon on board to ensure the protection of its 18-man crew—or rather, 18 men and one very large dog called Bamse.

When he stood on his hind legs, his front paws resting on the sailor's shoulders, Bamse was six feet tall. He must have weighed at least fourteen stone. On his head he wore either his personal steel helmet or his mariner's cap, the words *Royal Norske Marine*, or Royal Norwegian Navy, on its band.

Bamse, whose name means 'little one', was a true sea dog, a full member of the crew of the minesweeper *Thorodd*, and during the darkest years of the Second World War he was the toast of Norway and Scotland. Stationed at the foremost gun tower, his four legs firmly splayed to take the pitch and roll of the small craft, he would not move until the firing and fighting were over.

The ship's berth was on the River South Esk not far from Dundee, from where many tortuous convoys into the freezing North Sea and

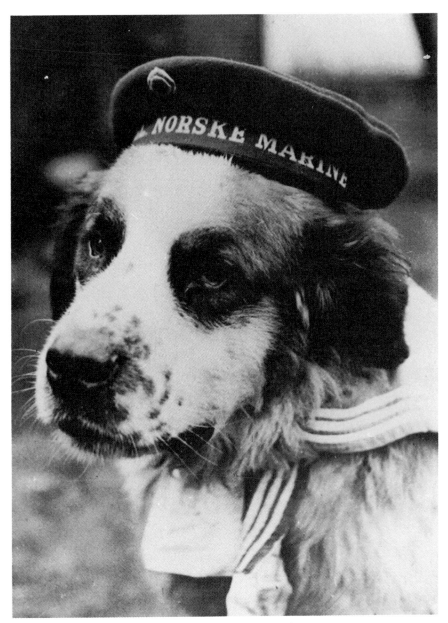

Bamse in regalia. *Photo: courtesy Mr Otto Opstad, Oslo.*

Atlantic began. Here in Montrose, too, he was loved by the local inhabitants, the children, bus drivers and innkeepers, and the sailors of both Norwegian and British navies, among whom his landside adventures were as renowned as his combat experiences. It was here that in July 1944 he was laid to rest.

Bamse was truly exceptional. He became a member of the PDSA's Allied Forces Mascot Club and was mentioned three times in the official Mascot Club history. On his grave a simple inscription expresses it all for posterity: 'Bamse—Faithful friend of all on board the *Thorodd*. Largest dog of the Allied naval forces'.

* * *

Relatively little is known of the fall of Norway in the Second World War and the significance that event was later to have. Had it not occurred, or had it happened in a different form with the Norwegians offering no resistance, Bamse would probably have spent his life quite happily, and unknown, in his home inside the Arctic Circle or on board his master's coastal vessel in its icy seas. But the events that unfolded within a few months of the commencement of the Second World War were to change his life, too, ultimately making him the largest and best-known dog within the Allied naval command. Bamse's story is closely tied to the extraordinary sequence of events that led to the fall of Norway and the imposition of the rule of the traitor Vidkun Quisling. It is a story of intrigue, mistakes, crossed intelligence assessments, treachery and deceit, revealing clearly how a nation's fate can hinge on a thread of circumstance and fortune.

Norway has a very long coastline, stretching for more than 1,500 miles from the North Sea into the Arctic Circle. Its fjords punctuate the scenery and are long, deep, and flanked by hills and mountains which are covered with snow for the best part of the year. Its population at the outbreak of the war was barely three million souls who largely made their living from the sea. It had followed a careful policy of neutrality, just as had its neighbour Sweden. It is in Sweden that the catalyst for the disasters that befell Norway can be found. Germany relied on Sweden's iron ore for its heavy industry and, as it prepared to expand the war westwards to France, Belgium, Holland and then

Great Britain, Hitler knew that Germany would need at least 11 million tons of that ore in the first full year of combat alone. The problem was that when winter came, the only access for supplies was delivery via Norway's port of Narvik. The issue was nothing new. It was a lesson that the German navy had already learned during the First World War. Then it was the British Royal Navy who controlled the waters from the Skagerrak to the Arctic Circle, putting a stranglehold on ore supplies and blocking the Imperial navy's access to the high seas. Throughout the years between the two world wars, German naval supremos had never forgotten that lesson nor changed their opinion that it had contributed to the loss of the war. This time, then, they were determined things would be different. They felt that the German navy must control the waters instead and, with the advent of modern military aircraft, they would be in a unique position to dominate from the air too, hitting at Scotland's shipyards and the ships within its vital sea lanes.

With this in mind, on 14 December, 1939 the Naval Chief of Staff presented two pro-German Norwegians to Hitler – Vidkum Quisling and Quisling's assistant Hagelin – with the idea of persuading the Führer to back a political coup there. But Hitler preferred that that sector should remain calm, that the Scandinavian countries should remain neutral, at least until he was ready to turn eastwards to implement his long-held dream (as he did eighteen months later with Operation Barbarossa, the attack on the Soviet Union). Hitler, in those first awkward months of war, had to take into account that, for a start, Germany had a friendship treaty with her arch-enemy the Soviet Union and the USSR had a common border with Norway in the north: any German move there would inflame matters. More, as neither Britain nor France appeared to be reacting to the Soviet Union's attack on Finland a month earlier, he was convinced that as long as Germany did nothing in Norwegian waters, neither would they. Raeder's plans were laid aside.

But the unexpected did happen: Britain and France did react and hastily threw together a plan to bring aid to Finland. Confusion set in from that moment and, effectively, the Allied effort to assist never made it. German intelligence had heard about it, though, and translated it as the Allies' first step to barring ore to Germany. The potential

in the North Sea had always been known by Britain's First Sea Lord, Winston Churchill. He had even submitted a policy document urging that an arrangement be made with Norway for patrolling the seas, but that had been laid aside by the Chamberlain government. It was now raked out at double speed when British intelligence in its turn learned of the German blockade proposals. The fact that neither event had to do with the other and that there were no direct links between all the elements was, in the end, academic. Finally there was the question of King Haakon. Hitler knew of the Norwegian royal family's close ties with the British. This, he probably correctly adduced, would increase the likelihood of either resistance at a landing or a Norwegian appeal for British help. Still he was uncertain.

Any hesitation that Hitler may have had vanished with the *Altmark* incident. The *Altmark* was a supply ship for the German pocket battleship *Graf Spee*, which had just been sunk in the Battle of the River Plate while the world looked on. On board the *Altmark* in Norway's Josing Fjord were more than 300 British seamen, the survivors of the *Ashlea*, *Doric Star*, *Huntsman*, *Newton Beech*, *Tairoa* and *Trevanion*, six of the nine merchant ships sunk by the battleship. The seamen prisoners had been concealed on the *Altmark* in special metal containers to avoid Norwegian neutrality controls. If Hitler had hesitated, Churchill did not. He ordered a British destroyer flotilla to go into Norwegian waters, board the *Altmark* and release the prisoners. It was a spectacular double blow to Germany. 'Führer orders' for the attack on and occupation of Norway were signed at once. In signing, Hitler authorised an unique infringement of accepted norms in international conflict. His ships, in approaching Norwegian ports, were to fly the Union Jack and respond to challenges in English. It was now a case of who got there first.

Churchill's plans, delayed for so long, were now given priority. In Operation Wilfred, British forces, mostly commandos, and French troops, principally from the Foreign Legion, were set to land at Narvik, Trondheim, Bergen and Stavanger. The German orders for the attack due to begin at 05.15 on 9 April, 1940—whose priority was to capture the royal family and force either surrender or acquiescence—largely coincided with British forces moving in.

54

The Norwegian population did not buckle as Quisling and German intelligence assessments had predicted. In fact, Norway went on to deny Germany its victory for the longest period of any nation in western central Europe, although its naval stations were quickly overrun and resistance, such as that put up by two ancient ironclads in Narvik, came to an end with their sinking and considerable loss of life. Sola airfield, close to Stavanger, was taken by German parachute troops and was a considerable coup for the German forces. From that prize, all naval bases in northern Britain were vulnerable to attack by the *Luftwaffe*. Within a few hours of the German landing in Norway, all the coastline from the Skagerrak to the Arctic was in enemy hands. Yet despite their early losses, Norwegian naval resistance, including on the tiny *Thorodd*, increased rather than waned. As the royal family and government withdrew to Hammar, north of Oslo, several naval battles took place. Of these none was more frustrating for the *Kriegsmarine* than the loss of the newly launched heavy cruiser *Bluecher*, blown from the water by batteries from the ancient fortress of Oskarsborg. Not only were 1,600 men on board lost in the cold waters, but top Gestapo agents too, whose mission was to arrest the King. Vidkun Quisling was embarrassed by his fellow countrymen's resistance and his own inability to deliver. He had claimed that he could rely on the support of practically all the politicians and leaders of the nation, but this was quickly shown to be an illusion, a figment of his imagination. When the Norwegian cabinet met in Hammar a few hours after his declaration, only five of the 200-strong government were absent.

History, particularly the history of war, is one of endless ifs—'if this had been done', or 'if only that had not happened'. But events could indeed have been very different if Churchill's plans for the Anglo-French contingent in Norway had been implemented earlier. As it was, it became an unhappy fiasco which was to leave a great deal of bitterness in those who fought with dedication and gallantry. Although British and French units had been reinforced by three further battalions of *Chasseurs Alpins*, élite French ski troops, they were put on shore at key positions after the area had been taken by the enemy and after air cover was in the hands of the *Luftwaffe*. They were

pummelled mercilessly from air, sea and land. Hammar was no longer safe for the King and government and they were again transferred, this time to Tromso, aboard the cruiser *Glasgow*. The gallant resistance was to last a full two months as the Norwegians and Anglo-French units withdrew into the mountains, making good use of commando-like delaying tactics, for time was of the essence. Time was needed to assure the safe evacuation of the royal family and government to England. Time was needed to obtain reinforcements—but no reinforcements came. On the contrary, the British and French troops in Norway were themselves evacuated: they were needed elsewhere, for France was falling and Dunkirk's miracle was but a few days away.

The *Thorodd* arrived at Lerwick in the middle of June after a rough trip in the sad convoy. The seas had been high, and the ship's screws had often been out of the water, crashing down into the sea with shuddering impact, salt water spraying the entire deck. It was not the

The minesweeper *Thorodd*. Photo: courtesy *Mr Otto Opstad, Oslo*.

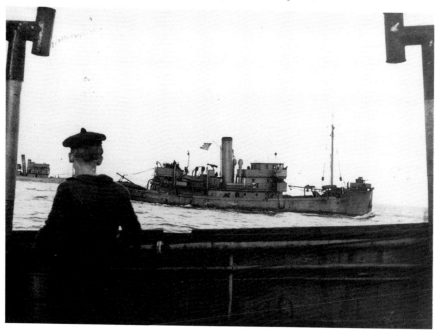

56

kind of sea that Bamse relished. In fact, he never did quite get his sea legs on rough days. When they occurred—and they were likely in the regions covered by the North Sea and Atlantic convoys— the crew became accustomed to having Bamse's huge, damp nose prodding their faces or necks. In his unhappy seasick state he needed comfort.

They stayed for just three days in Lerwick before setting off for Rosyth, where the ship was to be totally rebuilt as a minesweeper. Transforming the single-funnelled craft into a small war vessel was accomplished in record time. Heavy calibre and anti-aircraft guns were installed, communications equipment renewed and upgraded. The deck was altered to make room for the minesweeping paraphernalia and the hull was repainted. On it, in huge white characters, was FY-1905, the *Thorodd*'s number in the charts of war.

All this was a far cry from Bamse's origins and the time when he knew nothing other than romping around with the children, carrying them on his back as if he were a pony. Those were days of laughter and play in the weak sunshine of the Arctic Circle in the deep snow, days that were so long there was practically no night. Bamse was born to a seaman's life. He was adopted as a puppy by the master of the *Thorodd*, Captain Erling Haftoe, principally as a companion for his four children in their home in Honningsway, Finnmark, during the long stretches of winter. But Bamse was not destined to be an ordinary-sized St Bernard. He was larger than life and scared the local inhabitants as he bounded good-naturedly around, not knowing his own strength. He would have to go to sea, it was decided, in order to keep the peace. He was taken on board and entered into the ship's log as a member of the crew. This would probably have been the natural evolution of his life anyway. Having dogs on board ship in Norway was an accepted tradition, for it was a country that lived primarily off and from the sea. Dogs on board served a purpose, but most of all they were loving reminders of home.

Bamse fitted in well. He was not particular about his food and ate whatever was being cooked in the tiny galley of the wallowing vessel and was mostly hand fed by the adoring crew. The voyage from Tromso to Scotland had been the longest Bamse had ever known. It

was to be the beginning of a series of adventures that would ensure him a place in the animal roll of honour.

* * *

The *Thorodd* slipped its moorings just as dawn appeared on the horizon, casting rays across the choppy waters. The gulls flew low, skirting the ship berths, snatching at any waste that had been thrown overboard. Ships' hooters sounded and boatswains' whistles announced departure. The *Thorodd* was on its first sweep of the North Sea. Sitting by the forward gun turret was Bamse, his nose in the air, sniffing. Once into open sea, the gunners locked the heavy-calibre ammunition belt that trailed the deck into the gun and fired, its tracers illuminating the trajectory of the live rounds. The noise was deafening. The deck plates vibrated but Bamse stayed his ground, his specially adapted steel helmet firmly fixed to his huge head. There was an air of expectancy, of uncertainty, on board, and Bamse could sense it. The crew were talking about Dunkirk and the naval miracle that had seen hundreds of craft, including the smallest civilian boat, rescue 338,266 British and French troops from under the nose of the German armed forces and bring them back to England where, Churchill said, they would 'live to fight another day'.

The lull in what became known as the phoney war was not to last long. On 16 July, Hitler signed 'Directive No. 16 on the Preparation of a Landing Operation against England', but already the German high command had hit perhaps its first snag since war had begun. They just could not put together the number of transport vessels necessary to attack England. Thousands of troops would need to be landed in the first days of Operation Sealion, the code-name for the attack, complete with tanks, heavy artillery and ammunition. Hitler knew that he could not depend on obtaining any of these from captured stores; nor would the inevitable heavy resistance be easy to overcome. To land adequate troops in the first waves of the attack, plus tanks and artillery, would require hundreds of ships. The naval logistics for Operation Sealion were already more daunting than the Third Reich would ever again have to face. The cautious German high command, the *Wehrmacht*, insisted upon its requirements; the *Kriegsmarine* promised

them. But even after scouring the occupied countries and requisitioning everything that could float, there was still not enough for the operation. Hitler raged; the *Wehrmacht* blamed the navy; Field Marshal Hermann Goering, head of the *Luftwaffe*, waffled; and the navy bit its tongue. The fight for Norway had been much more expensive to Germany than had been thought or planned for. Its losses had been such that, when the battleship *Bluecher* was sunk, its sister ship, the *Deutschland*, was immediately renamed the *Lutzow* for fear that the nation's namesake might go to the bottom of the seas.

In fact, that early in the war, when the forces of the Third Reich seemed invincible and the future looked grim, Germany had already suffered its first reversal of fortunes and exposed the first chink in its armour. It had misjudged the resistance it would encounter, misjudged the nature of the terrain in which that resistance would hold out for record time, and misjudged the effects the loss of so many surface craft would have on other operations then being planned. It is a pity that historians have yet to recognise that the nature and length of the Norwegian resistance—in particular the amount and quality of ships it sent to the bottom at a crucial moment—played a significant role in seeing that Operation Sealion never took place.

Even had the German navy been able to surmount this difficulty, they would have found themselves up against a new foe, a new barrier—the unpredictable English weather as autumn approached. Attempting to land in the teeth of a gale in the English Channel could spell disaster for an invading army which had, up to that point, known only success. That risk was seen and none, including Hitler, was willing to take it. 'Britain,' said the contented head of the *Luftwaffe*, Field Marshal Hermann Goering, 'will be pummelled into submission by my bombers instead.'

So began the Battle of Britain. Less known, however, was the simultaneous struggle to keep the food supply lines open against the torpedoes of Germany's U-boats which roamed the seas in wolf packs, and the mines laid down in the sea lanes, attrition against the British Isles that was the start of the murderous Battle of the Atlantic.

* * *

Bamse in his steel helmet, with the crew of the *Thorodd*. *Photo: Imperial War Museum.*

Bamse stood up well to the deafening detonation of explosives, to air attack and the chattering of empty shell cases as the *Thorodd*'s guns opened up. There is no record of his ears being plugged, as were the

crew's, to avoid deafness, but nor is there any record that he suffered any loss of acuity. His ears, therefore, almost certainly were protected by his doting sea companions, as a dog's hearing is extremely sensitive. He fared less well with the pitch and roll of the minesweeper in heavy seas. On one occasion the *Thorodd* was on sweep about 100 miles north of Scotland. The sea was running high and the ship was bobbing like a cork. It was fearfully cold. Ice had begun to form on the bridge and weaponry. Suddenly, the ship pitched into a wave at least 15 feet high. Bamse held his ground well as the swell drenched him, but was subsequently 'as sick as a dog' and confined to quarters, where he was nursed by the devotion of the crew, who took it in turns to be with him.

In calmer waters, Bamse would prance to and fro between the officers' mess and the forecastle, nudging the men as he went, his paws thudding down on the deck in a rhythmic one-two-three-four. There were even times when the crew played football on deck, always careful that the ball stayed on board. On those occasions Bamse was goalkeeper, centre forward, all known positions, often flying into the air to butt the ball, cheered on by the crew.

Bamse knew what it was like to go overboard too—a terrifying experience, being borne down by the weight of the water in his thick fur. It happened to him only once. There was no hesitation on the part of the *Thorodd*'s crew. Several of them jumped in after him, swimming around until he was found, paddling frenziedly. Getting him on board ship was no easy matter.

The *Thorodd* was one of six minesweepers with a regular circuit to patrol. But the dog's seasickness in high seas was causing a problem as German attacks on surface vessels protecting the sea lanes increased. When the weather was bad, therefore, Bamse would be left ashore. Well, not really ashore—there were always at least two minesweepers in dock at any given time and Bamse would spend his time on those, or on shore with their crews, until the return of the *Thorodd*. He also got to know the local population quickly. Their initial impression had been one of amazement. They recognised him as a St Bernard, of course, but this one was the largest they had ever seen, with a chest span that must have been at least two feet, and with a huge pink tongue that lolled around his jowls.

At first Bamse felt abandoned, lost, when this new regime was imposed. He sat for hours on the decks of other ships, or at the edge of the quayside, eyes locked into the distance. His massive form became familiar to the crews of other ships as they came and went along the waterway. But when 'his' ship came into view, he was able to distinguish it from all others. He would let out a howl, jump to his feet and, barking non-stop, would run up and down until the *Thorodd* tied up. Then he clambered on board and sought out his particular companions, knocking them off balance as his front paws slapped down on their shoulders. They returned his greeting with hugs and stroking, and even a kiss or two on his deep and warm fur. His tail wagged incessantly, and woe betide anything in its range that was not screwed to the floor!

But it was being on shore leave with the crew that Bamse was happiest. He was permitted everywhere they went, into cinemas and shops, homes and pubs—particularly pubs. He would be seen from afar and recognised, for on his head was his own Norwegian Navy cap, tied securely under his chin. Around his shoulders was a sailor's wide collar that came a quarter of the way down his back. Both were always spotlessly clean and in place. Bamse became a favourite on the buses, too. He would know when some of his crew were late back at the ship and risked punishment: he had an uncanny sense of timing, no matter what the season or the changes in hours of light and darkness. He would run to one of the bus-stops and wait for the bus to arrive. No longer did the driver or conductress or passengers glare with surprise or fear. Everyone knew him now, and many greeted him by name. He hopped onto the bus and clambered up its steep steps to reach the top deck, his bulk filling the stairwell from side to side. He seemed to know that dogs were not permitted on the lower deck.

He knew too the range of pubs where he was most likely to find his companions. He could open the doors with a quick movement of his paw. Popping his head round the corner, he listened for familiar voices and the sound of his native language. On many occasions, like anywhere else during the war, he found some of his charges the worse for drink, unstable on their feet and perhaps even argumentative. He

would purposefully place himself beside the seaman, catch hold of his sleeve or coat, and gently but forcefully pull him away—a long way away, on to the bus, off the bus at the correct stop, and back on board the *Thorodd*.

Sailors attached to ships close to the *Thorodd* knew the ropes and would look out for Bamse to appear. When he was around that meant it was time to get back to ship. If they were unsure of the way, all they had to do was to follow him. Bamse quickly became the beacon for all seamen at Montrose and Dundee, and news of his existence and antics began to spread. His services in recovering his sailors became so famous that a fund was raised and the proceeds spent in buying him a bus season ticket. With the ticket secured inside a transparent pouch around his neck, he must have been the only dog in the world to possess one. He became the pet of the bus drivers and conductors, who would stop the bus between stops if they saw him and beckon him on board.

Despite his size, Bamse was gentle and loving. He hated squabbles but squabbles did occur, particularly in bars and public houses. When trouble loomed, he would push himself between the fighting sailors. He was never aggressive: he did not need to be. His weight alone was sufficient. He would lift himself up to his full height and place his paws on the chest of one of the sailors and breathe closely into his face. There is no known incident when this did not have the desired effect. There were times too, if a situation looked ugly, when the landlord would seek Bamse out. On one particular day a confrontation did take a nasty turn, and the potential victim was Bamse's second in command. The officer had taken Bamse with him on a tour of the docks of Dundee when suddenly a man appeared from behind high, stacked crates. A knife was in his hand and he lunged at the officer, knocking him to the ground. Bamse, witnessing this from farther down the docks, raced to the spot, grabbed hold of the offender's clothing, dragged him to the edge of the dock and threw him into the water.

Bamse loved participating in sports too. He enjoyed the sudden roar at football matches and was a familiar sight at local games. On one occasion the Norwegian sailors were playing against a Polish team

in Dundee. The St Bernard was a loud cheer-leader. At every goal or near-goal, he would leap from his allotted seat and bark or howl his delight. Children from far afield, knowing Bamse was likely to be at matches, began to come to see him just as much as the match. Bamse was now an idol, a model of getting on with life when all appeared bleak, a symbol and everyone's mascot. He would play with the children, give them rides and roll playfully on the ground. His huge bulk never caused harm or injury.

When the *Thorodd* was in port, Bamse spent a lot of his time on board. He was a brilliant watchdog and the crew knew that no one would come aboard ship anywhere along its length without Bamse raising the alarm and doing something about it. A great deal of cleaning went on during the ship's port call, including the long and dirty job of cleaning out the huge galley kettles. Not to be left out, Bamse took part in this activity too, and became filthy as a result. The grime sank deep into his thick, long fur, sticky and smelling. The captain would not have Bamse on board in that condition and ordered him to be taken ashore to a veterinary surgery to be washed professionally. The crew fell silent for they had bathed Bamse before and knew the difficulties that could arise. They offered to take him ashore and do it themselves, but the captain insisted. It had to be done by a professional. His handler easily found a veterinary surgery that was willing to take on the considerable task. It would cost a pound, the vet said, and take an hour. In just one hour the handler returned to the surgery. Bamse was ready, and spick and span. Even his claws had been cut for him. His fur shone and he flicked his back with pleasure as his sailor's cap was fitted onto his head. But the veterinarian was not in such a good shape. Visibly haggard and mucky himself, he demanded two pounds instead of one and said that the ship was not to send Bamse back for more.

News of the canine phenomenon spread not just widely, but in high places. Allied naval forces heard of him, articles were written about him and his photograph became well known. He was the mascot of all the Norwegian naval forces throughout the war. To many of them, living in exile, he was a symbol. His photograph, dressed in his navy collar and sailor's cap, or wearing his steel helmet, was sent to Nor-

wegians throughout the world, especially at Christmas or on 17 May, Norway's national day.

Bamse had been through an incredible adventure in life. Shelled and strafed on a rolling deck, he had weathered the tremendous din of combat and had never varied his calm and loving temperament. He had weathered too the bombs that wrought havoc on the civilian streets while the ship was at sea without him. But at last his gallant heart, worn out by his ceaseless efforts, failed, and he died quietly on board his ship on 22 July, 1944, among his seamen.

The shock and grief were palpable and sincere. It was, as one person described it, as if the silence that descended upon the little vessel was a special silence. A great emptiness was suddenly there. No member of the *Thorodd*'s crew was unaffected. Grown men who had stoically endured a cruel war, separation from their families, grave losses and exile from their country, cried openly. This was a very personal bereavement to them. Grief was not confined to the *Thorodd*. It was instantly echoed far and wide, in the naval depots, on visiting ships, on the streets of Dundee and Montrose, in the taverns and on the buses, and in all the local schools. There could not have been a more loving bond between two peoples, the Norwegians and Scots, than that which Bamse had created.

Bamse's funeral two days later was a significant affair. His standard-sized coffin was draped in the Norwegian flag and his sailor's cap centred upon it. He was transported to the graveside on a hand-wagon and lifted on to the shoulders of six of the *Thorodd*'s crew for the last service. Eight hundred Scottish children silently lined the way, and all schools were closed for the day. Shopkeepers, factory workers and housewives turned out with them. Local dignitaries attended with their chains of office, and the crews of six Norwegian ships, resplendent in freshly pressed uniforms, stood guard of honour. Bamse was laid to rest in the sand-dunes that led to the banks of the South Esk river, his head facing north-east toward his beloved snows of Norway. A wooden cross was sunk into the ground as his memorial.

There would be no time at which the grave was unattended or at risk of disappearing. It was cared for throughout four decades by local inhabitants, some of whom were Norwegian sailors who remained in

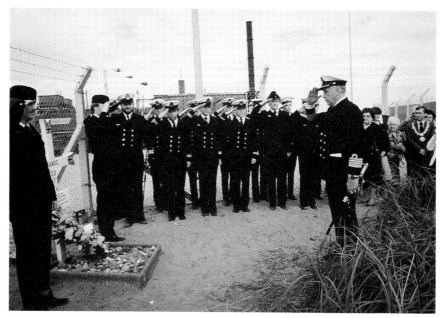

Major honours ceremony at Bamse's grave on the fortieth anniversary of his death. *Photo: courtesy Mr Otto Opstad, Oslo.*

Scotland after the war. For more than 40 years, every time a Norwegian naval vessel passed Montrose or docked there, the ship's crew would muster on deck and salute Bamse's grave. On the 40th anniversary of his death, the memories of him had not diminished, nor were the passions he engendered lessened. Newsmen turned out to report on the ceremony. Two Norwegian submarines, the *Utsira* and *Utvaer*, both part of NATO's fleet, put into port with a special mission to accomplish. They were there to salute Bamse yet again. A considerable crowd gathered in the warm sunshine, including local councillors and the Provost of Angus. Flowers were laid on his grave, covering it, from official wreaths to a posy of locally grown blooms laid there by a child.

Bamse's grave is still in existence. It lies within property now owned by GlaxoChem, the pharmaceutical giant. Glaxo continue to maintain the grave.

4

VOYTEK OF MONTE CASSINO

There was a lull in the fighting. The soldier, accustomed to many strange sights, was fascinated by the scene unfolding before him. He pulled a sketch-pad from his knapsack and began to draw. The result created a legend and flashed the renown of the central character around the world. Depicted was Voytek, a six-foot-six brown bear, outlined against the steering wheel of a supply truck, a 25-pound artillery shell cradled in his arms.

Yet Voytek was not a trained soldier; far from it. He had been cosseted, fed, sheltered, loved and protected. Now those who had taken him into their hearts were in trouble in one of the bloodiest and subsequently most controversial battles of the Second World War, and Voytek could not let them down. He watched what they did and pitched in to help, prepared to accept anything as long as he remained with them. They and what happened to them had become his world.

* * *

It was February 1944. Voytek was not alone on the quayside. With him in the Egyptian port of Alexandria was a veritable menagerie: a pigeon, two guinea pigs, a parrot, Kaska the monkey, bane of his life, and the captain's dog. They sat silently in a huddle in the warm winter sunshine while all about them was activity and noise. Cargo thudded into the hold of the converted troop-ship *Batory* and there was a constant revving of engines as long lines of trucks rumbled up the wide gangplanks. The small, strange group was tense and anxious, aware that much depended on negotiations then taking place with embarkation officials. The soldiers keeping close to their charges had reason to be concerned, for all the animals, including Voytek, were pets, and pets were not allowed onto the field of combat. Indeed, the rules and

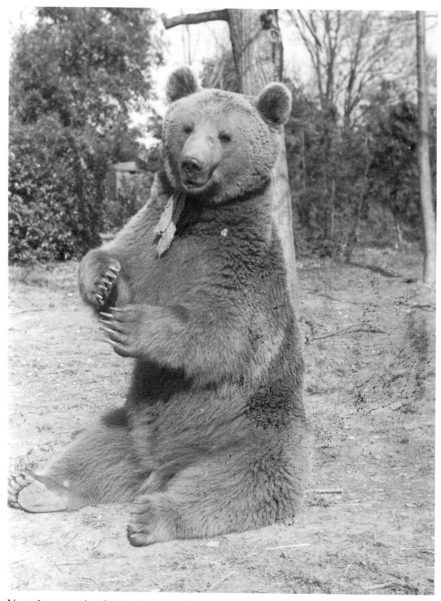

Voytek, a massive Syrian bear, gentle but formidable. His huge paws were armoured with six-inch claws. *Photo: courtesy Mr W.A. Lasocki.*

regulations were, understandably, very strict on that point. Only the professionals among the animal kingdom were permitted—message and guard dogs, horses, ponies and pack mules.

The application for the animals to board was refused. Voytek sank disconsolately onto his rear, his legs with their huge paws and six-inch claws thrust out in front of him, and he groaned. He understood the importance of the rejection, for what would happen to him and the others if they were abandoned? Frantic appeals were made, all to no avail, and then, as is often the case in the making of history and the direction of fate, one person took note—the South African liaison officer. He would do what he could, he said. His absence was a torment for all concerned. At last he returned waving the embarkation papers in the air. By some miracle he had persuaded the authorities: the animals would be going to Italy and into one of the most tenacious battles of the European mainland, Monte Cassino.

In the five days before the *Batory* docked in Taranto, Voytek spent most of his time on the deck, where his 15-foot long chain was tied to a mast—more for his protection lest he fall overboard than for fear of any aggressive act on his part. He would clamber up and slide down the mast repeatedly, much to the delight of the troops crowding round, craning their necks to see the bear who loved humans. He was the centre of attraction, and he knew it. He showed no fear when aircraft zoomed low over the deck or when battle stations were called. He feigned fear, however, of the swooping, diving, cawing seagulls. His mammoth paws would suddenly snatch at them and close over, but when he slowly opened them, there was nothing there. He groaned his disappointment and spent the next couple of minutes rubbing his back up and down the mast to appease his frustration. But it was mainly with the troops on deck that his sense of humour and theatre came into play.

Everyone had noticed how docile and loving Voytek was with his company and in particular with his handler, Peter Prendys. Seeing Peter's easy closeness to the bear and the amusement that was permanently around him led others to believe that they too could get close and play with him. Several soldiers decided they would like to have a go. They approached him with chocolate bars. Voytek loved choc-

olate, as confirmed by a drool of anticipation that dripped down into his thick fur whenever he saw any. He sat down on his rump, his huge paws extended palms up in a totally submissive manner. They came closer and either dropped the chocolate in his paw or offered to feed him with it directly. Whichever, Voytek was happy to oblige. Out stretched their hands to stroke his head, touch his fur, tickle his feet. Suddenly he jumped up. The soldiers, startled, took a couple of steps back on the crowded deck, but before they could retreat farther his arm had flashed out, catching one of them behind the knee, drawing the howling soldier towards him. Usually Voytek would release his 'prisoner' easily. It was all part of the game, the charade. Sometimes Peter would have to tell Voytek to let go, because the soldier or sailor was unconvinced it was a game and was panicking. But on one occasion the bear's sense of enjoyment went farther than usual. This time he did not let go. Gripping the unfortunate man by his ankles, he completely up-ended him, shaking him up and down. Then, with a deft movement of his claws and to the hilarious applause of a couple of hundred cheering onlookers, he pulled the soldier's trousers round his ankles. Released as suddenly as he had been taken, the embarrassed man hurried away, clinging to his pants.

The voyage had been on calm seas and Voytek had adapted well to this strange method of transport and the restriction of his space. But suddenly, on the final full day of the voyage, the weather changed, the sea rose and the ship rolled and yawed. Voytek was seasick. He jammed himself in a corner near the mast as best he could, sometimes holding his huge head between his paws, gently groaning, refusing all food and drink. A feather-stuffed cushion of mega proportions was brought to him, in the hope that this would give him some extra comfort, but in his confusion and agony he took his feelings out on it. The cushion was ripped to pieces and he disappeared for a moment in a haze of feathers. Suddenly the seas calmed and Voytek immediately felt better. He spent a few exciting minutes diving into the flurrying feathers before they were swept away by the wind.

The troops on board the *Batory* knew they were going to reinforce the Allied armies battling to open the road to Rome. They had heard, too, that a particular range of mountains was said to be barring the

70

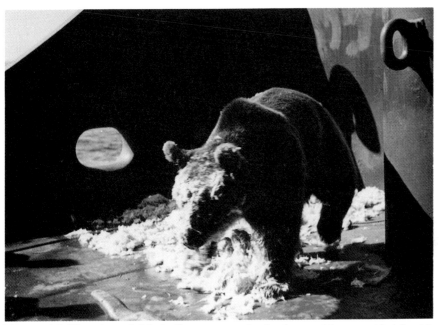

The seasick Voytek took his feelings out on the feather cushion provided for his comfort. *Photo: courtesy Mr W.A. Lasocki.*

way and that two battles to take the most important of these, Monte Cassino, had resulted in failure and terrible loss of life. These were salutary and unnerving thoughts. To keep their minds off the situation as the ship ploughed its way to its destination, talk drifted, as it generally did when there was boredom or tension, to Voytek and how it had all begun.

Per capita, Poland was to be second only to the Soviet Union in loss of life and property in the Second World War, a stunning tragic statistic. The country had been beset with intrigue and duplicity, caught between two mighty powers, Germany and the USSR. Then the Soviets made peace with Hitler's Third Reich and a non-intervention pact was sealed in the teeth of the outbreak of war, going down in history as the notorious Molotov-Ribbentrop Pact. The instant Germany attacked Poland, in September 1939, beginning the Second World War, Soviet forces crossed into Poland too, without warning

71

or any declaration of hostilities, and annexed half its territory. This was the beginning of unparalleled terror on two fronts for the beleaguered and ill-equipped Poles. Germany was to commit crimes against humanity on its territory within the camps of Auschwitz, Treblinka, Sobibor and Majdanek, and the USSR would create its own version at Katyn, where the NKVD, the forerunner of the KGB, the Soviet secret police, wiped out the Polish officer corps and leading intellectuals. The Soviet hold on Poland was short-lived, however. Twenty-two months later Germany attacked the Soviet Union in Operation Barbarossa, taking all Poland's territory and pushing the Soviet forces back to the gates of Moscow before the winter snows halted their advance.

Those Poles who could fled, but they had to leave their homes, their families, everything they knew, to an uncertain and dark future. There were Polish pilots and navigators within RAF squadrons—even with the Chindits in Burma—and they were to figure in every major battle in Europe. Perhaps their personal tragedy was a reason, if not the reason, why they were so attached to animals, for animals reminded them of home and they could pour out their affection on them. Certainly, there is no record of so many pets being in the field of battle with a single company as there were with the Poles. Could this have been a reason why the rules were bent? Or was it also that the men concerned with Voytek were themselves, until recently, Soviet prisoners of war?

The released or escaped Poles had come together at the seaport of Pahlevi in Persia. There they volunteered for induction into British forces and were sent to Palestine to be assigned. It was during this journey that Voytek came on the scene, as W. A. Lasocki vividly describes in his brilliant book, *Soldier Bear*. The convoy had stopped in the hills not far from the town of Hamadan when they noticed that someone was close by, watching them. It was a small and scruffy boy, clutching a large bag at his side. He was thin, barefoot and obviously hungry. He ate what was offered him almost without drawing breath.

The bag beside him moved. When it was opened, a tiny snout emerged, then a head with two sparkling eyes. The men jumped back in surprise, not believing what they were seeing. It was a bear cub. Peter Prendys carefully picked the cub from the bag and held him

72

aloft, like a baby. The animal's fur was coated with dust and caked dirt, and it had obviously been some time without food. It was not very old and visibly weak. How to get food into him was the first priority. A bottle was hastily found and filled with milk, and a rough teat was made. The cub was cradled in Peter's arms and fed until it dropped to sleep.

The cub had come from the caves high in the hills. Its mother had been shot by hunters, the boy explained, and he had come upon it and had been trying to save it from starvation ever since. He knew he could not keep the animal. Nor did he particularly want to, as he was hungry enough himself without having to fend for the bear. So when he was offered a considerable sum in payment for handing the cub over, he was delighted. For Peter Prendys and his friend Stanislaw there was no question. They adopted the cub on the spot and dubbed him Voytek, or little one.

Voytek was a Syrian bear, one of the rare breed that is capable of being tamed. They were rare too in numbers, although perhaps the most noteworthy of breeds, for they are considered to be the biblical bears of Mount Lebanon; their fur is light brown and grows long and mane-like between their shoulders. When Peter adopted the starving cub he weighed barely 15 pounds. By the time they landed in Italy, he was just about fully grown at well over six feet, and weighed between 200 and 250 pounds. But much was to happen before then. First of all he had to be nursed back to health and his strength restored. His first bed was in a washing bowl that Peter padded out for his comfort, his milk bottle lying beside it when the pair settled down for the night. But Voytek was often lonely in the dark, and it was not long before Peter became used to the cub suddenly appearing by his bed and nestling up to him until dawn.

From the moment Peter and Stanislaw bought Voytek to the moment they arrived at their destination of Ghedera in Palestine, they were worried about their officer's reaction and whether he would let them keep him. After all, introducing a bear into a military unit is a rather unusual occurrence. But they need not have worried. By the time they arrived, everyone knew about the bear and had popped round to see him in the back of Peter's lorry every time they stopped

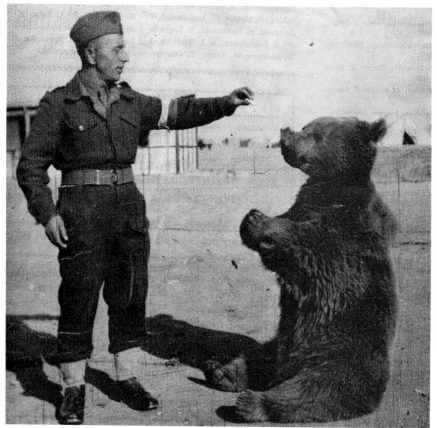

Voytek developed a marked taste for food. *Photo: courtesy Mr W.A. Lasocki.*

for a rest. Voytek was the most heard name of all, and the fact that he existed was public knowledge.

Voytek was intelligent and inquisitive. He would sit at the opening of Peter's tent, or the field-kitchen entrance, watching all that was going on around him, and then venture out himself, farther each time. Eventually, he would appear anywhere in camp. He developed two marked tastes. The first was for food. Anything that was growing: plant shoots, twigs, fruit, flowers, ants—although he spat those out—

and honey. On one occasion, and in his innocence, he attacked a beehive, stole some of the honey, and was attacked in turn by the enraged bees. He put up a fight to get himself out from the haze of black, buzzing stingers, and when he did his nose was double its size and growing. He charged down to the water's edge and plunged in, turned and sank his nose in the warm mud, getting some form of comfort from that. His other taste was much more popular, not only with him but with the troops as well. He liked playing pranks which made him the centre of attention, liked an audience and the titbits they gave in reward, and liked to play at mock battles with them.

He chased and wanted to be chased. He was charging around when he first encountered another animal, a Dalmatian. The dog was not in the least put out when confronted with the furry bear; instead it wagged its tail and rubbed its nose on Voytek's. He met a donkey too in the middle of the Iraqi desert. The donkey, terrified by the lumbering apparition coming its way, dashed off at speed hee-hawing loudly. It may have been Voytek's sense of fun and of the chase that led to quite a scene when his unit was based near Quisal Rabat. Not far away was a section of the Women's Signal Corps. Voytek paid them a visit and was intrigued by the many items of flimsy clothing blowing in the wind on a clothes-line. He didn't know what to make of them. He tugged some garments off the line and tried to get his head into them, or pull them up his arms. Not getting anywhere with that, he suddenly tugged the clothes-prop from the ground and ran away as fast as he could, the undies in a long stream behind him. The owners reclaimed their property, and Voytek was in instant disgrace. But he looked so unhappy that the ladies forgave him and, to Voytek's delight, offered him sweets and other tempting morsels to induce him back to happiness.

Voytek, who had a permanent sense of fun about him, once met up with another bear, but it was not a happy experience. This bear was the opposite of Voytek, unpredictable, irritable and with a penchant for being vicious, and Voytek came off worse. But it was with Kaska the monkey that he would have his most extraordinary relationship. Kaska was the bane of his life and gave him nothing but misery. The monkey delighted in Voytek's discomfort and loved to see him

flinch whenever she threw stones that hit him on his head or nose, the most sensitive part of his body. It was as if she planned her forays against him and implemented them with malicious, almost military, precision. In the end, Voytek would dash off and hide himself whenever he saw that Kaska was around, or the soldiers would call out a warning to him that she was coming.

As the Italian port of Taranto came into view, all the men's reminiscences came to an abrupt end. The laughter from Voytek's antics on ship, and those recalled from the past, died away. There were other considerations to think about now and a battle, a hard battle, to fight.

Benito Mussolini, the Duce of Italy, had been toppled from power in September 1943. For Hitler this was a grave development, for it left a vulnerability on his west European flank and opened combat close to Germany's own borders. He rushed troops to Italy, including the crack Waffen SS, to fill the breach while he tried to restore Mussolini to power, and for some time succeeded. On the Allied side there was considerable pressure from their partner in combat, the USSR, to open up a second front in Europe in order to reduce pressure on the Soviet's western front. D-Day was at least six months away, was still secret and remained largely on the drawing-board. But the fall of Mussolini had altered much in strategy and a plan was formulated for a double-pronged offensive, the objective of which was to take Rome.

The plan itself was bold and simple. Allied forces advancing from the south were to take the Gustav Line of defences that spanned Italy just north of Naples. This would draw Field Marshal Kesselring's forces south to confront them, reducing the defences within the capital city. In parallel, a landing would take place on the beaches of Anzio, by that time north of Kesselring's troops, which would be able to profit from a fairly free run to Rome. Several things were to go badly awry, however. First, Kesselring's forces were not overly diminished in Rome, and only a minimum of reinforcements was sent south to face the Allies. Second, the battle took place in the teeth of winter, when transport and infantry were easily bogged down. Third, and most important of all, the Allies hit up against a formidable obstacle in the range of hills and mountains that separated them from their objective, the principal among which was Monte Cassino. German positions

there had been ready for at least three months before the attack, relying on the closely packed mountains, cut only with narrow valleys, to assure their defence. In the south, a band of mountains stretched from Minturno to Gaete. In the north, in the Abruzzi, a small pass led to Atina and the Liri Valley. Moreover, two natural anti-tank barriers protected German positions—the fast-flowing and icy Rapido and the River Garigliano, both swollen by non-stop autumn and winter rains—bogging down heavy equipment and tanks.

The Allied forces committed to the campaign were considerable. Under the overall command of Field Marshal Alexander's xv Allied Army Group were elements from Clark's US Fifth Army, Leese's British Eighth Army, and the French Expeditionary Corps led by Marshal Juin. In addition to British, French and US forces there were New Zealanders, Canadians, Indians, Moroccans, Tunisians, and the Polish 2nd Corps under General Anders.

Even at the planning stage there had been a difference of opinion among the Allies on the question of tactics. Bearing in mind that he who holds the heights holds the valleys, it did not seem unreasonable to believe that Monte Cassino and the ancient monastery which dominated it had to be taken rather than skirted around or left isolated. The thought of bombarding or fighting in a monastery, at a time when the Allies were trying to cultivate their image with the Vatican, was daunting. Would the German defenders occupy the monastery and use its formidable walls as a fortification from behind which to shell the valley, or would they leave it undefiled? On the known record of the Third Reich to date, the Allied forces did not feel they could take the chance.

The Allied attack was launched on 17 January, 1944. The 94th Panzer-Grenadier division, almost alone in charge of the sector, was at risk of being submerged. Its commander, General von Senger und Etterlin, strongly recommended a withdrawal to Kesselring, abandoning the mountains to the Allies. But Kesselring would have none of it. Without reducing the forces at his disposal in and around Rome and all access routes to it, he called in the strategic reserves. To bolster the 94th Panzers, he sent two more Panzer divisions, the 90th and 29th, as well as General Schlemm's chief of staff of the 1st Parachute

Corps. The battle raged savagely from the first moments. The German heavy MG-42 machine-guns raked the river banks and the small craft attempting to cross. Most were sunk even before arriving in the middle of the river. Others, landing, had the troops they were carrying blown up in the minefields which had only been partially cleared the evening before. What had been intended as a total assault ended up by being a first assault only, as the weather and horrendous human losses forced a temporary halt. So many US lives were lost that questions were asked in Congress. The Americans' lot was no worse than that of the other Allies, however. One French officer wrote: 'It's hard, very hard. Everywhere are the dead and injured. We are filthy. Plastered with damp mud, hands black, nails filled with earth. There's blood, a lot of blood! The chaps are just not getting through this . . .'

The second offensive commenced on 15 March. Both sides had taken advantage of the intervening period to rest up their forces and to regroup. The Allied opening this time was intended to force submission by saturation bombing. In a period of less than 30 hours, 1,250 tons of bombs were dropped on Cassino, blasting everything in sight. Buildings became smouldering ruins. Huge craters dotted the landscape. The aerial bombardment was followed by a massive artillery shelling and still, as the 2nd New Zealand Division advanced, it was repulsed by withering fire. For a whole week the battle continued, with ground being taken and lost in an eerie repetition of First World War encounters. The troops suffered from the cold and the mud and the excruciating loss of life. On 22 March, General Alexander called a halt to the offensive. There was an uneasy lull. Both sides were entrenched in their positions in an area of utter devastation.

It was in March 1944, as the Allies prepared for what was to be the final onslaught on the heights of Cassino, that the *Batory* arrived in the port of Taranto. The Italian dock workers could not believe their eyes. A bear? They ran, shouting *Orso! Come grande orso!* Indeed, Voytek must have seemed formidable: he towered above the soldiers around him and his paws were capable of inflicting mortal damage, yet he was so obviously like a playful child that they soon warmed to him and came closer for another look.

The unit settled under canvas at Okonor. The 22nd Company had

an unenviable task. It was responsible for supplying all the British and Polish front-line troops with ammunition, artillery shells and food, almost always under fire from sniper and aerial attack. Peter was acutely aware of the danger to which the bear-mountain was exposed, and shooed Voytek away when he clambered into his munitions truck and set course for the front. But it was not long before Voytek made up his mind to do something about it. The next time he saw Peter and Stanislaw move towards their loaded truck, he rushed forward and barred the way. Peter pondered on this. Clearly the bear wanted to be with them and was unhappy to be left behind. At a nod of Peter's head, the bear opened the truck door and was inside in one easy swoop of his lumbering body. His huge head hanging out of the window was to become a familiar sight as the truck passed through the villages and troop emplacements.

Voytek suffered greatly in his baptism of front-line fire. He whimpered fearfully as artillery shells exploded near him, and cringed at the approach of aircraft. One occasion was particularly bad and he was truly terrified. During his first drive to the front line at night, through twisting narrow mountain roads, the supply convoy was attacked by the *Luftwaffe*. The roar of the planes was deafening and their bombs, exploding on the high, rugged mountain slopes, showered the trucks with bits of metal and stone as if in a furious hailstorm. Yet his fear was transitory and it was not long before he was marching up to forward gun positions to hand in heavy boxes of ammunition just like the rest of the supply team. On one of these occasions 25-pound artillery shells were being unloaded and passed gingerly between outstretched arms. Suddenly Voytek decided he would give a hand. He stopped hesitantly as he passed by the open door of the truck and looked round, searching for Peter, a shell cradled in his furry arms. It was at that moment that a soldier took out his sketch-pad and jotted down what he saw: a huge bear, outlined against the steering wheel, carrying live munitions. An officer gawped and yelled out 'Is that shell live?' Peter confirmed that it was, but that 'Voytek won't drop it!' Within a period of one week, the 22nd were to deliver 17,320 tons of ammunition, 1,200 tons of fuel and 1,116 tons of food to the front-line troops.

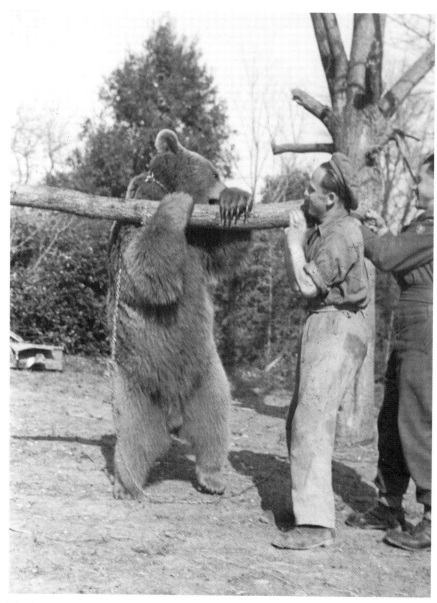

The bear became an active member of the supply team. *Photo: courtesy Mr W.A. Lasocki.*

The supply truck often stayed for some time at the forward gun positions. Voytek looked around to find some distraction in this noisy, desolate place. There was just one substantial tree left standing, almost stripped of its bark, and leafless. He nimbly hauled himself up to the topmost branch, pulled himself along its full extent, and peered over the battlefield like an official observer. He stayed there for a long time, huge and exposed. He must have been quite a target, so can we assume that the enemy saw him too and drew so much amusement from him that he was spared? Whatever the answer, he seemed to lead a charmed life, and would dash to the tree the instant he could on every trip.

On 11 May the third and final offensive began. At a signal transmitted via the BBC in London, 2,000 artillery guns opened fire at 11 p.m. along a wide front. One hour later, just before midnight, the ground attack began, and at dawn Allied aircraft filled the skies. The decision to demolish the monastery at the summit of Monte Cassino had now become a reality. Yet, still, the losses were high as point after point was eventually taken, and none higher than among General Anders' Polish units. In one battalion alone, towards noon on 12 May, only one officer and seven men remained. Reinforced, Anders renewed his attack in conjunction with British forces against the 1st Division of German paratroopers, and held their positions despite further heavy losses. But by this time all sense had gone from the fighting, and Kesselring withdrew his remaining forces from Monte Cassino under cover of darkness. So when, on the morning of 18 May, the 12 Polish Regiment *Podolski* finally entered the ruins of the monastery, they found it empty except for a few elderly churchmen.

To take Monte Cassino and Rome was to cost 107,144 men in the American forces alone. Added to this was a further loss of 7,835 men from the British Eighth Army, which included Polish losses, and an unknown, but heavy, loss on part of the French forces under Marshal Juin at Monte Cassino.

* * *

The local Italian population quickly got to know Voytek as the spring days returned to a calm that had not been known for some time. Not

even the local farmers, from whose land the bear stole grapes and food of all kinds, had other than a warm greeting for him. He was the local character, even in the midst of a cruel war. One of Voytek's favourite pastimes was swimming. He loved to join the local people in the water. He enjoyed nothing more than to swim unnoticed, under-water, and suddenly pop up between several women. Their reaction was always predictable. They were terrified by the sudden appearance of a huge brown bear surfacing from the depths beside them. Scream-ing, they scrambled for the shore as fast as they could. He also found it highly amusing to chase the ducks and turkeys he saw strutting round the farmyards, and when that fun was over he would seek out trees in the farmers' orchards and swing from branch to branch. But it was with a crane that he caused the biggest snarl-up of military traffic in the whole campaign.

A British convoy was returning from the front to rest and an Ameri-can convoy was 'going up'. Suddenly, at the turn-off to the mountain road, a bear appeared on the jib of a mobile crane. The traffic in both directions ground to a halt. Voytek was holding court. Like a hair-raising circus act, he stood on his head, turned a somersault, then started to swing from side to side, hanging from the jib first by one arm, then the other. He did this over and over again to the huge amusement and applause of the audience below. Military police bellowed that he was to come down, all to no avail. Then they went into an animated huddle to discuss what to do next to get the traffic moving. Peter felt embarrassed when he turned the bend in his truck and was caught in the bottleneck himself. Without even seeing the cause, he knew it—Voytek! There was only one way to get the bear down and back into the safety of Peter's truck. It took quite a bit of searching to get hold of a bottle of beer. Peter held it aloft and called Voytek's name while hundreds of eyes looked on. The beer did the trick. Voytek slid down the crane and off the platform. He held out his paw for his reward, but Peter was not giving it that easily and as a punishment made him wait at least five minutes.

Voytek suffered his own kind of tragedy in a rather unexpected form. Kaska, the monkey, had continued to torment him in Italy as in the Middle East. He was sorely teased by her and did all he could

to avoid her. The situation was discussed at great length by the men. Then it was deduced that perhaps the reason Kaska did these things— and Voytek was not the only victim of her attentions, merely the largest of them—was that she was bored. If she had a baby, perhaps she would change. The local zoo keeper, eager to reconstitute his depleted stock of animals, readily agreed that Kaska should spend some time with the males under his control. Some time after her return, when all hope of a positive result had been abandoned, Kaska patted her middle. She was expecting after all. Everyone cared for her as she went into labour and produced a crumpled infant of whom she was instantly inordinately proud. She would take her baby, clinging to her front, around all the tents to show her off. Her temperament changed, too. Voytek approached Kaska and the baby and was well received. He was even permitted to touch the little one and play with her. It was a reversal of Kaska's former self, and a kind of affinity grew up between monkey and bear. Then the baby caught a cold and, despite all efforts to save her, she died. Kaska was inconsolable: her suffering was no less than that of a human. Voytek was visibly affected too, and offered comfort and sympathy which Kaska seemed to welcome. But the monkey was unable to pull out of her depression, and in her turn she died. For days Voytek, who previously had shrunk from the approach of the monkey, mourned: his little family, which had been through so much, had been grievously stricken.

* * *

In September 1945, four months after the end of the war in Europe, the 22nd Company of the Artillery Supply Command, now renamed the 22nd Company, Polish Army Service Corps (Artillery), sailed for Glasgow in Scotland. This time there was no hesitation about getting Voytek on board ship. His name was included on the passenger list and he was issued with his own ration card. For the first time he was to have his very own sweet ration. Voytek's fame had spread before him and there was a constant stream of visitors to his 'den', tied tightly to the ship's mast. When the ship docked in Glasgow there was a huge reception waiting on the quayside: 'Look! A bear! He's marching like a soldier on two legs!' Voytek knew he was the centre of attraction.

He drew himself up to his full height, puffed out his chest and marched proudly at the head of the Polish troops.

Some months later a ceremony took place in the local branch of the Scottish-Polish Society, where the chairman said he would like to speak especially of Voytek. 'He is probably the most famous bear in the world,' he began. 'His travels and adventures are now almost legendary. You all know of his journeys with the 22nd Company through the high mountains of Persia, through Syria and the Lebanon, across the deserts of Iraq, Jordan and Egypt, and of his life in Palestine and Italy. He accompanied them everywhere, even during the Battle of Monte Cassino.' And so it was. But Voytek went on to permanent fame. From that time on all the regimental insignia, on vehicles, epaulettes, banners and music stands, were to carry his picture, the most famous picture of all. Of a bear with an artillery shell helping out his family in the perilous time of war. He has figured ever since in exhibitions, and there are life-size and lifelike memorials to him in several historical museums. Voytek's fame has endured.

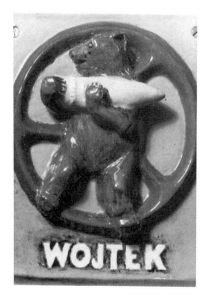

The most famous portrayal of Voytek, which became part of the insignia of 22 Company, 2nd Corps, VIII Army. *Photo: courtesy Mr W. A. Lasocki.*

84

5

I R M A , B L I T Z D O G

The noise overhead was different, not like the German bombers to which the population had become accustomed. It was a deep drone. Then suddenly it stopped and there was silence for about 40 seconds. The explosion that followed and the smoke from it could be heard and seen for miles around. This was the V-1 rocket, the *doodle-bug*. The V-2 was even more sinister: it could hardly be heard at all. It was just suddenly there, demolishing all in its path, burying mostly women and children beneath tons of debris.

Civil defence organisations would be on the spot in moments, clawing away at the rubble, stopping from time to time to listen for the slightest sound that might indicate any life beneath the mounds of wreckage. Then they would tear into the rubble again while ambulances waited nearby. Often no notice was taken of the dogs who, with their specialist handlers, were digging into the debris at full speed, their paws flashing, their noses deep in the fine dust that rose like a cloud, their ears pitched forward, ever aware.

This is the story of one of those dogs. She located life when all hope had been abandoned. She found life where no one was believed to have been in the vicinity in the first place. It is the story of Irma, who won the highest animal honour for valour, the Dickin Medal, in recognition of her dauntless devotion and the record number of lives she saved.

At the outbreak of war, the authorities were still not convinced that dogs were as good as, far less better than, humans when it came to seeking out people and bodies from under the rubble of bombed-out buildings. Everyone knew that the dog's sense of smell was infinitely finer than man's. All the more reason, it was thought, why the dog could not help, for the smells raised by a bombing incident were many,

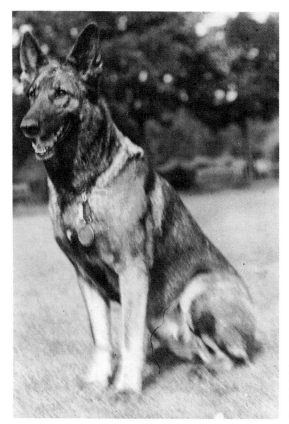

Irma, awarded the Dickin Medal for her work in searching out bomb victims. *Photo: courtesy the PDSA.*

sharp and mixed. Bombing destroyed bricks, mortar and chimney stacks filled with soot. Wood smouldered, releasing fumes from blistering paintwork, or burned to pungent ashes. Gas pipes fractured, creating a potential time bomb; sewage pipes were blown to pieces, leaving an obvious health hazard. Household smells of cooking, food, soaps and perfumes mingled with the acrid stench of burning metal and fired clothing. The rubble trapped the heat of the fires beneath it. Broken and jagged glass dotted the ruins, and hanging above it all in a tall, thick, throat-clogging cloud, was dust. Streets that had been rows of two- or three-storey houses were obliterated or gaping holes would appear in their midst.

For protection against the bombs, many families took shelter in community bunkers as soon as the shrill air-raid alarm sounded. Others had an 'Anderson' shelter big enough for their own family in the back garden, or a 'Morrison' shelter, a thick steel structure in their basement, like a huge table, on which they had their meals during the day and beneath which they slept at night. Some, particularly in London, slept in the tunnels of the underground stations. But there were always many people caught at home, or on the streets, or trying to get to shelter when the bombs and rockets fell. Throughout the long, drawn-out years of war, scepticism of the dog's worth in rescue efforts would remain. Only the performance of the dogs themselves would ultimately convince the authorities just how good and indispensable they were.

<p style="text-align:center">* * *</p>

Tired as she was, Margaret Griffin brushed down her two Alsatian dogs Irma and Psyche, fed them and returned them to their kennels to rest. They had been soaking wet from working in non-stop rain and their fur had been clogged with dust and grime, but they had done well, very well, and she was proud of them. Before she went to bed herself, she had to record the night's events. Her precise, patiently written account in her diary is now on exhibition at the Defence Animal Centre in Nottingham. It was to be the first of many entries that would, step by step, record a brilliant, yet relatively unknown and unsung, story of dedication and heroism.

26.10.1944. The dogs were called out to an incident at 00.15 hrs. We went to Ilford but had to wait over an hour while a woman was extricated from a Morrison shelter which had jammed her leg in the frame. This cleared, Irma next worked over the top of a collapsed house. She indicated below her. Digging commenced in the area indicated by me and after over four feet of debris and rubble had been removed the body of a woman was found. Working next over the debris of the house under which the woman had been trapped, Irma indicated round the top of a chimney breast, a strong indication, so I gave what I believed the

position was—three women were exhumed under this position, about fourteen feet down. Next I had a house to search further along with a negative result. Rescue teams cleared the whole site as a woman was missing from here. She was not found here but the following morning her body was recovered in another garden fifty yards away from the place of the blast. Irma had found the location of four people up to fourteen feet beneath the rubble.

* * *

Like most animals, dogs have the same senses as humans—sight, sound, smell, touch and taste. Training dogs to use these gifts to their full potential has produced guide-dogs for the blind, sheepdogs, guard-dogs and now dogs with a vital role in the fight against drugs, crime and terrorism. Only their sight is inferior to that of humans, for dogs do not recognise objects or people; they see only outlines which they identify as good, bad or questionable. However, they have a much greater ability to see movement than humans do. Next to the dog's sense of smell, its sense of hearing is possibly the most acute, being probably 5 to 10 per cent better than in any human. Again, however, it is not simply the fact that the dog hears better than we do that counts; more important is that the dog can hear high frequencies and pitches well beyond the limits of the human ear. The potential of a dog to pinpoint the source of a sound also puts his ability well beyond our own. At night, the sense of sight is of little importance to a dog and other senses come into play to compensate. He becomes more dependent on the senses of sound and smell, and uses his ears when surrounded by vast numbers of strange noises, each one quite distinct.

The sense that is most similar between dog and man is taste. Like us, the dog has its own likes and dislikes for food, and certainly enjoys eating meat, eggs, milk and biscuits. Anything that is sharp, however—vinegar, apples, fruit of most kinds and other foods that contain acids—is normally objectionable to the dog. The fourth sense is that of touch. In this dogs vary widely: some react to being tickled, others do not. But sound and touch are the first and most vital elements that

link a dog with its trainer, and these are the senses that send it on its way to search or attack, or bring it back to heel.

Nothing, however, is greater than the dog's sense of smell. It is truly amazing. Scent discrimination, the power of selective scent, is the canine's greatest attribute and, in the working dog, its greatest asset. A dog's nasal membranes contain more than 200,000 separate nerve-endings. These, if they were opened out flat, would cover an area as large as a pocket handkerchief; in comparison, a man's would cover rather less than a postage stamp. A dog's nose detects the faintest odours and is extremely sensitive to the slightest air currents, which bear an unlimited number of individual smells. Experiments prove that the dog has no peer in the animal kingdom, and is vastly superior to man in its sense of smell orientation and detection. For example, a dog is capable of selecting a test-tube containing one-tenth of a million parts of sulphuric acid against other test-tubes containing only water. In another experiment, a teaspoon of salt was added to over 1,000 gallons of water and a sample cupful placed in line with other cups of pure water; the trained dog had no difficulty in differentiating between them.

All these senses are brought together when training a dog to search for a human being. The exercise commences with the dog at heel. In the handler's right hand is a piece of green cloth approximately two inches square, which could well have been in his or her possession for between one and two hours. The handler starts to walk, leaving the dog behind. After ten or 15 yards, he will drop the cloth surreptitiously and continue walking without a pause. After 60 yards the handler takes a right turn, continues for a further 60 yards and turns left, and continues to zigzag for some yards before coming to a halt. The dog is then given the scent by placing the hand over his or her nose and told to 'Go seek'. The dog will track back at once, his nose down, until he finds the article and returns it to the handler. Another, very difficult, test that has been used involves a two-inch long blade of grass which has been tied in a knot. The handler's dog will find and retrieve even that, despite the fact that the ground on which it has been dropped has been trampled by many people and various animals such as sheep and cattle. The dogs taken to the sites of bomb attacks were

to show just how effective such training could be in getting all their senses to work together.

* * *

By the spring of 1944 there was no longer room for illusion. The Allies were winning and Hitler knew that soon there would be a massive second-front landing on mainland Europe that would mark the beginning of the end for his empire. Efforts to bomb strategic targets, particularly southern England's garrison towns, ports and airfields, no longer had the rate of success or frequency of action as before. But Germany still had its secret weapon, the pilotless aircraft, the rocket. Whether Hitler's intelligence services ever knew the exact date of the D-Day landings remains conjecture. That he was aware of something imminent—within the range of 14 days—is certain. His V-1 rocket programme was designed to snatch back the initiative and halt any build-up of forces that would lead to a landing in Europe. Yet it was not until one week after D-Day that the first of Hitler's avowed 'terror weapons' lifted into the skies from France's Pas de Calais region and crossed the English coast. There was a lull until 15 June when, from 55 separate launching sites on the European mainland, a total of 244 missiles was launched in a period of just 24 hours. Throughout August an average of 155 missiles per day lifted off; on the worst day, 3 August, London was hit by 103 missiles from a total of 224 fired.

German withdrawal from the French coast at the end of August, and the demolition of the missile sites, did not halt the attacks: instead, the rockets were launched from modified Heinkel HE111 bombers until mid-January, 1945. No less than 1,200 V-1s fell as far afield as Manchester and Cheshire by this make-do-and-mend procedure before the programme was taken over by the dreaded SS. The latter hastily built launch pads at several sites near Delft in the Netherlands and fired a further 275 V-1s before the Allies overran and destroyed the sites. The pilotless monoplane, powered by a pulse jet motor, had carried a warhead of 1,870 pounds of high explosive; now, worse was to come from the V-2—Hitler's last throw of the dice.

The V-2 arrived without warning as, unlike its predecessor, it was almost silent. Consequently, its casualties were higher. The rockets,

A V-1 flying bomb drops on Central London, photographed from a Fleet Street roof-top. *Photo: Imperial War Museum.*

almost 46 feet long, hit the ground at speeds approaching 3,000 miles per hour. The first attack by this supersonic, high-altitude rocket came on a balmy September evening in 1944. Suddenly there was a terrific explosion, and 11 houses in Staveley Road in Chiswick ceased to exist. Three civilians died, the first of more than 2,700 to be killed directly by the V-2. Between then and the end of March 1945, by which time V-1 attacks had long ceased, a further 518 V-2s fell on London alone.

In that brief time 8,958 people, almost all of them civilians, were killed and more than 24,000 seriously injured by V-1 and V-2 attacks. Some 75 per cent of Croydon's houses were either damaged or destroyed. Nor was Britain the sole target. In its fury, the SS turned the rockets against Belgium, too. In a period of only two months more missiles were to land on that comparatively small country than even Britain had to endure.

* * *

91

Such mass, or carpet, bombing only really came into its own during the Second World War, making it a relatively modern development in the long history of warfare. When the bombs first began to fall in 1940, no one was too sure how best to protect against their devastating effect, nor how best to help those buried in attacks. Everything had to be developed from scratch. Irma's story really began when a group of civilians—all of them expert dog trainers—started to train dogs for security duties, to guard the perimeter fences of military installations. The result was impressive. The Air Ministry authorised the go-ahead for the group, led by a Colonel Baldwin, and a Ministry of Aircraft Production guard-dog school was created early in 1941. There was little money, however, and the handlers themselves had to contribute to the building of kennels. The training programme and even its purpose were novel and had to be created as they went along. Baldwin drew extra assistance from Margaret Griffin, Charles Fricker and Bill Barrow. At that time, Mrs Griffin's Irma was only a puppy. Both of them were destined to go on to work with the rescue team.

* * *

'*27.10.1944.* A rocket in Leytonstone at 12.17 hours. Arrived at the site at 12.50. A fine day. Breeze. Very dusty. Irma indicated a spot but a bed, bedding and night attire only were recovered from here. On the opposite side of the road, got indication from dogs round a shelter built inside the sitting room of a house. I heard later that 3 bodies were recovered from here. Got home about 3.30 in the afternoon.

'I saw later in a Civil Defence report that three bodies were recovered. The dog was right.

'*30.10.1944.* Call at 01.20 hrs (1.20 a.m.) to Maryland Point, West Ham. Left home half an hour later. Put Irma in at once. She took me through to a cellar where 3 kiddies were trapped. Rescue got to work on this place at once, but the children died before they could be reached through the heavy debris. Worked next over completely collapsed house, all furniture crashed into basement and all floors, carpets and linos concertina'd on to the top of the rest. Irma gave good indication at central point. Digging commenced and though we waited

some while, the dogs (Irma and Psyche) gave the same indication each time and in no other place. Returned here at 17.45 hrs.

'31.10.1944. Called out again to West Ham, to the same incident. The floors had by now been removed and the mass of furniture in the house. The back half of the house was still all jammed up together and [it was] impossible to find any crevices. Dogs indicated at a central point and towards back of the house. After approximately two hours digging, two women's bodies were found and soon after this their remains were recovered. During this time we had tried a wrecked house further along and I got indications from both dogs over a chimney pot leading to a small kitchen piled up with the finest of debris. The [dog's] indication was good and as the base of this chimney communicated with the floor below the debris, a rescue party was put on and clearing down through this, the body of a woman still unaccounted for was exhumed. The weather was fine, cold. Light breeze.

'2.11.1944. Practice at Ilford at 15.00 hrs. When we arrived we received a message that the dogs were wanted at Deptford . . . Arrived at Shardeloes Road, Deptford at 16.00 hrs. Both dogs indicated at one spot on left of site. Irma later gave a sudden and violent indication in mouth of cellar next door and we took out a pile of debris between the "suspected" site and this cellar but negative result . . . After about two hours work, a man's body was recovered . . . the dust from these buildings was the worst I had encountered and made the dogs constantly sneeze. The bomb fell in centre of train track. About 5 houses on either side being demolished and a lot of blast all around.

'11 and 12.11.1944. Rocket at Shooter's Hill, 20.05 hrs. Public House, Ambulance Depot and 2 offices. Arrived at incident 21.00 hrs. Put Irma on right away. Frightful mess. Most of the casualties known to be in bar and billiard room of Pub but a few "unknowns" had to be located. Irma gave strong indication to right of debris, a perfect mountain of stuff at right boundary of site. Digging proceeded here and after 2 hours the bodies of 2 women were recovered in the exact position, under approximately 7 feet of debris below the dog's indication. An office site . . . both dogs indicated keenly now and on 3 or 4 subsequent occasions, always pointing away from the crater (which fell in the court of [the] Pub) and towards left boundary of site. Dug

all night and removed literally tons of material without success. The blast on this incident seemed to be exceptionally fierce and though we got to ground level on the office sites (2) we found only 2 door sills— no doors nor door joints and no window frames! These have all been blown clean away from the heap of rubble which had been the offices and the ambulance unit room. The door mats (approximately 5 ft square) we found blown out through the doors under the debris 6 ft outside the office door sills, in the roadway between these and the Doctor's house next door. The wall of this house, facing the Ambulance depot, had been subjected to a "sucking action" and had come out whole. It had fallen in 2 sections (each one whole) broken laterally and was standing about 7 ft high as a double wall, between the roadway up to the Ambulance yard and the office site. Directly behind this double wall, and blown there from the offices was a pile of brick debris some 12 or 14 ft high. It was in the direction of all this that the indication was given by the dogs and when we had cleared to the wall we had still not found our body, nor had we yet found the 2 office doors, nor the window . . . Returned to the Depot about 09.15 hrs. Weather dry, bitterly cold all night. Very light breeze veered to opposite quarters constantly throughout the night. Result: 2 women recovered from hotel, 1 woman indicated but not found up to time of departure and 2 bodies certain.

'20.11.1944. Called out approximately 10.30 hrs. Went to East Ham (Marlow Road). Tried both dogs over 3 sites. Got quite good indication on No. 1 site. First under large chimney stack which had come to rest upright, on 2 huge mounds of clay, thrown from crater. Got an indication at other side of site as well. The officer got a crane immediately and pulled chimney off—a void was seen below and some clothing could be seen by torch light. Digging down to this they found the woman for whom they were searching, alive and conscious, but terribly crushed. . . .

'21.11.1944. Rocket on Walthamstow, 12.30 hrs. Arrived on site 13.30 hrs. Four houses completely demolished, about 12 badly knocked about. Searching a house, things were made no easier by water pipes burst in all directions and a bad gas leak under the debris. A smashed meter was pouring gas into the rubble. Worked Irma. In

94

Irma with Mrs Margaret Griffin (far left) on duty after a bombing raid. *Photo: Imperial War Museum.*

spite of the stench of gas, she indicated distinctly at a point at the back of the debris. From front of building, she and I went right under the floors crawling on our stomachs in water. She lay down here when we reached a point approximately dead below the spot where she had indicated. Rescue starting operations from above came to the broken gas meter first and below this the bodies of a woman and two children. These were about 4ft. buried in fine rubble and dust.

'*1.12.1944*. Some rockets had fallen. At 23.40 hrs. called out with the dogs to Black Horse Lane, Walthamstow. Got there at 24.00 hrs. What a mess! Concrete road blown to bits, rocket landed in the middle. 18 inches of concrete. About 15 houses all-told collapsed. Searching one house Psyche took me up and over a broken wall to indicate a child's body [the child was later found to be alive and relatively unhurt]. Rescue dealt with this right away. A good indication from

both bitches on a big "shoulder", also behind it on the opposite side of the road was being dug out still when we were leaving. Went a bit further along on this side and got an indication from Irma, into rubble near base. Digging here: bed and bedding was all that we found up to the time of leaving. Irma also indicated upwards and back towards wrecked bedrooms. Could not get into this from front at all. Later, Rescue party made a way in at the back and found two children. On the other side of the road again Irma indicated above a caved-in house and below the floor in another spot. Coming forward here, I tried to get under the front of these floors where there was a cavity. About 4ft. back from the front [Irma] indicated the body of a woman lying in this cavity. The next house on our left came under scrutiny, and I got indications round chimney breast of caved in room and at back of same house where a fire smouldering beneath the floor boards made detection very difficult for a dog: a great deal of smoke was belching forth out of this debris. I have no figures of this incident's victims but a policeman who, on duty there, watched the dogs at work, told me a few days later when he saw me that in his opinion they were "really marvellous" so presumably a good few of the victims were found where we told them they would be.

'14.1.1945. Dogs fed at 18.00 hrs. Went to bed 22.30 when call came for dogs to go to London Road, Barking. Nasty mess. Wind light, variable. Incident, two storeys of flats over top of row of large shops. Cement and girder building—complete collapse. Got indication over lefthand end with Peter and 4 places along debris with Irma and Psyche. We did not wait to see work completed as it was heavy material and slow to remove. Report received later told us that one live and 4 fatals had been recovered from large mound of debris in centre of incident, also one fatal from far end. The two other indications I did not hear about. N.B. Months later I heard that 17 casualties were recovered from here, where the dogs indicated. . . .

'20.1.1945. Call to Osborne Road, Tottenham at 21.00 hrs. In house No. 1 Irma found two live casualties. In No 2 Irma again gave good indication just to one side of fairly large and fierce fire burning through collapsed house debris. Thick smoke rising here. Family of five found. In No. 3 a strong indication from Irma over the debris. Rescue found

a live cat. Working over No. 4 I got another clear indication under a collapsed floor, and later had report from Rescue Leader on this site that 4 adults had been taken, 2 more located and one was suspected lying behind the 2 located ones. From here we went to X and here spent 15 or 20 minutes trying to locate a "voice" which we and the dogs heard at intervals but none of us could pin point. . . . Called again to No. 3, Irma gave a light indication at same spot, but conditions by now were very difficult as not a great deal of fire debris had been removed; chiefly roof timber and ceiling and the debris over the collapsed house floors was packed tight by the Rescue men's feet. Work now held up until daylight on this site. Now got a keen indication from Irma close to crater at XXX, between and below two enormous mounds of clay, with a lot of brick debris below there. Could get no one to dig as everyone was busy so marked the spot and showed it to the Squad Leader nearest who was helping to dig down to a trapped woman who, though terribly crushed, still lived.

'27.1.1945. Dogs call at incident at West Ham. There was a small crater. A rocket had gone through one house and 6 houses had been flattened. While 2 boys (alive) were being extricated from the top of No. 90, I took Irma round the surrounding debris and perimeter. She suddenly went forward, between No. 90 and the road and indicated clearly down into the debris. She was so keen I felt sure the victim must be alive. Called to Rescue Officer. He called 3 or 4 rescue men and tearing into the debris they were not long in locating the casualties and then uncovering them. A small boy and a young woman all wrapped up in blankets and bedding had been blown out of their room on the mattress and had landed down among the falling debris. Only the miracle of some boards sticking up had saved their heads and lives, and Rescue had been walking all over their bodies before my arrival! Both were conscious, but the girl was very much shocked and exhausted.

'29.1.1945. Bitterly cold. Snowing. . . . [Back to the Gordon Road incident in West Ham]. I went in under the floor cavity [of Nos. 90–92] with the dogs. Psyche whined and went down. Irma scratched below me in rubble and found bed clothing here. Advised digging this out first. Rescue party put onto this and excavation gave bodies of

one female and one adult male. From here I was asked to try over 94 and remembering the indication I got there with Irma 48 hours previously, I took her over the ground again. She too remembered and went direct to the little cavity where she had previously begun to indicate when I had been hurriedly called elsewhere. She examined round about and told me there was someone there. Taking the wind into account I advised working a bit back from indication point up into wind. Rescue did so. At 4 feet back was found the body of one adult female.

'1.2.1945. Called at 03.00 hrs. to Barnaby Road, West Ham. Went mooching about while some live trapped casualties were being dealt with. Got indication over large mound of debris at back of house. [Was] told this place was clear. Later report told me all my indications had been proven correct. 1 adult here. Further down the road got indication from both dogs. Later a report told me that 1 adult male and 1 adult female had been taken from here alive. Next tried round perimeter without any results. Called next to what had been a house, but was now a mountain of bricks mixed up with clay and dust out of crater. Irma gave an indication here at one spot. Later report gave me 1 adult taken from here. . .

'1.2.1945. (same day) I tried both my bitches in turn over 2 other blown up houses, opposite side of crater. Got an indication by both bitches in a spot here. House supposed to be cleared. Left Rescue working here on the indication of the dogs. Went over other side of site round perimeter [found] dead dog only. Over on other side where house presumed cleared up, Psyche gave an indication. Started to search myself and heard a whine below. Setter was trapped against a live fire under debris of collapsed floor and furniture. It took us some time to get him out and when he came to the surface he was so exhausted I feared he would die right away. However after some hot tea and being wrapped in blankets and allowed to lie in the air he revived a bit and we sent for PDSA van to come for him.

'Sunday 5.2.1945. Call at 02.30 hrs (Monday morning). Rocket at Chingford. Nasty mess. Rocket had gone right through one house. Gas was very bad up here, about 14 ft or a little more above ground level. Irma followed up by nosing in behind a half buried bath half

way up. . . . Irma continued to indicate that she was getting the scent from above her head and also towards the dividing wall of the two houses. Climbing onto the debris and going up it to a height of about 20 ft, I got the indication downwards and definitely towards the dividing wall which was standing to a height of about 30 ft. Climbing down again I got the indication in behind the bath again and very keen. There was a cavity here and we cleared here and also forward of the bath in toward the party wall. After 15 mins work, silence was called for and listening in behind the bath, we thought we could hear a little sound—more digging—silence again, this time we definitely could hear a baby's cry.

'Digging and tunnelling as hard as hands could work, a way was made in and voice contact was made with a woman who had with her a baby and little boy. [They] were trapped in a Morrison Shelter on ground-level and back against the party wall. An answer could be got from the woman periodically during the time (about one and three quarter hours) it took to reach the corner of the Morrison; but 5 minutes before the Shelter corner was cleared she ceased to reply. On getting a hole large enough to look in, it was found that the two children were still well and they were both brought out alive and unhurt, but their mother had now lost consciousness and on the Dr getting into the corner of the Shelter, he found her dead from asphyxiation. All three would have lost their lives had it not been for Irma and Psyche.

'About an hour later Squad Leader Bird (Chigwell) asked if I would take the dogs back as they had cleared an enormous quantity of stuff from the indication and still had not found anyone. I took them over and got an immediate indication on the outer side of the debris, Psyche lying down. A ridge of about 4ft high—4 or 5 wide still remained here and digging this out the husband of the woman, found at the top of the blasted houses, was uncovered. He was still alive and the Dr tended him immediately and he was taken to hospital. . . .

'*Monday 12.2.1945*. Rocket at Leytonstone. Crater tremendous. Water and gas very bad. Two houses blasted completely flat. Wind conditions very difficult. Very sharp cold breeze and terrific lot of dry and stinging dust blowing in all directions. Had to wait while 4 live

casualties upwind of the main damage were being got out and removed. As soon as the worst of this was over I started to work, but the screaming of an hysterical woman, trapped, made it almost impossible to get the dogs to keep their heads down. Live casualties at 2 and 3. At 2 a good deal of stuff was taken out and no one has as yet been located and as the indication now seemed stronger at No. 4 digging was proceeded with at this spot. While this was in progress I did the perimeter with the dogs on the side of the road where the bomb crater was only, as the other side was considered clear at this stage. No pieces, but an indication was given by Irma at 4, near a wall where part of a floor blown out of a building had lodged forming a sort of cavity. Digging here a girl of 17 was found under about 2 ft of debris . . . The IO [said] that Irma and Psyche had saved hours of digging and that 8 persons, two of them still alive, had been taken from beneath the collapsed floors where they had given their indications. He was loud in his praises of the dogs and as he had been sceptical previously it was a great satisfaction to me.'

* * *

In all, 233 people were located by the Irma–Psyche team, of whom Irma alone found 21 alive and 170 killed, a record number. On a day of extremely bad weather on Friday 12 January, 1945, Irma was taken to Langley Park for her reward. She was awarded the animal's Victoria Cross, the Dickin Medal, by Admiral Sir E. Evans of the *Broke*. Her citation read: 'IRMA. For being responsible for the rescue of persons trapped under blitzed buildings while serving with the Civil Defence Services in London'.

Irma was in good company for the occasion. Also presented with Dickin medals were two other exceptional dogs, Beauty and Jet. Beauty was a wire-haired terrier belonging to a veterinary officer of the PDSA, who led one of the animal rescue squads during the bombing. Beauty went with her master as he scoured the bomb damage, and began to dig at one spot. After some minutes of hard work, a cat, still alive, was found beneath a damaged table. As a result of Beauty's efforts, 63 animals that might otherwise have died were rescued alive from the ruins.

Irma licks the casualty she has found. *Photo: courtesy the PDSA.*

The conditions under which such rescuers toiled were hazardous in the extreme. Nothing was sure underfoot. Broken glass and jagged debris tore at the hands and, in this case, the paws of those seeking to get to a buried person before it was too late. Escaping gas meant that they worked endlessly in a dangerous atmosphere, at risk of further explosion. Mrs Griffin was subsequently awarded the British Empire Medal for her exceptional devotion to the work and for the training given to her dogs that permitted the saving of so many lives.

It is said that dogs react to kindness and respond to knowing they have done well. That may well be so. But importantly, as is clear from Mrs Griffin's simple diary notes, the story of Irma shows that such dogs were also aware that they were saving lives, and it was that which ultimately spurred them on.

6

GALLIPOLI MURPHY

When fishes flew and forests walk'd
and figs grew upon thorn,
Some moment when the moon was blood
Then surely I was born;

With monstrous head and sickening cry
And ears like errant wings
The devil's walking parody
on all four-footed things

The tattered outlaw of the earth
Of ancient crooked will;
Starve, scourge, deride me: I am dumb
I keep my secret still.

Fools! For I also had my hour;
One far fierce hour and sweet
There was a shout about my ears,
And palms before my feet.

('The Donkey', G.K. Chesterton)

In 1914, when this story begins, Australians were regarded in Britain as rowdy, undisciplined, crude and unsophisticated—'not quite nice', in the phrase of the rather Victorian atmosphere that still reigned. Yet by the time the Battle of Gallipoli ended in one of the worst defeats of the First World War, the Australian had established himself in his own right, forged his own identity and earned the respect of the world. This story is about a donkey whose fortitude and attachment to his handler—the man who adopted him—immortalised them both,

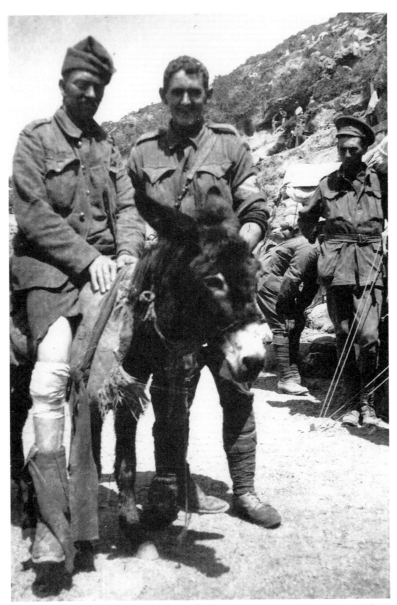

Simpson and his 'donk', a Gallipoli legend. *Photo: Australian War Memorial neg. no. J06392.*

and helped ensure that Gallipoli would be a name to be remembered in the context of human endurance. It is a sad story and cannot, by its nature, be otherwise; but it is also punctuated by the wit and humour for which the Australians are famous.

In the Gallipoli Galleries of Canberra's War Memorial stands a bronze statuette, mounted on a marble plinth, of a man leading a donkey on whose back sits a wounded soldier. The extraordinary story that surrounds it has been recorded in books, articles and poems. It is one of such emotive depths that it is not surprising that the author of *The Man with the Donkey* drew on Chesterton's poem to describe its greatness. Another writer, Laurence Sterne, found the donkey '. . . the most companionable, the most talkative of beasts'. No matter where you met him, 'in town or country, in cart or under panniers, in liberty or in bondage, I have ever something civil to say to him'. Sterne found it easy to fall into conversation with the donkey. Compared to birds, apes, dogs and cats, he said, that animal alone had a 'talent for conversation'. Donkeys are rough-haired and not exactly beautiful, and are among the most maligned of creatures, but they are not stupid. They possess a lively intelligence and perhaps understand when they are being mocked. They are sure of foot and of extremely hardy disposition. They also recognise affection and understanding. The donkey of our story received both and returned the affection lavished upon him in the only way he knew, by dogged devotion. The time during which the man and his 'donk' made history was short. Yet their achievements created a legend which survives, fresh and enduring, 80 years after the event.

*　　*　　*

The Battle of Gallipoli was one of history's great disasters. It was fought almost by accident and could well not have occurred at all; it was as if, once engaged, it had to be pursued right to the bitter end, no matter what the cost. The First World War suffered from many ill-judged decisions which cost thousands of lives for little gain. Gallipoli was the outcome of one of those, and its name became notorious along with those of Ypres, the Somme and Verdun. Before the battle, few had ever heard of the place, a rugged, rocky and largely barren

peninsula that stretched like a finger south-west into the Aegean and eastwards into the Sea of Marmara and out into the Black Sea. There is no reason to suppose that it would be any better known today were it not for the battle that was fought there.

As early as three months after the outbreak of war, Winston Churchill, then First Lord of the Admiralty, had urged an attack on Turkey to knock it out of the conflict at an early stage. Churchill's plan had been prompted by Turkey's intention to seek control of the vital sea lane of the Suez Canal. To counter this threat, colonial troops, particularly from Australia and New Zealand, were sent to Egypt to be organised into units and trained. If anything occurred in that area, they would be on the spot to respond. If not, they would become a reservoir of manpower for the main conflict in Europe.

Churchill's plan was put aside until February 1915, when two events saw its hurried resurrection. First, Turkish and British forces had several skirmishes in the Suez Canal area. Second, Czar Nicholas II of Russia needed help. Would Britain make a feint against Turkey to ease Turkish pressure against Russia in the Caucasus? he asked. It was not an unreasonable request under the circumstances, as the czar's troops were already heavily engaged against considerable German and Austro-Hungarian forces in the north-east. But the resurrection of Churchill's plans meant that there would be no question of a feint. It would be a fully committed operation.

The plan was to force a passage through the Dardanelles Strait—at its widest no more than two and a half miles across, narrowing to just half a mile—into the sea of Marmara, and there lay siege to Constantinople, Turkey's capital, now called Istanbul. It was not considered a difficult operation and could be restricted to a simple naval action. The Royal Navy held indisputable sea supremacy, and its French allies, with their not inconsiderable fleet, would be joining the operation too. But from the time of agreeing a plan of action, nothing was to go as intended.

For a start, the shore batteries on the Gallipoli peninsula and across the narrow straits on the Turkish mainland were not only stronger than predicted, but also used in a far more professional manner than had been expected, taking the Allies by surprise. Despite preparatory

bombardment of the batteries and intensive mine-clearing within the straits, three battleships, two of them British, were sunk on the first foray, and three others severely damaged. Battleships and cruisers were capital ships of the day and carried a nation's prestige with them; such a loss was an embarrassment that could not be permitted to recur. Although one submarine had managed to reach the Sea of Marmara through the mines and anti-submarine netting, the naval operation was cancelled. Whether there was ever any analysis of why the failure occurred—apart from ineffectual mine clearance—is not recorded. Even if there was, it is unlikely that the joint chiefs of staff and Allied political leaders would have changed their minds about opting for a full-scale military occupation of Gallipoli instead. What they probably did not know, and certainly had no means of quantifying, was that a highly professional and able German officer, Otto Liman von Sanders, had been placed as commander of the Turkish Fifth Army in Gallipoli and, secondly, that a young Turkish lieutenant colonel, Mustafa Kemal, later President Kemal Atatürk of Turkey, was leading the defending forces.

What had begun as a sideshow and was initially seen as a quick operation now took on a new imperative and importance. The rocky heights of the Gallipoli peninsula, some topping 980 feet, would have to be taken and held by the military.

<p style="text-align:center">* * *</p>

The Australians were quick off the mark to volunteer when England, the old country, was in trouble, even though the ostensible cause of the war—the assassination in Sarajevo of Archduke Franz Ferdinand of Austria—happened on the other side of the world. Among the first to volunteer was John Simpson Kirkpatrick, who enrolled in the 3rd Field Ambulance of the Australian Army Medical Corps. It was not by chance that he ended up in the unit. He had no particular medical skills, but as rumour succeeded rumour he heard that a military field-hospital contingent was being formed to go to England to tend Australians wounded in Europe. To John this was a heaven-sent opportunity of achieving his long-held ambition. He would be able to see his mother, his sister Annie and his dog, the Yorkshire terrier 'Lilly', all

of whom he had left behind in South Shields, County Durham, when he set off to seek his fortune in the new world. He should be 'home' for Christmas.

John, more commonly known as Simpson or Murphy, dashed off a letter to his mother. It was full of expectancy, excitement and plans and, as always, a thought for helping his mother financially:

13 September 1914. Blackboy Camp, Western Australia. We are expecting to get orders to leave at any minute for the old country. I left you 4/- a day out of my pay. We only have 5/- a day and 1/- deferred pay. So you take 2/- a day for yourself and put 2/- per day in the bank for me when I come home from the war. I will be having a good holiday . . . 14th September 1914: AAMC. I am in the Australian Medical Core. My address when I get to England will be: Pte. Jack Simpson 202, C Section, 3 Field Ambulance, AA Med. Core, 1st Australian Contingent, England. I think we are going to Aldershot.

Simpson had been only 17 when he left England in 1909. He liked the Aussies' pithy mannerisms, their humour, their gift for innovation and, most of all, their unaffected friendship. He soon became a 'mucker' with the 'cobbers' around him. Simpson was no scholar, but that did not deter him from writing regularly to his mother in his highly descriptive prose, telling her how he was faring, reassuring her, and even castigating his sister Annie for lack of attention in class: 'You'll catch it orlright from me if you don't do your schoolwork,' he wrote to her. To his mother, he wrote, 'Now mother, I do hope you are keeping your pecker up and not worrying about me for there is no call. I eat enough for two horses at meals but I am always 'ungry . . . but there's plenty of grub.' He told her, too, of his latest precious acquisition: 'I have such a nice dog out here, a cattle dog, such a pretty dog he is and the licence here is only 2/6 per year. . . .'

The exchange of letters continued throughout his working life on ships, in the coalmines—when he wrote, 'Only sent 15/- as only had 7 shifts this fortnight and after paying two quid board and paying for my fags I am about cleaned out. I will send you 7/6 for the New Year

licence for Lilly'—then back to ship again. Of 1913's Christmas feast on board the SS *Koringal* he recorded: '[it] became so rowdy that [we] went for a celebratory fight with the local sailors which left [me] with a black eye and broken nose', adding, 'am sending you a couple of quid.'

Working as a stoker in temperatures that rose above 135 degrees Fahrenheit took its toll nonetheless, and he confessed that, 'I look more like a corps than anything else and if the excheker will hold out, I will leave and go up the bush for a while as I am sick of the sea.' Whether he was sick of the sea or just sick is not clear. He certainly went through a period when he believed he was tubercular, a condition from which few then survived. It is not surprising, then, that when he saw an opportunity for returning to England, he jumped ship and enlisted.

At a top-level meeting in London, meanwhile, it was decided that, rather than have the 'rowdy and ill-disciplined' Australians in England, it would be better to send them to Egypt for formation and subsequent allocation to combat zones. So Simpson's hopes, written of in such enthusiastic terms from Blackboy camp, turned to bitter disappointment. He set off instead for the heat and dust of Egypt. Arriving there he wrote: 'I would not have joined this contingent if I had known they were not going to England. I would have taken the first ship home and had a holiday at home and then joined the army at home and went to the front instead of being stuck in this Godforsaken place.' A few days later he added to that letter, 'I see in this mornings paper that Australia is going to send 100,000 more men. I am not surprised for men were simply going mad out there to go to the war. There was many a man envied us 1st Contingent for being so lucky as to get off to the war.'

In Egypt, three divisions—two infantry and one mounted—were formed into corps strength: the 1st Australian Division under General Bridges, a New Zealand and Australian division, and a mounted division composed of three Australian light horse brigades and the New Zealand Rifles. Perhaps Simpson would have been less disappointed had he known that the corps that had just been created, the Australian, New Zealand Army Corps, was to be one of the best-known fighting units in history, the Anzacs.

As March 1915 slipped into April and spring came to an embattled Europe, the Australians received their orders to move out. Simpson took the opportunity before boarding ship for an unknown destination to dash off another letter home. 'You will find out where I am when the Australians make a start,' he wrote prophetically.

* * *

The Anzacs, the 29th British Division under Sir Ian Hamilton, and French forces under General d'Amade were already on the Aegean island of Lemnos when the decision was taken to downgrade the naval activity in the Dardanelles and mount a military occupation of Gallipoli. The troops were prepared, but the transport to get them to the target areas was not. Transporting thousands of men, and the equipment and animals necessary to establish and maintain the first waves of attackers, would take a great deal of shipping and it simply was not available. There was a five-week delay while transport was organised, and the enemy put the time to good use. Forewarned of Allied intent, Otto Liman von Sanders poured reinforcements into the peninsula, dug in on all the heights and hardened the shore garrisons.

The main thrusts of the Allied landings were to come from the 29th Division and later the Royal Naval and French divisions at five places around Cape Helles, at the tip of the peninsula. The two Anzac divisions were to beach north of Gaba Tepe, 13 miles to the north. The southern landing was intended to take the heights of Achi Baba, while the northern attack would take first the rugged Hill 971 and then Mal Tepe, which would give the Allies the Kilid Bahr plateau.

During the night of 24–25 April, troops, equipment, weapons, ammunition, medical equipment, food stores, horses and donkeys boarded a massed fleet of troopships. It was a balmy night and the sky was clear and bright. Hundreds of shapes and forms flickered on the water in the reflection of the moon's rays, and the shafts of shaded light that came from the ships as they put to sea. There was little noise. The troops were oddly subdued, alert and expectant, each with his own thoughts. Halfway to Gallipoli, the advance landing parties were transferred to destroyers and then, about half a mile from the shore, into small rowing-boats. Tied one behind the other, to the

The Gallipoli Peninsula and the Allied landings. From *History of the 20th Century, World War 1*, J. M. Winter. Reproduced by permission of Andromeda Oxford Ltd, Abingdon, UK ©.

Turkish gunners eyeing them from their machine-gun nests in the dugouts on the heights they must have appeared like strings of beads ploughing through the water.

While hundreds of oars pulled for shore, Allied naval cover laid down a fearful barrage on the coastline. The ships' decks rang to the sound of the blasts, vibrated at the guns' recoil and became littered with spent shell cases. The sky lit up with gun flash and the air was thick with the smell of cordite. The earsplitting noise was hardly noticed by those nearing the shore in their small craft, illuminated by the gunfire like so many dots on a sheet of dark-blue water.

Machine-guns opened up from the heights, cutting swathes into the troops struggling to get out from the boats and on to shore, hoping to find some cover that just was not there. In the first moments of battle a record number of Victoria Crosses, Britain's highest honour for valour, was earned by the Lancashire Fusiliers; their awards became known ever after as the 'six before breakfast'. British and

110

French forces nevertheless managed to establish a bridgehead by the end of the first day.

If the situation at Cape Helles was bad, it was worse for the Anzacs. They were landed in the wrong place. Instead of the shoreline they expected, which would have enabled forward movement and the possibility of digging in, they found themselves on a narrow strip of shingle facing rocky cliffs that towered above them. More, Lieutenant Colonel Kemal was encamped with a garrison of troops on top of the cliff, not far from the escarpment. The Anzacs in the assault—the 3rd Australian Infantry Brigade, to which Simpson was attached—rushed from their small craft under heavy, accurate fire. What beach existed was rapidly filled with abandoned and broken rowing boats, some shot through. To the dust and darkness was added desperation, as hands and limbs were torn in the effort of clawing a way forward into the cliff's gullies. The fighting was relentless, continuous. There was no possibility of organising into units, nor of establishing reliable communications or a casualty service. It was hot and dusty and the men suffered sorely from thirst. A hasty effort was made to organise the donkeys to carry water to the front line, and water immediately became a major factor in the battle. Some said it made the difference between life and death. Yet, by some superhuman effort, the objectives of Battleship Hill and Gun Ridge were taken by nightfall and held despite two days of determined Turkish counter-attacks. Top priority had to be given to three requirements: the supply of ammunition to the front line, the provision of water and servicing the casualty stations. Donkeys were the key to them all.

In those first three days, the intensity of the struggle in the Cape Helles region, and particularly in Anzac Cove, as the area where the Australians landed was dubbed, meant only one thing. The whole object of the assault had failed: Turkey would not be quickly knocked from the war. For the three weeks that Simpson was to survive with his 'donk', and over the whole nine-month period of the campaign, this was a war of attrition, with each side taking staggering losses and gaining no worthwhile ground to alter the balance of the conflict.

* * *

The accounts of how Simpson met his 'donk' vary enormously, as do those about the name of the animal—Murphy, Simpson and even Abdul have all been suggested. Simpson himself called the creature which became his shadow Murphy. Some say that Simpson found the terrified animal in a lean-to shortly after the landing and adopted him. Others say Simpson was seen on shore during the landing, talking to a donkey which had just hauled itself from the sea after swimming from the ships, and calling it Abdul. This is probably the correct version, and it is possible that Simpson himself placed the donkey, which must have been in a wretched state, in the lean-to until he could get back to him. How the donkey ended up on the shore is an interesting story.

While waiting on Lemnos to go into action, the 16th Battalion machine-gun section worked out how, once they landed, they would get to Constantinople as fast as possible, more than 200 miles through enemy territory. And how they could do it comfortably. The only problem they could see would be humping along their heavy equipment. That was when the idea of getting a couple of donkeys arose. They clubbed together, negotiated with a local peasant and bought two animals for just over £2. One was called Abdul; the other was a pregnant mare who gave birth to a foal a month after landing in Gallipoli.

There were hundreds of mules and donkeys on Lemnos, almost all taken over by the military. They were needed to carry water and ammunition to the front line, and to haul the injured on casualty limbers. On the kind of terrain the invading forces would encounter, no animal could be surer of foot than the donkey. The New Zealanders and British had many hundreds of donkeys, but only two are known to have landed with the Australians on the first day at Anzac Cove. Abdul and the mare's Australian masters probably had second thoughts when they boarded the troop-ship *Haidar Pasha*. Packed closely with them on deck, they found that both donkeys were alive with lice and made up their minds to do something about it. They cropped the animals' long hair. One donkey had been completely shorn and the other half-finished—and the ship was halfway to Gallipoli—when they had to transfer first to the destroyer, HMS *Ribble*,

then to the rowing-boats. In the heat of the moment the donkeys were forgotten. The last time the gunners saw them, the donkeys had been lowered into the water and were swim-paddling as fast as they could for shore. Their heads and long ears could be seen bobbing up and down just above the water in fleeting glimpses from gunfire light. Both animals made it to the shore.

But if Murphy's arrival on the beach is something of a mystery, there does not seem to be any doubt about his appearance. According to one source, the donkey was 'a queer looking animal . . . a bantam in size, save for his ears'. Another described him as 'a little mouse-coloured animal, no taller than a Newfoundland dog'.

<center>* * *</center>

Within a week of the initial attack, positions on both sides had become static. Forays into no-man's land were repelled at great cost to both sides. Sometimes a dug-in position would be only a matter of a few yards from that of the enemy. Set in their positions, most of the troops relied on their own inventiveness to keep alive. They made periscopes six, sometimes seven, feet long to sight over the parapet and help them home in on their target, using lengths of wood and pieces of mirror taken from the transports or their own shaving gear. They used jam tins to manufacture improvised bombs, and strung up rows of them to act as warning signals in an entanglement. Decoys were made of tin plates and hoisted up to draw sniper fire. But all activity tended to halt when it rained and the misery increased.

In the front line was Shrapnel Gully, deep, winding, narrow and on an incline. It was often shrouded in a haze of dust and earth as a shell exploded in or near the closely packed men, blasting rock and earth in all directions. To get the injured down to the field ambulance seemed out of the question, for it would mean slow movement exposed to the murderous gauntlet of fire. The injured and dead of Shrapnel Gully stayed where they were, the living resigned to the inevitable in the increasing heat and dust and thirst. Suddenly, appearing from round a bend in the gully as if by a miracle, Simpson would appear. Often stripped to the waist, he led Murphy on whose head a Red Cross brassard had been tied and fixed beneath the ears. Their pace

<center>113</center>

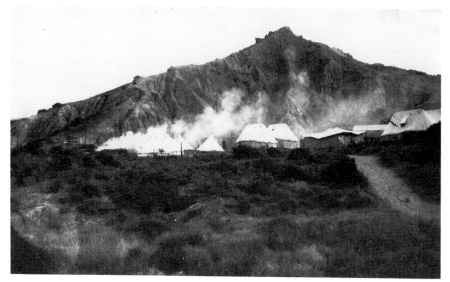

Encampment at Gallipoli, a harsh, hostile landscape. *Photo: Australian War Memorial, neg. no. J02661.*

was slow and measured, without concern for the mayhem around them. Simpson would stop, tend a wounded man's injuries as best he could, then lift him gently on to Murphy's broad, solid back. Murphy was so small that the injured man's feet barely cleared the rocky ground. The quiet pair would disappear with their charge as silently and suddenly as they had appeared.

News of Simpson and Murphy spread like wildfire. It was said too that if, during his journeys, Murphy swished his long ears, everyone had better duck, for he sensed trouble and could foretell the imminent arrival of a particularly lethal type of shell. Countless times during day and night the trip was made to the front line. It seemed as if Simpson and Murphy were leading charmed lives. Trench mortars, artillery rounds and snipers' bullets whistled, thudded and exploded around them, yet they carried on undeterred and without any change in pace. Simpson escaped death so many times that he became completely fatalistic; the deadly sniping down the valley and the most furious shrapnel fire never stopped him. Officers asked questions about Simp-

114

son and his donkey, who seemed to operate at will. Simpson's field-hospital commander sprang to his defence. He had recognised early on the special value of the work the man did with Murphy, and what it meant to the morale of the troops. He allowed Simpson to carry on as a one-man independent unit, so long as he reported in to base once a day. And so it continued for just over three weeks, until the early hours of 19 May.

Simpson was up early as usual. He had brushed Murphy down well and put a clean cover on the donkey's back. They left the Indian Mule camp where his tent was pitched and, just as dawn was breaking, set off up the valley. He went past the water-guard where he generally had his breakfast, but it was not ready. 'Never mind', he called, 'get me a good dinner when I come back.' It was the day of a massive enemy counter-offensive, for the Turks had guessed that the Anzacs were vulnerable. Eleven days earlier the 2nd Australian Brigade and the New Zealand infantry brigade had been sent to join the British forces' advance on Krithia Heights, leaving Anzac Cove reduced in strength. The Turks decided to strike before the survivors of that battle could be sent back to their original positions.

From 02.30, the Turks threw themselves repeatedly against the entire Anzac front. By noon, when the battle flickered out, the Anzacs were still installed in their trenches and some 3,000 enemy dead lay strewn on the ground. The losses on both sides were so bad that an armistice was agreed so that the dead could be collected and properly buried.

Seeing that he would have extra work to do, Simpson took a second donkey and tied him behind Murphy. He got through to the front, collected two injured soldiers, and set off down the creek, the leading soldier with his arm round Simpson's neck. The donkey never hurried, no matter the danger through which he plodded. Many felt that Murphy knew that, if he did, the jolting would cause extra pain. They had managed to get through the worst of the attack when there was a furious hail of fire, snapping and criss-crossing in all directions. Both patients were hit again and slumped forward round the necks of the donkeys. Simpson, trying to hold one man steady on the donkey's back, received a bullet in the heart.

Some reports say that Murphy was killed too, but evidence suggests that he was not, and that he continued his journey back to the field ambulance and delivered his dead charges. The following day, General Monash wrote a letter to HQ, New Zealand and Australian Division. It said: 'I desire to bring under special notice for favour of transmission to the proper authority, the case of Private Simpson, stated to belong to "C" Section, 3rd Field Ambulance. This man has been working in this valley since 26 April, in collecting the wounded and carrying them to the dressing stations. He had a small donkey which he used to carry all cases unable to walk. . . .' (The general was under the impression that Murphy had been killed, but there is stronger evidence that the donkey not only survived but was later evacuated with the 6th Indian Mountain Battery.) The general's letter was, of course, a nomination for a decoration—the Victoria Cross. No award was ever made to Simpson, however. Such decorations are awarded for one single act of valour, not a multiplicity.

Although the Turks were to make more counter-attacks, they would not do so again in the Anzac Cove region, so well had the Anzacs defended their positions. Several other battles took place throughout Gallipoli, however, and the course of those encounters, along with what had occurred in Anzac Cove, was flashed across the world: Anzac Cove, Sari Bair, Leane's Trench and Lone Pine became familiar names.

Simpson's mother heard of it too. She remembered his last letter that said that she would know where he was when the Aussies made a start. She wrote to him via the Red Cross: 'Jack my son, my heart is fairly bursting with sorrow and with pride to think that you are amongst such a lot of brave men—but mind they have paid dearly for their bravery. I saw the Australian list of casualties this morning and I am sorry to say that it's very heavy. I see that the 3rd Field Ambulance has got some wounded but thank God that your number was not there. . . .' Not receiving any reply she wrote again, almost four months after Simpson's death: 'Now my dearest lad, I wonder if this war will keep me from seeing you again. I hope Not. I cannot settle. I am worried to death and I can't help it. Goodnight and God bless you.' Her letter crossed with that of Captain Fay of the 3rd Field

Ambulance. Marked Gallipoli, it was addressed to Annie and said:

[Your brother] discovered a donkey, took possession of him and worked up and down the dangerous valley carrying wounded men to the beach on the donkey. . . . Everyone from the General down seems to have known him and his donkey which he christened Murphy. The valley at the time was very dangerous as it was exposed to snipers and also continuously shelled. He scorned the danger and always kept going, whistling and singing, a universal favourite.

A landing of reinforcements took place in intense heat on 6 August in a bid to end the expensive deadlock and take the advantage once and for all. But the deadlock remained, and it was not until November that it was admitted that the Allies could not win this one. Just about the only success of the entire Gallipoli affair was in the organisation

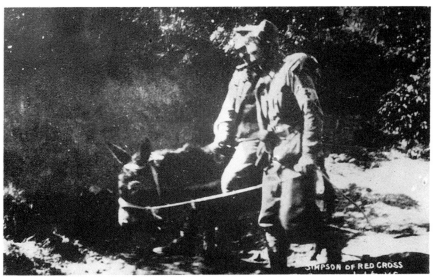

Simpson and Murphy help a wounded man to safety. *Photo: Australian War Memorial neg. no. A03114.*

117

of the evacuation. It was brilliantly conceived and executed over the Christmas period of 1915–16. According to official Australian sources, Gallipoli had cost a total of 116,739 dead and injured. According to the well-researched *History of the 20th Century: World War I*, the total dead reached as high as 200,000.

The relationship that existed between Simpson and Murphy was one of very real animal–human understanding, as if, in Simpson's great gentleness and consideration, Murphy had encountered something he had never known before. To Simpson, this donkey was much more than an animal. Perhaps Murphy could not foretell when shells were coming. But the men believed he could and wanted to believe it, and Murphy fitted the bill of what they needed at the time. That on its own was reason enough for Simpson to love him.

Many years after the event, Philadelphia Robertson visited the shrine of remembrance at Melbourne, that looks out over Port Phillip Bay. She spent many moments in silent contemplation of the bronze statuette of Simpson and his donkey. Then she wrote what is probably the most appropriate tribute to Murphy that could be penned:

> Would it seem strange to you
> If somewhere in elysian fields
> Cropping the herbage by a crystal stream
> Wandered the little ass, tall Simpson's friend?
> Or strange at all
> If, down the hill, beneath the flowering trees
> By meadows starred with lilac and with rose
> Came Simpson, singing, his brown hands
> With celestial carrots filled
> For his old friend?
> To me, not strange at all,
> Amidst the beauty of some shining sphere
> They surely move—
> Those deathless hosts of Christlike chivalry.

7

SEBASTOPOL TOM

It had been a terrible winter. The armies of France and Great Britain had been exposed to the full rigours of the Russian snows as they laid siege to the Russian seaport of Sebastopol. Added to that was the suffering of the wounded. In the mid-1800s there were no anaesthetics or drugs to ease pain, and no antibiotics to clear up infections that ravaged officer and soldier alike. Food was scarce and the water was described as 'brackish'. But, at last, as the siege ended and the victorious Anglo–French forces marched into a largely demolished citadel, the officers and men were able to find shelter and warmth.

Inside one cabin found by officers, or the remains of a lowly building, was a scene that would be immortalised on canvas, its central figure destined to become one of the most famous animals in history—Sebastopol Tom, the tabby cat of the Crimean War. Sitting on an upturned box, Tom is seen slumbering, enjoying all the affection and tender care that his new masters were pouring on him. Tom had survived the campaign from which the French would name several Metro stations in commemoration of battles fought there. Sebastopol, Pont d'Alma, Crimée. The war also gave us the raglan sleeve, the cardigan and the balaclava; it produced the Charge of the Light Brigade about which Alfred, Lord Tennyson wrote his memorable epic poem; it saw the work of the first woman ever permitted to tend the injured in the field of battle and who was to be, to a large extent, the founder of modern nursing—Florence Nightingale. It was the campaign from which the greatest distinction for valour in the field of battle, the Victoria Cross, was created. To this exceptional list of hallmarks must be added Tom, for he captured the hearts and minds of all those men and officers who marched into his home town of Sebastopol and found him with the dead and wounded defenders in a dark, cold and dusty

cellar, and in his own way he was instrumental in saving their lives.

Of all animals—and particularly domestic pets—the cat is the most mysterious. No one can ever be sure what their thoughts are, yet we know that their capacity to reason is one of the greatest in the animal kingdom. Their aesthetic beauty and the magnificence of their co-ordinated limb movement has enthralled people ever since the ancient Egyptians immortalised them in gold, precious jewels and stone. They can be haughty yet skittish, their huge, round eyes dominating their tiny faces, melting the hearts of all but the hardest of beings. At one and the same time they are passive and inscrutable, yet sensitive and highly strung. The cat cannot be trained to perform any function that the human would like it to, and will only do a certain thing because it wants to, for its own reasons or ultimate gain. No one can impose

Sebastopol Tom. *Photo: National Army Museum (Hamilton).*

120

upon it. The cat sets the ground rules and dictates when it will permit fondling and affection, when it will come and when it will go.

At a sudden movement or unexpected noise, cats will run for cover or to seek solitude. Yet they have always been found standing their ground in the middle of chaos, when all about them has foundered into rubble and confusion. Tom was found in a situation such as this and became a legend because of it.

<div style="text-align:center">* * *</div>

In 1854 there were three great empires: the British, whose navy undisputedly ruled the world's waves; the French, whose emperor, Louis Napoleon III, was eager to improve his international image after coming to power in a *coup d'état* barely three years earlier; and the Russia of Czar Nicholas I. It was an uneasy time of empire building, colonisation and suspicion of others' ambitions. Britain jealously guarded its dominions, which brought a third of the world's population under allegiance to the Crown, and viewed any territorial move on the part of Russia with deep misgiving. The British could well have had reason to be suspicious, for only 30 years earlier Russia had supported a campaign in Afghanistan that had led to the First Afghan War, posing a major threat to India, Britain's most precious possession. France anxiously watched Russia's moves too, particularly if they appeared to be towards the Levant, the Middle East, for, like Britain, France was keen to preserve its influence and territorial gains there and, if need be, to fight to ensure their safety.

For its part, Russia ignored the anxieties of both and ploughed on with its own ambitions. So when Russia marched in to Turkey's Dardanelles, alarm bells rang. It was a move Britain was not prepared to tolerate; it was too reminiscent of the Russian ruse in Afghanistan. Under no circumstances would London permit them a second bite of the apple at attaining their objective simply by tackling it from a different direction. France reacted too, for its territories in the Levant were under immediate threat. Necessity led to the two traditional antagonists, Britain and France, forging an alliance. To their troops were added a significant Austrian contribution and, of course, the army of Turkey itself.

The combined force landed on the beautiful and rugged peninsula of Gallipoli, which 60 years later was to see one of the bloodiest battles of all time, and pushed on to Varna, on the Black Sea north of Constantinople, to await orders to attack. The strength of the international opposition he now faced surprised the Czar. He tried negotiations via his special envoy Prince Menshikoff, but the allies were having none of it. Finally, to the humiliation of his army, the Czar pulled out from Turkey. He no doubt felt that that was an end to the matter. The British and French had other ideas, however. They had seen the threat and recognised its implications. Now that their forces were on the spot, they did not see the point of withdrawing and leaving a situation that Russia could exploit at a later stage. The allies reasoned that if Sebastopol, Russia's deep-sea port in the Black Sea, could be taken and occupied, any risk of a Russian offensive towards the Dardanelles and the warm waters of the Mediterranean would be eliminated.

The strategy for taking Sebastopol appeared simple enough. There were high hopes that the capture could be achieved speedily and relatively cheaply in terms of both manpower and financial cost. Landing just over 50 miles north of the citadel, the French were to march southwards, hugging the craggy coastline, while the British forces marched in parallel inland. The presence of such massed forces so close to Sebastopol was intended to isolate any resistance and deprive it of speedy reinforcement. More, the distance to be covered was not through towns, villages and cities, but across rolling hills and valleys, with the right flank largely protected by deep gullies. Before autumn turned into the feared Russian winter, it was believed that Sebastopol would be taken and the allies sheltered within its walls.

There was every reason for confidence in such plans. They should have succeeded. But although victory would come ultimately for the allies, it would have to be bought at a very high price, and the fault of that lay principally with the incredible bungling of the leadership. What could have been just another campaign, one among many in a long line of conquest and conflict, became *the* campaign that would be dissected, analysed, written about and filmed; a *cause célèbre* that still endures today. Only the outstanding courage of the men in the

field in the face of appalling adversity was the saving grace of this pyrrhic victory.

Three main factors, from cause to effect, played an unscheduled role in events. The first was that, unlike the Russian defenders, the troops that landed at Calamita Bay in driving rain on 14 September, 1854, were the survivors of the army that had waited in Varna for the war that never began. Their numbers had been decimated by cholera, dysentery and fever. They were gaunt and generally in poor health. Their brilliantly coloured uniforms, normally so well tended, were dishevelled and dulled by accumulated grime. They had few supplies and no tents for shelter at all. Added to this, the way south would be heavy going on rain-sodden ground, adding to their discomfort.

The second problem was the state of the leadership. Of the divisional commanders, the young Duke of Cambridge, cousin to the Queen, had never seen combat or been on active service before; Sir George Brown had not seen active service for 40 years; Sir George de Lacey was considered too old for such a campaign at almost 70, and Sir Ralph England was referred to as 'a terrible fool'. This left Sir George Cathcart as the only experienced officer in the field. Matters were just as fraught at higher level. Lord Cardigan, who had no previous combat experience, was argumentative, resented authority and was constantly at loggerheads with his brother-in-law Lord Lucan, commander of the cavalry division. Lord Raglan, the commander-in-chief, was seldom seen. As if that were not enough, there was a severe lack of co-operation and coordination of effort between the French and British commands.

The third factor was that the skill of Prince Menshikoff had been underestimated. He was quick to see the opportunities presented by so much bickering on the allied side, and took full advantage of them. First evidence of that came early, within 48 hours of the landings, when the British attempted to take the heights on which Menshikoff's 35,000-strong army, including cavalry, was entrenched overlooking the River Alma. Three times they charged. On the first attempt they succeeded in their objective, but could not hold on to their advantage and had to withdraw: there had been no follow-up support. The second assault proved no luckier because flank support was either too slowly

dispatched or launched too soon, creating confusion and adding to the difficulties and casualties. It was only when the Grenadier and Coldstream Guards, the Highland Brigade and the 2nd Division counter-attacked that the heights were taken and Menshikoff's troops put to flight. Lord Raglan called on the French to provide support to pursue the Russians and nip further opposition in the bud. The French hesitated too long, however, and by the time they made a move, on 23 September, the Russians were gone.

The battle had not taken long. Battles then and earlier seldom did, given that they were almost exclusively close-range combat and relatively static. In less than two hours it was all over, and silence descended upon a scene which had so recently been one of noise, smoke and carnage. Often it was said that the dead were the lucky ones, so horrendous were the wounds created by the weapons of both sides, the soft lead balls leaving gaping holes in the body, pulverising and shattering bone. Even if the wounded managed to survive the shot itself there was another, invisible, danger. In entering the body, the ball took uniform material and any other matter into the wound with it. Infection set in and there was no cure: septicaemia quickly led to gangrene.

The superiority of the British muzzle-loaded rifle, the 'Minié', and the solid prowess and discipline of the soldiers had carried the day and played a key role in the eventual success. The Minié was accurate and could hit targets at more than three times the distance of the enemy's converted flintlocks, and with such force that one ball could go through several men.

The lost opportunity at the Alma River created its own problems. The ailing French commander St Arnaud sought a revision of the whole plan of attack. He was no longer in favour of an assault on Sebastopol from the north. Now he reasoned that a southern approach would permit the taking of two harbours through which reinforcements and supplies could be channelled, Kamiesch for the French and Balaclava for the British. Raglan agreed to this more from a reluctance to invite an Anglo–French strategy dispute than on sound military principle. The result was dispersed troops and, more importantly, lost precious time. Although in all justice the eventual outcome of the

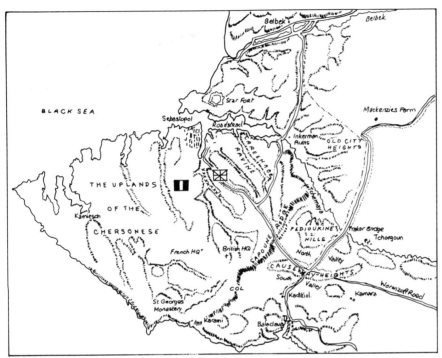

The Crimea. From *Heroes of the Crimea* by M. Barthorp.

decision may not then have been clear, it effectively condemned the armies of both Britain and France to passing the winter without protection from the elements. Menshikoff was again off the hook, and able to regroup.

While he left the Sebastopol garrison at half strength, Menshikoff was able to reinforce resistance elsewhere, at Balaclava and at Inkerman (*see map*), where the British would face two major battles. This turn of events came at a particularly vulnerable time for the allies. They were having problems getting supplies through, and the field artillery had to be hauled over long distances on difficult terrain. More, as the autumn drew to a chilly and wet close, there were outbreaks of cholera and dysentery among the ranks again. While Anglo–French

125

troops set off for the south, the rest of the joint command installed themselves on the Chersonese Plateau overlooking the citadel of Sebastopol. The siege had begun.

Two desperately fierce battles took place within a few days of each other—at Balaclava, where reinforcements had begun to arrive as early as 4 October, and at Inkerman, on the British right flank about eight miles east of Sebastopol. Among the battles around Balaclava was the ill-fated charge of the Light Brigade. The charge has been called many things—foolhardy, reckless, a stupid waste of life and horse; great, inspiring, awesome, courageous and an act of dedicated discipline—and it was probably a mixture of all these. It was certainly the unnecessary result of personality conflict and arrogance at the highest levels of command.

The Russian forces, which included cavalry, two Dnieper battalions and at least six squadrons of lancers, were quite the largest they had amassed since the allied landings. They were installed in two areas opposite each other, on the Fedioukine Hills north of Balaclava and on the Causeway Heights barely one mile away across the plain. The Light Brigade attack, which was followed through by the Heavy Brigade, took the Russians by surprise. They were not expecting any confrontation, and had encamped to regroup and decide upon tactics. But Raglan, from a vantage point, had noticed several Russian artillery horses being led into the plain in an effort to capture and haul away a few British heavy-artillery pieces. He issued an order to Lord Lucan that he 'wished the cavalry to advance rapidly to the front—follow the enemy and *try to prevent* the enemy carrying away the guns' (my italics). By the time the message was delivered by a zealous young officer, the order had the additional 'Tell Lord Lucan the cavalry is to attack immediately' attached. The debate on the interpretation of the order and the manner of its delivery is well documented and need not be laboured further here. The result was that, with Lord Cardigan leading, the Light Brigade began its fateful passage into the Valley of Death to the sound of the bugle and the call to 'Walk, March—Trot'. And so the 17th Lancers, the 4th and 13th Light Dragoons and the 8th and 11th Hussars first cantered then sped on, wielding their sabres, straight down the centre of the plain while grapeshot, musketry and

shells poured into them from both sides. The slaughter of men and horses alike was grievous, and it remains a miracle that not only were there survivors of this débâcle, but that some actually managed to get through to the enemy.

Inkerman, meanwhile, dominated the Old City Heights, as well as the head of the sea inlet to Sebastopol and the Black Sea. To dislodge the allies from this key position, Menshikoff launched a counter-offensive on 26 October. It began in the early hours of the morning when heavy mist shrouded movement. At the day's end, when the light faded, Menshikoff admitted defeat and retreated from the battle-ground, leaving more than 10,000 casualties behind him. This conflict was subsequently dubbed 'the soldiers' battle' for, as Michael Barthorp puts it in his book *Heroes of the Crimea*, 'of generalship there was little or none'. One survivor referred to it as a 'curiosity of war' in which the battlefield 'resembled an abattoir and an earthquake blended—bruised, gashed, disembowelled, man-flesh and horse-flesh intermingled with broken instruments of war'.

The regiments involved, each with an illustrious history before arriving in the Crimea, were to go on to new heights and contained the first recipients of the Victoria Cross. Formed into five divisions and Lord Lucan's cavalry division, they comprised the Dragoon Guards, the Lancers and Hussars, the Grenadier and Coldstream Guards, the Cameron and Sutherland Highlanders, the Cambridgeshire, West-moreland, Derbyshire, Welsh, Lancashire and Herefordshire Regiments, the Staffs and Gloucesters, the Fusiliers, the Connaught Rangers and the Rifle Brigade. Now they were set for the long winter's siege of Sebastopol—and none had any warm clothing.

* * *

We do not know whether Tom was a stray or someone's beloved pet. He was certainly resilient, fleet of paws, able to care for himself and friendly to strangers. He must have been about seven years old when the siege began. While the humans suffered from sporadic food short-ages, hunger never bothered Tom. Even without a siege, in peacetime, there was no lack of mice in the port area, near the tall-masted ships or running around between the bales of stores stacked high on the

quayside. Summer or winter, Tom could count on food. He must have known his colourful city well: the green domes of its churches, the huge white columns that flanked the temples, its public buildings and the stark white walls of the magnificent houses belonging to wealthy tradesmen that overlooked the harbour, whose rich blue water shone in the sunshine.

For nine months, the allies bombarded the city with shot that went straight through the soft freestone walls of buildings, leaving gaping holes which were hard to repair and demolishing all within. Although Menshikoff had increased the strength of the garrison up from 18,000 to 25,000, they were gradually worn down in a war of attrition, shortage and constant skirmishes which the defenders could not win. The casualties inside the besieged citadel mounted, and fresh water became harder to obtain. The wounded were collected in the cellars of buildings that were still standing and stayed there, motionless and uncomplaining, dying unnoticed. One observer noted the increase of cats and dogs roaming the ruins—probably in search of water to quench their thirst—'A great many cats and dogs stuck to their old homes, the latter skulking and downcast, the former making for their retreats in a great hurry.' The British forces on the heights noticed this too, and dogs and cats became a familiar sight in their camp. All appeared well looked after, even spoiled, and a Lieutenant Colonel Hamley was presented with a kitten as a gift. He wrote warmly: 'It was given to me by a brother officer who saw it on board his transport and knowing my penchant for the tribe, brought it up to my tent in his pocket handkerchief. She is called Topsy and having formed an intimacy with a vagrant lover with one eye, who came from who knows where, has been the mother of one family and has every prospect of another.'

In the first week of September 1855, almost a year after the Anglo-French landings, the Czar decided that Sebastopol too must be abandoned, but not without creating severe problems for the victorious armies. The last hours of the siege were tense. One officer in the British lines, knowing something was afoot, wrote:

There was little sleep in the camps. Successive explosions of the most tremendous description shook the plateau making every-

thing quiver as if in an earth quake. The information thus loudly given that the enemy was about to abandon the place was confirmed soon after midnight in a singular manner. Fort Paul [inside the port] was veiled in smoke but visible. It remained standing on its jutting position till afternoon when the fire in a building nearby, being connected with its magazine, was hurled into the air. When the dust subsided nothing was left except a heap of stones. Joining the ground between this and Malakhoff was the Karabeluaia suburb—a large collection of insignificant houses with a few better class among them—now a mass of ruin. . . .

The destruction of the port's facilities continued until the last moment. A great many ships were sunk in the harbour. The spars and ropes of a long line of battleships rose above the water. 'The *Twelve Apostles* had heeled over as she foundered and lay across the inner harbour, marked by three top masts and top gallant masts. There was charred remains of boats and in the dry dock lay a blackened remains of a steamer which had been destroyed by fire. Scuttled boats and half burned craft of small tonnage lay near the wharfs and quays.' When the victorious armies descended into the citadel, they found bags of black Russian bread abandoned in the streets close to dead horses which were attracting flies. All freshwater sources had been demolished except for one public fountain. The French and British soldiers strolled together around the once lovely port, gazing curiously at the place they had won. The Algerian Zouave soldiers of the French army set to chasing cats and using them as bayonet practice, to the general disgust of the British, one cat being particularly cruelly slaughtered almost as a show-piece for the revelling men.

Searches of the cellars of the port went on throughout that day and into the night. It was a sad affair, for the opening of the doors delivered shafts of light onto the dusty debris upon which the dead and dying lay together. In one of the cellars entered by Captain William Gair of the 6th Dragoon Guards, otherwise known as the Caribiniers, was a large, wide-eyed tabby cat sitting on a pile of rubbish between two seriously injured people, covered in dust and grime, yet serene and

totally unperturbed by the commotion around him. Captain Gair made his way to the animal and bent down to pick it up.

The cat was quite tame and made no move to hiss or scratch. Tucked under Captain Gair's arm, he was taken back to the officers' shelter where he was received with open admiration by several other officers there at the time. But there was little food to be had and the personnel responsible for supplying food to their officers were desperate to find fresh sources. They noticed, however, that the cat was hale and hearty, well padded beneath his thick tabby coat, and the injured defendants left in the city did not appear to have starved, despite the siege. If the Russians were still relatively well fed, they must have had continuing access to supplies until the city was evacuated—but had these been left behind and if so, where? The initial search had revealed nothing amid the debris.

Then Tom took the lead. He hurried out from the military compound towards the sacked city. The men followed, and as they neared the dock area, the cat stopped at a place where access had been blocked by falling rubble. Behind this was a storeroom that was full of food, most of it still in edible form. Tom, of course, had come in search of the rats and mice that were scrambling, squeaking, over the ruins and debris, but for the victors of the siege the discovery meant salvation. Their hunger was assuaged and the story soon got around that the cat knew where to find food and was to be followed. Subsequently he led them to further supplies, still stockpiled by the waterfront. Just how many people's needs were met as a result of Tom's assistance is unrecorded, but he became doubly a hero.

We shall never know what trials and tribulations Tom had suffered. Up to that point he had been just one of many hundreds of anonymous cats in Sebastopol and had certainly lived through the traumas of the worst explosions, remaining with those he knew, who, no doubt, had loved him. Now he was anonymous no more. Cherished by the officers in whose company he slept and ate, he was brushed and cared for, cradled fondly, and slept for hours on end on this lap or that. When, finally, the withdrawal took place, there was no thought of leaving Tom behind. How the officers obtained permission to bring a cat all the way back to England is not recorded; it was something that had

Tom, cosseted figurehead of the Sebastopol campaign. *Photo: National Army Museum (Hamilton)*.

certainly never been done before. But it was a measure of their grati-
tude to him that they felt they could not abandon him. Not only was
he a beloved pet who had brought them affection in a strange land,
but he had played a decisive role in assisting them. He travelled and
marched with the Dragoons on their homeward journey, and ended
his days as the cosseted figurehead of the battle for Sebastopol, one
of the most controversial campaigns of all time.

8

SIMON OF THE AMETHYST

The longest-running civil war in history was reaching a climax. Since the Boxer Rebellion at the turn of the century, the battle had raged virtually without ceasing, and there will probably never be any remotely accurate figure of the lives lost. There had been only brief periods during which the Chinese made common ground: from the 1920s, when it was under genocidal attack from Japan, and throughout the Second World War. Then their own war took off again with renewed vengeance. By early 1949 a new trend was emerging. Chiang Kai-Shek's pro-Western nationalists were losing ground heavily to the Communists and the end was in sight. Nationalists were already flooding into the offshore island of Taiwan (formerly Formosa), and seeking refuge in Britain's tiny colony of Hong Kong.

In April 1949 the Chinese Nationalist government had moved its seat from Nanking to Canton. Several embassies, the British included, stayed in Nanking. The British Ambassador had asked for, and obtained, a Royal Naval guardship to be based at Nanking (as was allowed by the Anglo-Chinese agreement) to protect British lives and property as the civil war swept through the area.

None of this seemed of any consequence to Simon, the black-and-white tom cat born in Hong Kong a year after the end of the Second World War. He had been adopted and brought on board by the *Amethyst*'s captain about a year before the start of the events that were to unfurl. Simon was a conscientious ship's mouser by anyone's standards: eager, enthusiastic, dedicated and good at his job. He was not the only pet on board, though. There was Peggy, a four-year-old terrier with whom Simon rapidly made friends or, alternatively, according to his whims, ignored. As for the crew with whom the animals lived, they doted on both of them, for Peggy and Simon provided that touch of

Simon, the only cat ever to receive the Dickin Medal. *Photo: Imperial War Museum.*

homeliness that was so important during the long periods at sea.

Simon (and Peggy) could therefore have led a simple, even mundane life, like so many other ship's cats, had it not been for the Admiralty's orders to sail on that particular voyage. The *Amethyst* was to go to

Nanking to relieve the guardship-destroyer HMS *Consort. En route* for Nanking, the *Amethyst* called at Shanghai and anchored overnight at Kiangyin. The first portent of what was to come took place when, some sixty miles short of Nanking, the *Amethyst* was fired upon while steaming along a sparsely populated stretch of the river.

Within a few days the world would hear of the Yangtze Incident and just over three months after that Simon would become the only cat ever to receive the animal VC, the Dickin Medal.

<div align="center">* * *</div>

HMS *Amethyst* had been built six years earlier in 1943 as a modified Black Swan class sloop with a top load of just under 2,000 tons and an armament of three four-inch twin gun mountings. Its main duty then had been in anti-submarine work, but with the ending of hostilities it was reclassified as a frigate. Its markings, the pennant number *F116* and the white ensign flying from the masthead, must have been clearly visible from the shore as the vessel approached the mouth of the Yangtze river and turned into it.

It was foggy as the *Amethyst* steamed up the river and there was little sign of life on shore, although farmers and fishermen must have been working out of sight. Suddenly, from the north bank of the river where the Communist Chinese People's Liberation Army was installed, came gunfire. There were several hits on the *Amethyst* but none was serious and all fires generated by them were quickly dealt with. Some shells whizzed overhead and were lost while others fell short, sending up great spouts of water and showering the crew. Once the shore batteries found their range, gaping holes began to appear in the *Amethyst*'s superstructure, igniting fires again. Shrapnel spun through the air, slicing into anything in its path. The noise of tearing metal and explosions was ear-splitting. A direct hit on the open bridge mortally wounded the captain and seriously injured other officers on it, including the second in command who, despite his injuries, was able to assume command for the perilous 72 hours after the attack.

Another shell burst through the steel plates of the hull not three feet from Simon, forcing a hole more than a foot across. There was a vivid flash and an explosion. Simon was thrown high into the air and

landed heavily, lying motionless on the debris-strewn gangway.

As suddenly as the attack had started, it stopped. An eerie silence descended on the stricken vessel. The *Amethyst* had taken fifty-four hits. The good news was that the communications screen was still able to transmit. The bad news was that the steering mechanism had been damaged and the ship, juddering under repeated hits, had come to a halt on a sandbank. In addition to everything else it was now aground. (Under cover of darkness that night, the *Amethyst* managed to pull off the river bank, but then lay at anchor until the moment the ship fled for freedom.) With the lull came the opportunity to care for the injured. When he was gently picked up, still unconscious, no one could be sure whether Simon would survive the night. His black fur was singed by fire and he was thickly coated with grime and blood that came from several shrapnel wounds along his spine. Loving hands patiently removed the splinters of metal from his flesh, trying to ease his pain. Even if Simon survived, they thought, there was a risk that his ultra-sensitive ears would be permanently damaged by the explosion.

News of the incident flashed throughout the world. No one wanted a return to gunboat diplomacy or the threat of another war. The next three days were spent taking stock. The ship was all right for water as it distilled its own. It had been amazingly lucky, too, with the food supplies and relatively little had been lost. The biggest loss had been several bags of flour that had been used to 'sandbag' the bridge. The problem, as soon became evident, would be the supply of fresh items—potatoes, vegetables, eggs and so on. There was one major shortage, however, and an important one—fuel. During those crucial three days before seemingly interminable (and eventually unfulfilled) diplomatic negotiations began for the ship's release, there was little external assistance to be had. Among those who tried to get through in those early first hours was an RAF Medical Officer who arrived by Sunderland flying-boat. Shortly after its arrival on the river, the Sunderland came under fire and had to take off to avoid destruction, but the MO did manage to take one of the *Amethyst*'s wounded officers with him.

From the British Embassy in Nanking, a military attaché, Commander John Kerans, accompanied by some replacement officers, set

off overland to assess the damage and investigate the situation. When he arrived, three days after the attack, he was taken to the ship alone by the Nationalists while the others waited ashore, and immediately assumed command of the vessel. The priority then became the burial at sea of the dead. With the replacement officers now on board and sixty of the remaining crew, the burial of the victims took place and the crew settled in to what would be a long and torturous wait.

As Commander Kerans, a popular officer, took charge, so Simon's state improved. Although his wounds were still raw, he went to work with gusto and caught his first large rat. His achievement was a great boost to the morale of the crew, just when it was most needed. Negotiations for fresh supplies started at once via a Chinese interpreter from the Embassy who was the only 'friendly' contact with the shore.

As the days progressed into weeks and months, May, June and into July, so the heat rose and along came the midges and mosquitoes to add to the crew's discomfort. They were nonetheless kept busy,

HMS *Amethyst* after her ordeal in the Yangtze river. *Photo: Imperial War Museum.*

cleaning the ship and making any functional repairs that they could. The supply situation deteriorated and Kerans had to opt for caution: he cut rations by half and made water a precious commodity to be used sparingly. This was a blow to the crew's morale, yet it held very well for they had total confidence in their new captain and his reassurances, and they had Peggy and Simon—and Simon had now settled into a regular catch of one rat per day.

The third month of captivity was drawing to a close with no sign of release being any nearer. It was not just the threat hanging over their heads concerning food and water supplies that bothered John Kerans, for Simon's ratting was ensuring the safety of most of that, but the need to do something to extricate themselves from a situation that was becoming insupportable. The ship would have to make a break for it. Everything would have to be 'just right'—a night with no moon, perfect crew co-ordination, attention that no extra or unexpected noise was made. Even if the plan succeeded, there would still be the daunting task of having to sail 140 miles before reaching the safety of international waters, two-thirds of which would be under the guns of their captors.

The day of opportunity came on 30 July. Commander Kerans had kept his idea to himself until the last moment. It was mid-afternoon when he divulged his intention and that the attempt would be made that night. Throughout the remaining hours to darkness the crew continued their usual duties on board, aware as always of the watchfulness of Chinese troops on shore. The last moments waiting for total darkness seemed an eternity. Every man went to his post with a prayer in his heart, but the most tense moment came when the anchor was slipped. The crew had carefully muffled the anchor cable so that its movement would not be heard above the customary noise of the engines whose boilers had been kept working throughout. The plan and the moment must have been blessed, for as they prepared to slip away, a river steamer drew level, then passed by: the *Amethyst*, at slow speed, followed in its wake. It was the shore-battery's rocket flares that picked up the craft on the move and the Chinese were clearly taken by surprise. The darkness that had been the ship's cover was now punctuated by exploding shells and tracer rounds.

Miraculously, none scored a hit. The *Amethyst* increased speed to full, ploughing through the water to run the gauntlet of the shore batteries, one aim in mind—to get out. It was a nerve-racking experience that endured for several hours, and it was not until they were almost free of the long dash for freedom that, at Woosung, searchlights pinpointed the ship, sweeping over it, profiling it. Yet, incredibly, there was no reaction . . . it was as if the *Amethyst* had taken on a charmed life! The crew's jubilation and relief as they entered free waters were indescribable.

The *Amethyst*'s return to Britain in October, after completing repairs in Hong Kong's dockyard, was to a rousing welcoming party. Simon, who had continued to catch his one rat per day on board during repairs, was star of the occasion. How the indefatigable cat had kept the crew's morale going during those twelve long weeks of captivity was a story that preceded his arrival at Plymouth. But once in the United Kingdom, Simon was immediately separated from those to whom he had given hope, and placed into quarantine (Peggy had remained in Hong Kong). Simon's courage had already captivated the nation, and the announcement that he had been awarded the Dickin Medal was met with plans for an award ceremony as soon as he left isolation. But that was not to be. Simon had been through a lot, even though he was very young—not yet four years old. No one had noticed that he had a weak heart while he underwent the emotions and tensions of the Yangtze Incident, nor noticed anything strange in his behaviour as he took on the long and potentially dangerous battles with outsize rats. On 28 November, 1949, he died and was buried shortly afterwards in the PDSA cemetery in Ilford, Essex, where his tombstone tells of his valour.

Every member of the *Amethyst*'s crew, officers and men, was affected by the news of Simon's loss. It marred the joy they had felt at achieving the unachievable in the face of the impossible. The sadness that Simon's death evoked was such that there was an immediate search to find a replacement. A black-and-white tom kitten was found, named Simon II, and solemnly presented to the *Amethyst* and its crew.

In the presence of Commander Kerans and the officers and men of HMS *Amethyst*, Simon's medal was posthumously awarded.

Simon in quarantine at Wallington, Surrey, investigating a toy mouse. *Photo: courtesy the PDSA.*

9

WINKIE: PIGEON POST

Pigeons do not normally spring to mind when one thinks of animal—
or indeed bird—heroes. Yet no creature has received so many distinc-
tions for exemplary conduct in the field of battle, well outnumbering
any other.

Winkie was one of the most famous pigeons of the Second World
War and her story epitomises the invaluable and courageous contri-
bution made by pigeons with the military. But this chapter also breaks
new ground: for the first time we are able to see the role played by
pigeons in Britain's secret services, MI6 (SIS), MI9 (Escape Service),
OSS, PWE and SOE (which was especially created to organise resist-
ance in occupied nations). Until now the work of pigeons with the
intelligence services' networks has remained, like all the files concern-
ing the men and women within them, classified secret and bound to
remain so under the 50- or even 100-year rule. Now, however, we are
able to read the stories of some of those pigeons and the intelligence
operations with which they served.

* * *

It was icy cold—a penetrating cold well known to mariners plying the
North Sea and the Atlantic in February, an iciness that was to be
particularly feared by thousands of seamen in the Russian convoys.
The Beaufort aircraft of the Royal Air Force, trying to return to base
at RAF Leuchars after its mission in Norway, flew lower and lower
then plunged into the choppy sea. It had been badly damaged by
enemy fire and there was no alternative but to ditch. Large pieces of
the wing and fuselage broke off in the impact. All the crew were
thrown out and overcome by a deluge of water, hanging on to debris
and tugging at the release harness for the rubber dinghy. But they

were not alone in this dire moment. They had a blue chequered hen pigeon in a container with them and, despite the high waves, the crew searched for her. For a while she was nowhere to be found. Suddenly one of the airmen spotted her with a joyful cry – she was a slim hope but their only chance of survival. There she was, pushing herself out from her broken container. But the flyers' delight turned to dismay when she flopped into the oil-slick that was rapidly spreading around the aircraft. They knew what it meant if her feathers became covered in oil. She struggled to free herself from the water and its dangerous contamination, to get the lift necessary to take her into the air. To the crew's relief she made it; she lifted off awkwardly, circled the 'plane once, then gained height and was lost to view.

It was well into the afternoon and there were little more than one and a half hours of light left. The crew were 120 miles from safety, and the weather was deteriorating. Back at the base in Leuchars, radio contact had been poor and no positive fix had been possible, though it was known that the aircraft was down. An immediate air search was put into operation in the fading light, but the chances of finding anyone alive now appeared remote. It was like searching for a needle in a haystack. There was nothing to go on.

Shortly after dawn the next morning a speck appeared in the sky, flying lower, searching for its landing place. A totally exhausted, wet and oily pigeon had flown in to its loft, to the surprise of Sergeant Davidson of the RAF Pigeon Service. As he tended the bird, her physical state explained much to him. He could tell not only that she was from the lost aircraft but, by working out the time difference between the ditching and her arrival, taking into account wind direction and the oiling of her plumage which would affect her flying, he was actually able to log the route the pigeon had flown. It was not the area in which the search had taken place. On his recommendation another search was immediately despatched. Within 15 minutes the downed team had been found, their location radioed back and an air-sea rescue team sent on its way. It was the first occasion that a pigeon saved RAF personnel in the Second World War.

Some time later the crew, all of whom survived, gave a dinner in honour of their feathered friend and her trainers, Ross and Norrie of

Angus. But it dawned on them that up until then they had always referred to the spirited creature by her number, NEHU 40 NS1, or as the 'blue chequered' or just as 'the pigeon'. She had no name. This was something that had to be rectified immediately. In high spirits they sought an appropriate title. Some suggestions were humorous, others lacked that extra something; then the idea came. The pigeon herself seemed to be joining in the fun and winking at them. That was it—her name would be 'Winkie'. (In fact, it was not a wink she was giving, but an unusually slow reaction of the eyelid caused by the effects of extreme fatigue.)

Twenty-two months later, on 2 December, 1943, Winkie was awarded the prized Dickin Medal. The citation read: 'For delivering a message under exceptionally difficult conditions and so contributing to the rescue of an Air Crew while serving with the RAF in February

Winkie receives her Dickin Medal from Mrs Maria Dickin, founder of the PDSA. *Photo: courtesy the PDSA.*

1942.' Three months later, more than two years after the event, Winkie, in the presence of Wing Commander Raynor, received her medal from the hands of the founder of the PDSA and the Dickin Medal, Mrs Maria Dickin.

* * *

Pigeons have been used in combat since as long ago as 240 BC. Then, Hannibal sent them to gain intelligence in advance of his historic crossing of the Alps in record time—and without resistance—at the head of an army of 90,000 men, 12,000 of them on horseback, and an unknown number of elephants. They were used to great effect during the siege of Paris in 1870 and in the Boer War of 1899–1902; they forewarned the Western Allies of the first Zeppelin attack in the First World War and were key to communications and intelligence gathering when all other means of communication had broken down in that dreadful conflict, particularly during the battles of Verdun and the Somme. They flew for the army, navy and air force. In the Second World War they also flew highly classified missions for MI6, MI9 and SOE, the Special Operations Executive.

In all, some 200,000 young birds were given to the services as a contribution to the war effort in the United Kingdom. In the last three and a half years of the Second World War alone, 16,554 birds were sent for dropping and only 1,842 returned home to base—others were shot, or lost their way, or were eaten. They were used by the Americans, the Germans, the British and French, flying north, south, east and west in all climates and conditions, and often over very long distances. So before we look at the achievements of these remarkable and relatively unsung heroes, we should look at what makes them tick.

For those who know little or nothing of pigeons, learning about them is fascinating, complicated, educational and, in the end, humbling. To the uninitiated there are puzzling and strange words: 'squabs' 'squeakers', 'widowhood', 'gillipots', 'tossing', 'y.p.m's' and 'clocks'. There are at least nine varieties of pigeon in the UK, named after the colouring and formation of their plumage—dark chequered, the mealy, the grizzle, the white and red pied—and all are very special to their owners

and trainers. What quickly becomes apparent is that a successful pigeon is the result of a relationship with its trainer that is total: the best of them, the champions, are often owned by husband-and-wife teams. So much time, energy and dedication are put into breeding and training pigeons that nothing less than the full commitment of both husband and wife would permit the survival of a marriage. Much thought goes into the hygiene of the birds, their diet and how to assure a sheen on their feathers. Records are kept from day one on a bird's progress, its loft location, the latitude and longitudes and race points during training, the miles and yards covered, which are divided into 60ths to calculate velocity, its ring number, colour, sex and—as pigeons are one of the rare species to be monogamous—with whom it has been paired. Even the way they are held might mean the difference between a good flier and a mediocre one, as the bird responds to a feeling of security. Len Rush, keeper of the Queen's Flight of pigeons, describes it thus: 'Show it one hand and take it up with the other by bringing your open hand down on its back, then the thumb of that hand gently holds the wings while the bird's legs slip between your first and second fingers and its body is cupped nicely in your palm.'

The young, called squabs, do not leave the nest. They must wait until they are squeakers—when they are being weaned—to peer outside. Their flying is increased only gradually: first in short hops, then longer and longer distances, by which time the inducement, the incentive to return fast, and therefore be a winner, comes naturally. By now they would have been paired with another bird, and they know that they cannot be reunited with their partner until they have regained the loft where the widow or widower is anxiously waiting.

Just how the pigeon finds its loft has remained a mystery from Hannibal's time until today, despite several recent highly scientific tests. Many believe the answer lies in the magnetic field of the equator, and experiments on this theory have taken place in South America. In Europe, an Italian investigation concentrated on the pigeon's olfactory ability, which indeed is exceptional, and claimed to prove that the pigeon can smell its own loft while still miles and miles out over the sea. Specialists in Germany partly agree with this finding, but the Americans dismiss it. What, then, really makes the pigeon choose one

Pigeons being taken up to the German front line in special carriers. *Photo: courtesy The Racing Pigeon.*

house among a sea of rooftops in a built-up area? The answer remains an enigma and perhaps always will, eluding scientist and pigeon fancier alike. What is certain is that a pigeon attaches itself to its loft—not any loft but *its* loft—to its mate, and to its trainer. Those three facts give us the homing pigeon: one without the others will give nothing. These pigeons arrive home despite severe adverse weather conditions, injuries and all other problems they may find on the way, even when flying from a mobile loft often built on top of an old bus or truck which one would have thought utterly disorientating.

Of course, as we have seen from the sad statistics, not all pigeons survived being sent into enemy-occupied territory—far from it. Only nine per cent made it back in the Second World War. But the low rate of return had little to do with the pigeons' ability to home and everything to do with the nature of their missions, for most of them were surely killed or captured by the enemy. To those pigeon fanciers who contributed their cherished birds to help the war effort, it meant

giving up something precious to which they had dedicated their waking hours for many years and which, on a pecuniary level, represented a not insignificant amount of money. At the end of the day, it is truly extraordinary that so many pigeons managed to fulfil their wartime duties *and* return home. That they did so is a tribute to both the pigeons and their handlers. They richly deserve the distinction of receiving the largest number of animal VCs.

* * *

The siege of Paris in 1870 gave an indication of what could be achieved by the pigeon. It could, after all, go where no one else could get through and, in so doing, provide a communications link and intelligence network which would otherwise have been unobtainable. On 16 November, 1870, a notice was posted at the General Post Office in London. It said:

OPEN LETTERS FOR PARIS:
Transmission of by Carrier Pigeons

THE Director-General of the French Post Office has informed this Department that a special Despatch, by means of Carrier Pigeons, of correspondence addressed to Paris has been established at Tours, and that such Despatch may be made use of for brief letters, or notes, originating in the United Kingdom, and forwarded by post to Tours

Persons desirous of availing themselves of this mode of transmission must observe the following conditions:—

Every letter must be posted open, that is, without any cover or envelope and without any seal, and it must be registered

No letter must consist of more than twenty words, including the address and the signature of the sender, but the name of the addressee, the place of his abode, and the name of the sender—although composed of more than one word—will each be counted as one word only

No figures must be used, the number of the house of the addressee must be given in words

Combined words joined together by hyphens or apostrophes
will be counted according to the number of words making
up the combined word

The letters must be written entirely in French in clear, intelligible
language. They must relate solely to private affairs and
no political allusion or reference to the War will be permitted

The charge for these letters is five pence for every word, and
this charge must be prepaid, in addition to the postage of
sixpence for a single registered letter addressed to France

The Director-General of the French Post Office, in notifying
this arrangement, has stated that his office cannot guarantee the
safe delivery of this correspondence, and will not be in any way
responsible for it.

<div align="center">By Command of the Postmaster-General.</div>

GENERAL POST OFFICE.
16th November, 1870.

The response and use of the service was so phenomenal that, as
noted by the Osman family in their book *Pigeons in Two World Wars*,
'the messages were photographed very small in order that as many as
possible could be carried by the same pigeon. The photographs were
on little thin films of collodium and each film [held] 2,500 messages.'
Collodium dispatches no larger than illustrated here, could contain
up to 200 letters with 2,182 words. Its weight was just half a gram and
it must have been the smallest yet most expensive piece of mail of all
time, for it cost in those days a colossal 1,000 francs, or £40.

In the Boer War three decades later, pigeons rendered some equally
useful work by carrying despatches and plans out of Ladysmith. So
successful were they that an official decision was taken to erect lofts
and add to the pigeon staff. After the war, some of the pigeons, now

that their potential was known, were shipped to Nigeria to play a part in communication links between north and south.

In the First World War, pigeons were used for the first time by three armed forces, the army, navy and the newly developed Royal Air Force, successor to the Royal Flying Corps. They were used almost from day one of the conflict by the Germans, French and Italians, and from slightly later on by the British. The Americans started in earnest the following year. So successful was the service rendered by the birds—flying through shell and small-arms fire, explosions, chemical warfare attacks and all weathers—that hundreds of lofts were created and mobile units roamed the front lines. By the end of the war there were 22,000 active pigeons, 150 mobile lofts and at least 400 pigeoneers in the carrier-pigeon service, up from 60 handlers at its start. In the Battle of the Somme the French alone used 5,000 birds.

Two types of French pigeon carrier used in the First World War. *Photos: courtesy The Racing Pigeon.*

At Verdun, the pigeon brought back hundreds of messages of vital importance, such as that of 16 April, 1916, marked 06.25 hrs:

The German counter-attack has been repulsed by the Companies occupying the Hautville Trench and he has entrenched a little in front of his old front. Artillery barrage is necessary on AUC9x. The 1st Battalion of the 36th is in position a little N. of the Driant Trench. Serious losses, at least 50 per cent of the effectives. Reinforcements urgent.

Another read:

28 February. 14.40 hrs. 2 pigeons
Colonel 166 at Verdun
A strong enemy attack has outflanked Chaplon and is now directed on the Tresnes Montgirmont Eparges. Telephones cut by a strong bombardment. We are resisting. 334

It was similar on the Somme, where one message dated 25 September, 1916, read:

On this day, on the Somme front alone, over 400 operation messages came back from tanks and the attacking forces. Not a bad record for the pigeons and a good mark to the stout lads who had to take them up with them over barbed wire, trenches, and shell craters and so on into the Unknown.

In the air force, pigeons were frequently carried on board the aircraft as there was no other form of communication. In just two years on the British side there were just under 200 commendations for their achievements. One bird had completed 170 active-service patrols; others had delivered messages that their aircraft or seaplane was down and giving its location. They flew in thick fog, in violent winds and in snowstorms, and one arrived in its loft with a serious back wound.

Then there was the Intelligence Service. A notice pasted on walls throughout Belgium and France by the German occupation forces read:

The enemy is in the habit of dropping from aeroplanes little baskets containing homing pigeons, by means of which they desire to obtain information concerning this side of the line. The pigeons are placed in small baskets and marked 'Please Open'. Any person who finds one of these baskets must, without tampering with it, report to the nearest military authorities. All persons are forbidden to open baskets or any letters attached to them or to remove them from the place where they are found. Inhabitants disobeying these orders are liable to the severest punishment. If they attempt to escape they run the risk of being shot instantly. Any town in which one of these pigeons is secreted is liable to a fine of 10,000 to 100,000 francs.

Spy mania set in, with pigeons at its heart. The Germans attempted to catch and then infiltrate the Allied birds back into Allied lines with disinformation—and were to do so again in the Second World War—but they had clumsy and obvious techniques, and the effort came to nothing.

At Pave, towards the end of that war, 1,500 Italians, then part of the Allied force, were surrounded and in danger of attack from Austrians who were more than twice their number. Two pigeons were freed with a message for help giving details of the enemy's position. The pigeons arrived at their destination safely. As a result, not only was the threat to the Italians lifted but the whole Austrian force was taken prisoner. Carrier pigeon services were subsequently started in India, and the Middle and Far East. France awarded diplomas to birds deserving the *Croix de Guerre* or *Croix Militaire*. The last but one pigeon serving Commandant Raynal at Verdun was awarded the *Croix de Guerre*, and his last bird, badly mangled after flying through heavy shell fire and dropping dead as he delivered his message, was awarded the ultimate and highest of France's decorations for valour, the *Légion d'Honneur*.

The pigeon service had its own Victoria Cross, although it was awarded only sparingly. Pigeon No. 2709 is a case in point. Despatched with a message to HQ by forces fighting on the Menin Road, the hen was shot down shortly after leaving her loft. She lay

wounded in the rain throughout the night but rallied in the early morning and took off again with her message. She staggered to the floor of the receiving loft and died before the message could be removed from her leg.

German intelligence had long been anxious to eradicate the centre of Britain's pigeon service. Indeed, it was aware of the pigeon's espionage potential even before the war, and resorted to many ploys to get information. A German claiming to be a doctor visited many lofts in England, taking notes and asking whether the War Office was likely to be interested in the pigeons should there be war. Another German even started a loft in the property next to the pigeon service HQ in Doughty Street. His pigeons were all destroyed at the outbreak of war, and the German disappeared after his arrest. The carrier pigeon service did well and was soon, because of expanding requirements, obliged to obtain Nos. 17 and 18 Doughty Street as well. Perhaps this was the last straw for the Germans who, towards the end of the war, tried to bomb the complex. Their bomb dropped into another garden, however, doing little damage and affecting neither the HQ nor the birds.

By the Second World War, much had changed. Communications were sophisticated, aircraft had radio and the secret services had state-of-the-art means of contact. The manner of war was different too. If the first war was one of static trench fighting, where the horrendous human losses were almost totally military, in the second civilian casualties were extremely high; it was a war of movement, of intelligence creativity and sophisticated communications. There was still a role for the pigeon, however, not only with the armed uniformed services, but also with the warriors working in the shadows, the SOE and PWE, OSS, MI6 and MI9 (Escape Chain).

The late Colonel Osman, who created the National Pigeon Service used in both world wars, observed, 'The advent and improvement of wireless has been the means of doing away with the use of pigeons for many services, but for espionage, scout service work and many important duties, pigeons will never be replaced.'

The biggest problem for British Intelligence—especially for SOE, the Special Operations Executive—was that of efficient communi-

Mobile pigeon loft used during the Second World War. *Photo: courtesy The Racing Pigeon.*

cations whereby agents in the field in occupied territories could contact HQ in Britain, their Cairo base or elsewhere. Radio operators were worth their weight in gold. Likewise, the Gestapo was aware that if they cut the communications links by capturing as many radio operators (nicknamed 'pianists') as possible, it would be a major blow to the organisation and to resistance networks working against the occupying forces. In several areas in Belgium, Holland, Germany and France (where SOE was present) problems arose if a pianist was arrested. There would be a delay before another operator could be organised and sent out from England as replacement. During this period the whole of that operator's network, also called a *réseau* or circuit, was suddenly under threat. The Gestapo had refined the art of torture. Efforts were made to use an operator from another circuit while awaiting a new arrival, but the leader of the other circuit would be reluctant to permit this, for sound reason. No operator could transmit or receive for more than a short period—usually no more than 20 minutes. Working longer gave the enemy's radio-goniometric vans, roaming the

streets, time to home in. Loading up one operator with work for two circuits risked exposing both. This was a classic error for which Pierre Le Chêne, alias Grégoire, operator for the Buckmaster Nicholas (Spruce) circuit in Lyon, paid dearly. He was permitted to transmit for other circuits as well as his own and, in order to get the messages across, stayed too long at his post. Indeed, he was arrested at it. The fact that his minder, who was supposed to watch outside for any sign of trouble, ran when it came, without warning Grégoire, only compounded the problem.

Some of the SOE circuits, finding themselves in such a catch-22 situation, resorted to the use of carrier pigeons; a good example is the Farmer circuit, which operated in France in the St Omer, Arras and Lille industrialised area. The circuit was set up and developed by Michael Trotobas, code-named Sylvestre, in November 1942. His radio operator, A.A.G. Staggs, was described in the official history of SOE in France by the renowned authority M.R.D. Foot as 'unable to make effective contact with base'. A replacement operator was sought and in June of 1943 'Olivier' arrived. He was soon to disappoint Sylvestre, for Olivier turned out to be a sabotage instructor rather than a pianist. They did not hit it off and there was a personality clash. Olivier was resentful of the visible popularity and the degree of success enjoyed by the circuit leader, and resentful too of Trotobas' stringent security rules. When Olivier was picked up by the Gestapo, he talked, thinking that the address he gave them for Trotobas had already been vacated. It had not. The Gestapo went to the premises and Trotobas and a woman agent were shot. That was in fact rather unusual. Invariably, the Gestapo kept their captives for interrogation, but in this case one of the Gestapo agents had also been shot, which could have led to an uncontrolled shoot-out. Despite the blow to the circuit of the loss of their leader and the sense of betrayal that went with it, Farmer did not fold. The remainder of the network rallied and continued as before, and Farmer was still operational at the end of the war.

The problems faced by Trotobas did not deflect him from his objectives, however, and he had a busy time between November 1942 and November 1943, when he was killed. In February 1943 he led Farmer's

first derailment, when 40 rail trucks were destroyed and the Lens–Béthune line was closed for two days. That set the pattern, and for the rest of his time there were between 15 and 20 derailments a week. He organised air drops of weapons and explosives, and received a particularly important one in July. All of this depended on communications and the coordination of the receipt of supplies. He could not depend on Staggs' radio to obtain all that was necessary nor, after a brief period following the arrival of Olivier, could he rely on that operator either. He resorted to pigeons to ensure links with Britain and with base.

Trotobas' circuit had several pigeon link-ups, probably from lofts at RAF Gillingham and Haywards Heath. Surviving records show how they would have worked:

Blue Hen NJUHW.40.EG.62. On the 8th May 1943, this pigeon was supplied to an Intelligence Section and was subsequently dropped with an agent in France. Released at dawn on 16th May in the French interior, it delivered its message on the 18 May in spite of injuries received probably soon after liberation [flight]. This pigeon was subsequently sent on another similar mission but was killed when the aircraft was destroyed by enemy fire— Haywards Heath.

Red Cheq. Cock NURP.38EGU.125. On March 12 1943, this pigeon was dropped in enemy-occupied France during the early hours and returned on the same day with a message. In May 1943 this bird was lost on a similar mission, presumably by enemy action—Haywards Heath.

B.C.Hen.NPS42.42004. In the course of her service was released in France 210 miles from base at 14.00 hours on the 31 August 1944 with a message. The weather conditions were adverse, with low cloud and rain. The pigeon arrived at 14.25 hours the following day—Gillingham.

Thanks to the pigeon service, the Farmer circuit was able to continue, to inform, to request arms and explosives and to organise, despite the

problems on the ground. For lengthy periods the pigeon was its only link with HQ in Britain. A similar situation existed with the Donkeyman circuit, which commenced in July 1942 in the Eure region south of the River Seine. Many other circuits also used pigeons on a more infrequent basis, but one bird in particular, who played his role well with the SOE in the shadows, earned the Dickin Medal:

Red Cheq.Cock 'Commando', NURP.38.EGU 242. On three occasions, namely in June 1942, August 1942 and September 1942, was sent with agents into occupied France and on each occasion returned with valuable information on the day of release. The conditions under which this pigeon had to operate on two occasions were exceptionally adverse—Haywards Heath.

Pigeons were also used by the SIS (Secret Intelligence Service, or MI6) and its offshoot MI9, the Escape Service. We are able to distinguish between most of MI6's operations and those of SOE in several ways. For example, the pigeon NURP.36.JH.190, a dark chequered hen known as the Kenley Lass, could not have been sent out on an SOE mission, for at the time of the drop that would win her the Dickin Medal, SOE was not operational in France. Nor was MI9 then fully operational. Since we know she was used for the intelligence service it could mean only one: the SIS, or MI6 itself.

SIS had been impressed with the ageless efficiency of the pigeon messenger service and introduced the birds into the new service it created, MI9, whose role was to get SIS and SOE agents out of occupied territory and back to Britain. Once underway, MI9 was extended to take care of the organisation of the escape chains that were to criss-cross Europe for downed Allied airmen and escapees from prisoner-of-war camps. The Kenley Lass's citation reads:

This pigeon was the first to be used for secret communication from enemy-occupied France. Her first task was one of particular difficulty technically as it involved not only a parachute jump with the agent using her, but the agent had to make a journey of nine miles on foot at night across country with the pigeon concealed

on his person; also the pigeon had to be detained for eleven days in concealment in a house before the information she was to carry had been obtained. This detention had been anticipated and the agent, who had no previous experience of pigeons, had been fully instructed. Eventually released at 08.20 hrs on 20th October 1940, this pigeon arrived at Kenley at 15.00 hours the same day, having covered a distance of well over three hundred miles with most valuable information. On the 16 February 1941 she was sent again on an exactly similar task, except that the length of detention was only four days and again homed in excellent time on the day of release with further information.

Another record tells us that: 'Before dawn on the 31 May 1942, this pigeon was released in darkness in the French interior eight days after its issue for the task. Arrived with most valuable information on the same day, inspiring a special letter of appreciation from the Intelligence Service—NMUHW.38.EGU 139—loft in Haywards Heath.'

PWE (Psychological Warfare Executive) was an offshoot of SOE which in turn was an offshoot of the secret intelligence services operational in occupied territory during the Second World War. PWE's aims and objectives were to deceive German authorities in radio and newspaper stories and to sow general disinformation. Whilst my husband Pierre was in SOE in Lyon as radio operator for the Nicholas Buckmaster network, his brother Henri headed up *Réseau Plane* in the Dordogne, a PWE operation. It had spectacular success in that it needled the occupation forces and gave comfort to the anti-German inhabitants. It also had the value of making the German and pro-German Vichy governments spend a lot of their time, effort and money in trying to track down what was, after all, a kind of modern-day Pimpernel operation.

Until now no material could be published on this aspect as it fell within the Official Secrets Act with an embargo of 50 or even 100 years. I am delighted, therefore, to have been permitted access to a document that was under the 50-year rule and has never before been released for information and publication. It permits us to see, for the first time, Operation Periwig, the code name for the use of pigeons

with PWE agents. No year is specified on the document, but it is unlikely to have been written before 1942. It states:

A number of carrier pigeon operations were flown in connection with PWE broadcasts, whose object was to deceive the German authorities and the German people into believing that pigeons were being successfully used by the Allies to obtain information from Germany.

The birds were placed in special containers with parachutes attached, together with message forms, small message containers for the leg, pencils, food, and instructions in German to finders encouraging them (by a reward system) to send back information by this means, and illustrating the method of fixing the messages and launching the birds.

The first consignment of 100 pigeons was received from no 3 Field Force Pigeon Service at Eindhoven on 15 March. Birds from the continent were used, as it was then thought best not to make the homing distance too great. This later proved to be unnecessary. The birds were housed in lofts at RAF Station Tempsford, and it was hoped to drop a number of birds on operations each night.

Owing to weather conditions, however, no birds were dropped until the night of 4–5 April when 20 pigeons were dropped in conjunction with operation Curland (German Directorate), in spite of the fact that the birds were by then getting stale.

It had also been decided to drop 'dud' pigeons, i.e. pigeons which would not home, with faked messages attached to their legs, in the hope that the birds would find their way into German army lofts, and give the impression that German disaffected elements were actually making use of the birds. The faked messages were provided by PWE and as 'dud' pigeons had not yet been procurable, six stale birds with attached messages provided by PWE were dropped from a weighted release sack on the same night, 4th April.

The Army Pigeon Service, Wing House, Piccadilly, which had already provided the actual equipment, i.e. parachutes, con-

157

tainers, etc., and experienced men to look after the birds at Tempsford, now offered to co-operate futher by providing birds. An arrangement was made by which fresh pigeons were supplied at the rate of 150 per week, and any stale birds returned.

As a result of curtailment of operations owing to the general situation in Germany, the possibility of frequent dropping from Tempsford, or the 38 Group aerodromes, became much less, and it was arranged through PWE that No 406 Leaflet Squadron at Harrington (Pinetree) which flew every night over Germany, weather permitting, would undertake to drop the birds. This system worked very well and between the nights of 11–12 April and 26–27 April, a total of 304 pigeons was dropped over a wide area.

The only difficulty encountered was in the dropping of the 'dud' pigeons which had also been provided by Wing House. The release sack was heavily weighted with sand to ensure opening and the aircraft used by Pinetree had no static line equipment and were not adapted to dropping them. A paper bag which would protect the bird long enough to let it drop free of the slipstream was developed and was on the point of being tried out by the Squadron when operations came to an end.

Of the total of 330 birds dropped during the month of April, nine birds homed to the UK and two were picked up in France. Five of the pigeons brought back messages written by Germans, but there was no information of value in them. There were reactions in the neutral press.

Pigeons played a vital role in one of the most difficult areas of intelligence and resistance operations one can imagine: inside Germany itself, where the birds risked being shot from the sky just for being there. There are many interesting details of their involvement:

Blue cock.NURP41.WMK64. This pigeon was dropped in Germany on special service during the night of 14/15 April 1945 and homed with a message at 21.30 hrs of the 2 May 1945—West Malling, Kent.

NURP.44.W.4891. This pigeon was dropped in Germany on special service on the night of the 13/14 April 1945 and home at 11.00 hours on 20 April 1945—Ipswich.

NPS.42.40624. Was dropped in Germany on a special mission during the night of 25/6 April 1945 more than 300 miles distant from home base and homed at 13.00 hrs on the 28 April—Thorney Island.

And:

Mealy Cock.NPS.43.21940. After 2 years consistently good work, including one service flight of 250 miles in 5 and a half hours, was dropped by parachute on special service in Germany in 1945 more than 300 miles from base and homed successfully after several days' detention in a small container—Gillingham, Kent.

From the Gillingham lofts also flew perhaps the most reliable flier over a period of five years. Called 'Neilson', dark chequered pied cock No. 385 had repeatedly flown distances of between 300 and 500 miles. In 1945 he was selected for a very hazardous job. He was dropped by parachute in the Ruhr pocket more than 300 miles distant, and after several days' detention homed successfully, one of the earliest arrivals.

Pigeons flew for the SAS when they were in Loyton, France, on 7 June, 1944, and took part in the well-known tragedy of Arnhem, where yet another Dickin Medal was won:

Mealy Cock 'William of Orange'. During training flew 68 miles in 58 minutes. On service with airborne troops at Arnhem; was liberated at 10.30 hours on 19 September 1944, returned to loft in 4 hours 25 minutes, distance 260 miles of which 135 miles was over open sea—Knutsford.

The blue chequered cock Maquis, meanwhile, flew for combined operations:

April, 1943. Returned with operational message to England in

159

four days. May 1943, returned from Amiens with operational message. February 1944, returned from France with operational message a month later—Bedford.

The pigeons' skills were put to the test round the clock during the Normandy landings. One example will indicate the pressure under which they flew:

B.C.Hen. NURP.43CC.2418. Was the only one to home from British airborne troops or paratroops in Normandy operation within 24 hours. The weather was extremely adverse and the birds were detained six days in small containers. Released with message at 08.37 hours on 7th June, arrived at 06.41 on the 8th June (23 hours 4 minutes including darkness). This pigeon was subsequently lost on a further flight from France—Thorney Island.

Cologne, Dickin Medal winner and survivor of more than 100 sorties. *Photo: courtesy The Racing Pigeon.*

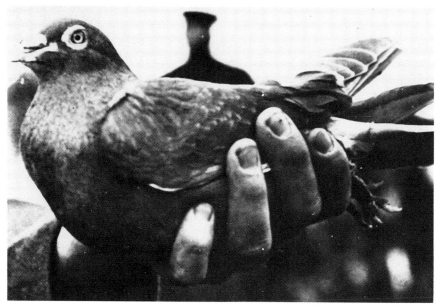

During the Normandy landings the United States used hundreds of pigeons which were recruited from the UK. But above all, pigeons were in constant use by the army, navy and air force. One pigeon received a mention because it had survived more than 100 operational bomber sorties. The citation reads: 'In the course of this service, he homed successfully from diverted or forced-landed aircraft on two occasions from 200 miles and on two other occasions from approximately 250 miles in various directions. On 22 March 1943, its aircraft force-landed 360 miles from base and the crew released him at 08.30 hrs in unfavourable weather and he homed in 8 hours 5 minutes—Bottesford.' Another was the first to deliver a message from a ditched aircrew in their dinghy. They were 115 miles from base and the message was delivered in just under three hours on 17 August, 1941. Another bird that also flew more than 100 sorties was at last thought to be lost over Cologne during a bombing raid in 1943, but almost three weeks later staggered into its loft in Nottingham. Its breastbone had been broken and its flight feathers were mangled, but it had still flown hundreds of miles to get home.

But if speed and accuracy were important—and they were—no less was the range of flight. The pigeon is extraordinarily strong and its wings and muscles are robust, but it is, after all, a small creature with a small, if great, heart—it has its limits. These were pushed to their utmost in war conditions. Perhaps the longest recorded flight was that of a red chequered hen known as Per Ardua which covered 1,090 miles in only 12 days—her nearest rival taking six weeks to fly the same distance—and in so doing set up a new British and, at that time, world record.

It was fitting, therefore, that a pigeon, capable of flying at a speed of 1,843 yards per minute was chosen to deliver the 'Wings for Victory' message from the chancellor of the exchequer in London to the mayor of Plymouth. By the end of the war, the pigeons had earned their primary role in military history.

10

STUBBY AND FLEABITE

The clerk at the reception desk of the smart New York hotel could not believe his eyes. Here he was, superintending the arrival of a stream of top brass who had been invited to attend a gathering of ex-servicemen, and what should he see coming through the door into the foyer but a rather old and scarred bull terrier. The dog wore a little leather coat embroidered and decorated with medals, and another medal hung proudly from his collar. With him was a man wearing campaign medals of the First World War.

Outraged, the clerk bustled officiously round the desk and accosted the ex-soldier with his offending intruder.

'You can't bring that dog in here,' he rapped, barring the way. 'Don't you know dogs are not allowed on these premises?'

'A dog?' Private Conroy retorted. 'This is no dog. This is a war hero.'

In the entire history of the United States—or indeed the world— no animal has received more awards and acknowledgements for bravery in battle than Stubby, unofficial mascot of the 26th 'Yankee' Division and stalwart of the trenches in the Second Battle of the Marne. Stubby distinguished himself not only by his endurance, his courage under fire and his devotion to his master, but by his uncanny ability to sense the approach of a shell or the imminent threat of mustard gas. He was famous throughout the regiment, a treasured and honoured member of the American Expeditionary Forces, whose memory was revered for years after his death in 1926.

* * *

To the Americans in the opening years of the twentieth century, life was good and free from the squabbles and wars that seemed to be

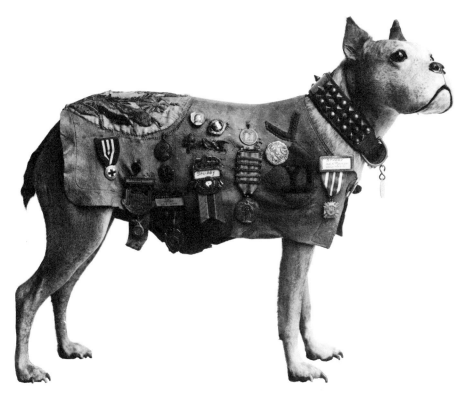

Stubby, the most honoured dog in history, famous for his devotion and his bravery in the trenches, wearing the embroidered leather coat made for him by the women of Domrémy in France. *Photo courtesy the Smithsonian Institution, Washington DC.*

afflicting countries in the rest of the world. Indeed, thousands of refugees from these disturbances were flooding into the United States, hoping for a better future. To varying degrees Americans knew of the Russo-Japanese war of 1904, the Bosnian crisis of four years later and the outbreak of open warfare in the Balkans in 1913—precursor of the First World War. For their own part, from the turn of the cen-

tury the nearest they came to problems of a strategic and security nature were skirmishes in Cuba and Central America. When the Balkan crisis became war in 1914, the American people in general found its reasoning difficult to understand and, in many instances, even the names of the towns and cities that started to appear in news communiqués were difficult to pronounce (a problem that was not to be exclusively theirs).

It was difficult to relate to a place so far off, for most of the growing native-born American population had not ventured outside the vast lands of the union. Even the immigrants, in a flow that had not diminished in numbers over a hundred-year period, tended to know only the land from which they came. Yet there was a significant group of individuals who nonetheless did know about Europe, were concerned at developments, did relate to it, and who read the signs correctly. As early as 1914, when even European nations on both sides of the conflict had not fully realised the long-term impact of what was about to happen, Americans volunteered for service in action in Europe. The problem often was that the volunteers, being US citizens, had no regiment or service to which they could be attached. The only alternative was to join the French Foreign Legion or, if some ancestral links could be drawn upon, to engage in a well-known regiment with a strong family background. They did both. Indeed, the French Foreign Legion's records are remarkable for that period and show an upsurge in arrival of US citizens whose names, by tradition in that illustrious regiment, were changed for the duration of their service.

As a result of this volunteer force's dedication, by the time the United States entered the conflict in 1917—at which time the war became global—many of its nationals had already become household names for the exceptional valour of their deeds and through them the battles in Europe were becoming well known across America. Within a few months of the outbreak of war, there was a rise in volunteers into the American armed forces, into the army, navy and the nascent new arm of combat, aviation. This trend continued throughout 1914 to 1916. One of the recruits into the infantry at that time was Private J. Robert Conroy.

Out on the town in the evenings when basic training permitted,

Private Conroy noticed a dog—a bull terrier with a nubbed, or docked, tail. It seemed to be hungry and responded eagerly to being noticed. In the end Private Conroy found himself looking for the dog when he left camp, but the dog also knew where the soldier was.

One day, on leaving camp and making for the local town, Conroy found the animal just outside the perimeter gates, waiting. Conroy no longer hesitated: despite the obvious difficulties he would have to face, he would adopt him. With a tail like his, the dog could have but one name: Stubby. Conroy infiltrated Stubby into the garrison, into his barracks, and made him a bed under the bunk.

That was the first step of a remarkable adventure for the dog and an equally remarkable relationship between Stubby, his master Private J. Robert Conroy and the entire regiment. It was to have historic repercussions.

There was a tense moment when authority, in the form of the sergeant, discovered the animal that had been added to the regimental strength. Had it not been for the fact that Stubby had already ingratiated himself into the esteem of everyone in the block, there might well have been no story to tell. But it was so evident to the sergeant that the animal was a part of the military and bolstered the morale of those around him, that he turned a blind eye to his presence. Nor were there any objections when Stubby accompanied Conroy on combat training where he was exposed to dummy and live ammunition explosions and the hazards of crawling beneath sharp entanglements.

Surprisingly, Stubby did not falter when the noises, at a deafening crescendo, were close to him, or when the ground was churned up in his path by exploding shells. He stayed close to Conroy as the soldier pushed his way forward on his stomach, his head down, his rifle cradled across his arms. Stubby's reactions became quicker and quicker. His head would drop low to the ground and he would freeze into a prone position even before a shell landed, almost as if his acutely sensitive ears had heard the distinctive high-pitched whine of the incoming shell before anyone else had. He was an endless source of amusement, too, to the rest of the recruits as he developed the trick of putting his paws over his ears just before an explosion occurred.

Conroy and Stubby had been partners for almost a year when a

presidential decree was signed for general mobilisation in May 1917. From October of that year, American Expeditionary Forces began to enter the battle on the Western Front and by March 1918 a quarter of a million US soldiers were being sent overseas every month. According to one authoritative account, the arrival of the Americans, most of whom had never participated in battle before and were fresh and assertive (and had an awesome amount of equipment with them), was like a breath of fresh air. When one marine sergeant was told by a French officer to retreat, his answer was 'Hell no! We just got here.' There is no record of how Stubby fared during the sea voyage when he sailed with Conroy and the 26th 'Yankee' Division in one of the first convoys, but it could not have been a very comfortable trip. Nor do we know whether the ship, one of many, berthed in the United Kingdom before trans-shipment to the battlefields, as so often occurred, or whether it docked directly in France.

By the time Stubby and Co arrived, in October 1917, the war had already been raging for more than three years and had still one more year to run. Yet there was no sign of let-up, not a glimmer that the end was in sight, nor who would be the victor, who the vanquished. Throughout that time several million lives had been expended battling for a few yards of terrain, only for it to be lost and retaken at even higher cost, again and again. Chemical weapons saw their modern debut, the battle of Gallipoli had been launched in hope and ended in tragic defeat for the Allies, aircraft had developed into a crude form of fighter bomber and tank warfare had become a key tactical weapon. Names that would become famous in a war that could not possibly have been envisaged then—the Second World War—were rising through the ranks: George Patton, Douglas McArthur (in command of the regiment in which Conroy and Stubby were to be found), Charles de Gaulle . . .

The Russians had had their revolution and were out of the war altogether, conquered by German forces while their internal divisions made them vulnerable. Even when the war had barely another six months to play out—although that was not foreseen at the time— nothing was sure and German forces were once again within thirty-five miles of the French capital.

The battlefields had become like a scene from a moonscape, pock-holed, barren, the subsoil churned up and over several times from the blasting of repeated artillery shelling, the trees uprooted as if they had never been there. Military-trained dogs sped through the lines laying telephone cables, passing messages, hauling ammunition supplies to the front and guarding installations. Pigeons flew through gas attack clouds, mules hauled the injured and the hale alike with stoicism, and horses endured . . . Right to the end it was anyone's victory and fiercely engaged. To top it all, in 1917 and well into 1918, a new enemy afflicted both sides alike and the civilian populations on its route: Spanish influenza. The epidemic killed 60,000 Americans alone, almost half their total dead.

* * *

For the Americans, the shock of the battle must have been consider-able, of a depressing savagery they had not known since the Civil War. Conroy's division, led by McArthur, arrived just as the autumnal rains began and the wind sharpened to chill the bone. They marched up the line to the front in long columns, passing close to countless field hospitals—a salutary reminder of what war was all about. There were periods of interminable waiting, of rubbing cold and stiff hands over braziers and brewing hot drinks, before the order came to move up again and dig in. Stubby remained agile and warm by being kept on the run, scurrying after any object that had been lobbed for him.

The problems really began when they dug in at the front line at Champagne-Marne. The winter of 1917–18 was particularly bitter and there were periods when nothing could move. Horses strained at pull-ing the loads from deeply rutted bog-like ground or from the frozen snow, and the troops in their trenches, six to eight feet wide, suffered greatly. They no longer felt their toes and their fingers were difficult to move. The constant thud of artillery shelling froze the reflexes and often a trench was overcome with silence, each man locked in his thoughts. For Stubby the trenches must have been a nightmare and one wonders how he coped with the clogged duck-boards and the

coldness that descended at night. Worse was to come when, dug in at Champagne in the Marne, the snow and ice began to melt. As far as the eye could see the land became one vast quagmire, the water that trickled down into the trenches increasing the misery already there, only to refreeze during the night. Did Conroy construct a form of hide-out for Stubby to protect him from the elements? One can only believe so for there is no record of the dog ever having been other than hale and hearty.

The change in weather was just what the Germans and their allies had been waiting for to launch a massive offensive against the British, French, Canadian and American forces facing them. In March it began and every inch was fought for, lost and regained. By May German forces were close to Paris and for a moment they must have felt that, despite the new blood from the United States, victory could be theirs. The Allies rallied, however, and what was known as the Second Battle of the Marne commenced. Everything was used in this, including chemical weapons. The two sides were locked, rocking along rigid lines that stemmed from the Belgian-French border on the Channel to Luxembourg and the German border. At Château Thierry in June, the Americans had the first of their many pitched battles and it was now that Stubby commenced his own personal role in support of his master.

The units were advancing over open, shell-cratered ground. Enemy artillery was intensive. Suddenly Stubby hurled himself to the ground and lay as flat to the earth as he could. His front paws came up over his ears. His tail lay straight and still behind him. Conroy looked at the dog and for an instant wondered if he had been hit: it could only have been a few seconds before suddenly an earsplitting explosion occurred close by, which threw him to the ground, stunning him. Stubby had known the shell was coming and that it would be close to them. From that moment on the troops tried to keep close to Stubby or at least to keep him in sight. He was an advance warning system, *their* advance warning system.

Stubby also knew how to distinguish friend from foe. On one occasion the troops in the trench were roused in the early hours of the morning by a fearful howling. Within a few feet of the top of the

trench lay a German soldier, his face ashen. Stubby was standing over him, his teeth sunk deeply into the man's backside: he stayed that way until the troops took charge of their unexpected prisoner.

There was another, less visible and far more lethal foe, that crept stealthily along the trenches and took its victims by surprise. Few could distinguish between the low, rolling clouds of early morning mist and the low, rolling banks of an advancing toxic chemical cloud—until the vapour reached the trenches, by which time it was often too late. When the gas struck it stung the soldiers' eyes, had them clawing at their chests and throats. They tried to cover their faces and eyes with their hands, for if it was mustard gas, any unprotected part of the body was affected as it burnt its way into skin and flesh, provoking huge blisters and burning the lungs as it was breathed in. There was phosgene and chlorine and a variant known as Yperite. Often the wind would suddenly change and the toxic clouds would veer and roll back over the lines of the forces that had released the deadly gases. At first there were no gas masks—they were only conceived in the crudest form, including versions made for animals, after chemical warfare began to be used at the end of the first year of the war. If a soldier was slow in putting on his mask the consequences were inescapable, and long lines of men, with their heads and eyes bandaged, could be seen marching, hand on the shoulder of the man in front, to casualty centres.

Stubby developed a good sense of detection of this silent foe, too. His nose would suddenly rise high as he pushed his head up and back as far as it would go, then he would let out a yelp, begin barking animatedly and run round Conroy as fast as he could. He would then bury his snout beneath stores or clothing or whatever could be found near him, his backside the only part visible. At first no one realised what Stubby was doing. They never doubted him after the first occasion, and if he began barking and dived for cover they would pull on their masks as one man. He was always in advance of the usual call, 'Gas!' that was shouted down the line.

On just one occasion, however, Stubby was not so lucky. A gas shell broke open as it landed close by while they were advancing in open ground. The toxic chemical was on top of Stubby before he could

169

Collie fitted with gas mask and anti-gas goggles. *Photo: Imperial War Museum.*

move far enough away from it and he was stricken. Conroy rushed back to the trenches with the dog cradled in his arms and the 'medic' was called. For several days Stubby lay almost without moving and was tended as lovingly as any soldier on the battlefield. His eyes had suffered greatly and were stuck together by oozing matter. With gentle hands, his eyes were bathed by a team of doting soldiers taking it in turns to be with him. He did not bark or even whimper, but lay inert and was occasionally sick. After almost a week he showed signs of being able to see and of having an interest in what was going on around him. Then, from a little wag of the dog's tail, Conroy knew that his beloved Stubby would make it and survive.

While he was ill Stubby had several times been carried into the casualty centre where teams of surgeons were bandaging minor injuries and operating round the clock on the more seriously wounded. At no time was the dog's presence there resented. Heads would turn, hands

would go up to give the sick animal a stroke; words of encouragement were spoken. As well as being a precious advance warning system, Stubby became a great morale booster. Even when he was as fully recovered from the gas as he would ever be and was once more prancing around, he was permitted free access to the hospital centre. The patients looked out for him and saved tit-bits to offer him as he passed.

By now the dog was famous, known by name to the lowliest of soldiers and the highest of leaders. He continued his warnings through the big counter-attack that would turn the tide in the war: at Château Thierry in June 1918, at the battle of the Aisne-Marne and, in September, at the key battle of St Mihiel, south-east of Verdun. There, combined forces of the Americans, French colonials and—for the first time in history—a massive 1,000 aircraft destroyed the German salient, and after that there was to be no more reconquest of lost territory by the enemy. In November 1918, when Germany surrendered and the Armistice was signed in a railway carriage installed for the purpose in the woods of Compiègne, near Beauvais, American forces were entrenched at the confluence of the Meuse and Argonne.

It was at the final stand that Conroy received a head wound—a fairly serious one. Stubby remained with him throughout the whole long process of primary and follow-up care. In fact he became a fixture of the centre, and when the stretcher bearers returned from the field with the wounded, Stubby would sidle up to the injured men, even cuddle against them. His long, rough, pink tongue, licking their faces or their hands and arms, was often the first thing they remembered on regaining consciousness.

Conroy's injury required more than the treatment available in the field casualty centre. He was therefore assigned to a transport to be sent to the American Hospital in Paris. For a brief moment it seemed doubtful whether Stubby could go too—what was acceptable on the field of battle was not necessarily in line with the rules and regulations behind the lines. Stubby clearly realised what was being discussed and made such a fuss that no one could deny him: he left for Paris in a bone-shaking ambulance along with his master.

As the war drew to a close and Conroy's injuries slowly mended, the pair were able to get out into the local community, among whom

Stubby's renown had already spread. In the little town of Domrémy—
the birthplace of Joan of Arc—the womenfolk had not only heard of
Stubby but were determined to do something to honour him. They
presented him with a hand-sewn leather coat decorated with emblems
of the Allied nations, and awarded him a hero's medal, too.

More honours were in store for Stubby, and a life of fame. When
he returned to the United States with Conroy, he was presented to
President Woodrow Wilson and, in a ceremony held shortly after-
wards, was awarded a medal by General Pershing who had been Com-
mander in Chief of American Forces in Europe. He returned twice
more to the White House: in 1921 when he was presented to President
Warren Harding, and three years later, in 1924, when he met President
Calvin Coolidge. Eventually he was made an honorary member of the
American Legion, the Red Cross and the YMCA, his membership
card for which stated that he was entitled to 'three bones a day and a
place to sleep'. Stubby probably still holds the record for the number
of honours bestowed on an animal in recognition of its courageous
service.

* * *

More than twenty years after Stubby's heroics on the battlefields of
Flanders, another dog was to make his mark with the American troops.
Sergeant Fleabite was a Pomeranian who earned his name in two
distinct steps. As plain Fleabite he walked into a recruitment centre
in the United States with his master, and enlisted. Just how he was so
easily accepted into the military is not recorded, but he was equally
easily accepted in barracks and on board ship as troop reinforcements
embarked for England and the assault on Europe. Nor is it recorded
how the dog managed to evade the stringent British laws on quaran-
tine, but he did.

Fleabite does not appear to have been any the worse for his long
sea trip or the trauma of arrival in a strange land, and he was shortly
to be seen with the soldiers undergoing intensive training with live
ammunition. An air of expectancy was about and everyone knew that
shortly the balloon would be going up. Fleabite raced ahead as the
troops wove their way across the obstacles during manoeuvres, diving

into slit trenches and barking just as shells arrived overhead. In fact he responded so well to training that he was awarded his stripes—three of them. Fleabite was now Sergeant Fleabite.

As June 1944 approached, all men were confined to barracks. They knew they were about to leave for the 'big event', as it was called, but did not know the exact location. It was a nervy time. Stores and equipment were amassed in a seemingly never-ending stream but the June weather, normally so pleasant, warm and calm, was bad. There was rain and high winds, and clouds obscured the horizon. Air cover for any invasion was doubtful and the wind whipped up the sea in the Channel that had to be crossed.

At last the order was given. Operation Overlord, which they had awaited so long, was upon them. Now that the decision to move had been irrevocably taken, the plans sped forward. German batteries on the French coast were bombarded by 640 naval guns while 2,300 Liberators and Flying Fortresses of Allied airforces pounded more than a hundred enemy strongpoints along the beaches. There were five landing points in Normandy that had to be secured: by the United States at Utah Beach Head (St Marie du Mont and St Lo) and at Omaha Beach Head (Point du Hac), by the British at Gold Beach Head (St Laurent) and Sword (Ouistreham), with the Canadians between the two British strikes at Juno Beach Head (Arromanches). As the armada of shipping closed with the French coast, among the first to land were 10,000 sappers, officers and men, with 2,800 tons of minesweeping apparatus to clear the dunes of deadly explosives. Following them in unending waves came the landing craft. At the head of one of these, as the landing ramp yawned open when the craft hit the shore, was Sergeant Fleabite.

Of all the landing sites, the American sectors were the most difficult upon which to establish a foothold. As soon as the landing craft hit the beach and men spilled forth, dragging their equipment behind them, all hell was let loose. The sand dunes were raked with murderous machine gun fire, mortar and artillery shelling, and many mines had not been raised in time. Sergeant Fleabite's ears were erect, listening, distinguishing between near and far shells as he sped from fox-hole to fox-hole. His master and those close enough to see what had happened

Beach-head on the Normandy coast on D-Day, 6 June, 1944, as Allied troops secured a toehold on the continent. *Photo: Imperial War Museum.*

followed suit and dived in, just in time. A few seconds later shells burst where they would otherwise have been advancing. They pressed forward over the barbed-wire entanglements and two, then three times more dived for safety as Fleabite had dictated.

By this time the dog had quite a retinue keeping an eye on his movements. They advanced again over the terrain towards a rocky promontory and dug in, but Fleabite would have none of it. With anguished yelping he sped up and over the newly dug fox-hole and

charged off into the distance. Without questioning, everyone in the fox-hole did likewise. Within seconds of vacating it an 88 mm shell burst directly on the spot. Fleabite's master did not escape this time and was badly wounded. Fleabite abandoned his battlefield watch to remain with him and was taken with him to the casualty centre. His master's injuries were too severe to be cared for in the field centre, and after basic attention he was transferred to a hospital ship bound for England. This time the army medical corps was adamant: the dog could not go. Fleabite was shooed away but stood his ground, looking forlornly after them.

As luck would have it Field Marshal Montgomery was in the area co-ordinating strategy and heard of the dog who had saved so many lives. He was well known as an animal lover and could not let pass the opportunity of meeting this courageous dog. It was feared that by the time the Field Marshal arrived at the water's side the dog would no longer be there, but as the jeep carrying Montgomery drew up, there was Fleabite, sitting just as he had been two hours before. Montgomery himself gave the order for Fleabite to accompany his master on board ship. More than that, he ordered that the animal was to stay with his master at the hospital in England, too . . .

Like Stubby, Sergeant Fleabite had earned a place in history for his bravery and acute senses. He received no medals, but he is remembered with affection and gratitude by the men who owe him their lives.

11

R I F L E M A N K H A N

Brothers and Sisters, I bid you beware,
Of giving your heart to a dog to tear
<div align="right">(Kipling)</div>

It was a day for which many had long waited. Two years after the end
of the Second World War the whole of Lanark in Scotland turned out
to line the streets as their very own regiment passed before them. It
was no ordinary parade. The regiment—put together in just one day
by Covenanters in 1689—was the proud Scottish Rifles, renamed the
Cameronians. They had taken part in every theatre of battle except
North Africa, and were now to be awarded the freedom of the city.

At the head of the column of men strode Corporal Muldoon. At
his side, head held high, ears erect and eyes bright, trotted Muldoon's
dog, Rifleman Khan. An Alsatian, Rifleman Khan wore the medallion
and ribbon of the Dickin Medal, which he had earned at the Battle
of Walcheren two and a half years earlier, when he saved his master
from drowning while under intensive enemy fire.

When one thinks of the sensitivity of a dog's hearing and the ear-
splitting noise that is part of any major battle, how is it that he can
distinguish his master's call for help above all else? Yet, just as dogs
have proved capable of distinguishing one aircraft engine from another
even of the same type, or one car's engine from all others, so Rifleman
Khan recognised his master's voice above the din and knew he was in
trouble. He was able to pinpoint where he was in the darkness, in the
water crowded with other soldiers struggling to get ashore. He alone
worked out what to do and decided to do it—not to run, as would be
the instinct of any animal, not to bark and run up and down the shore,
but to plough back into those dark waters upon which all hell had

been let loose and to reach his master. Taking that decision was the most remarkable and touching act of them all.

* * *

D-Day was a landmark in the Second World War and in history. The organisation and execution of Operation Overlord was a masterpiece of coordination and an awesome achievement. Yet without securing the gains made, it could have counted for nothing. By far the most immediate task was taking the ports of Boulogne, Calais and Antwerp: as long as they remained in enemy hands the landings would be under threat, and the push on through France, Belgium and Holland to Germany would be prejudiced. None would be easy objectives. For the same reasons the Allies needed to take the ports, the German defenders needed to retain them. It would be a mighty tussle.

One of the most difficult targets was Antwerp, the gateway to Brussels, Belgium's capital, not far from the Dutch border. It was immediately clear that no move against Antwerp would be possible unless and until the defenders, the German 15th Division, were cleared from the polders (low-lying lands reclaimed from the sea), especially those on the north bank of Antwerp's canal in Dutch territory, Walcheren. Walcheren itself held two highly strategic sites, the port of Flushing with its historic associations and causeway to the mainland, and Bergen-op-Zoom and the direct route south to Antwerp (*see map*). But the enemy were well entrenched in the polders on both Belgian and Dutch sides of the canal. The range of Dutch fortifications and dykes were legendary for their strength and ability to keep out the seas. In Westkapelle on Walcheren Island, for example, the fortifications dated back to the 15th century and some were up to 30 feet high and 300 feet wide.

Two issues dictated the outcome of the battle: the decision from supreme Allied HQ to take the polders, and the actions of the enemy to counter or frustrate them. The Allied plans centred on a three-pronged assault. First the German 15th Division had to be dislodged from the so-called 'Breskens pocket' on the south bank; second, they were to be pushed out from South Beveland and finally excluded from the island of Walcheren on the north bank. An artificial causeway

Walcheren island, key to the ports of Flushing, Bergen-op-Zoom and Antwerp.

linked all three sites. These plans presented intractable military and political problems. One was whether or not to bomb the dykes in the polders and flood the low-lying land. Such a strategy would have the advantage of forcing the defending army out from its strongholds and shore batteries onto higher ground where, it was thought, they could be tackled by a paratroop air assault. This was rejected as unfeasible by the supreme commander, General Eisenhower, as there was no hard ground in the region from which to supply support troops. Another consideration was the effect of the flooding on the local Dutch population, for it would mean wiping out their farmlands and orchards. There was the question, too, of whether the dykes could be breached at all by low level bombing, especially as many of them were ancient and had withstood all that time could throw at them.

The second factor in the battle, the German defenders' own plans, made many of the Allies' problems academic for they had been think-

ing and planning along the same lines. In an effort to frustrate the Allies' moves, a 'Führer Order', written in a letter dated 7 September, 1944 to the OKW or *Oberkommando der Wehrmacht*, the army high command, and transmitted verbally to Army Group B, ordered that the 'Fifteenth Army is to ensure that everything is done to put Northern Belgium under water by blowing the locks and dykes, as soon as the bulk of our forces have been withdrawn behind the sector to be flooded'. This was largely accomplished, but despite the expert demolition of the German engineers, the Allies still decided that a bombardment was necessary to eliminate what remained and to ensure total flooding.

Engineers had been studying the problem and doubted that bombing the dykes would have the hoped for result, as the fortifications were strong and had resisted so much. Nevertheless the Allies decided to go ahead and reduce the dykes and fortifications to rubble. The first attack came in mid-September, when about 600 tons of bombs were released on Walcheren's coastal batteries. Before any conclusive result could be obtained, however, the aircraft were diverted for action in the Calais region and the bombing was temporarily shelved.

* * *

Walcheren and Flushing are both linked in history with famous conflicts: the Spanish Armada and its efforts, born of religious fervour, to subdue the Protestant queen Elizabeth I of England, and the long drawn-out Napoleonic War. Although England emerged victor in both struggles, it was not without losing some battles, including at Flushing and Walcheren. One wonders if the spectre of history flashed across the thoughts of the Allied planners, especially as some of them, such as Field Marshal Montgomery, were ardent amateur historians.

All previous English efforts in Walcheren had ended in failure and huge loss of life, mostly through disease and starvation. They began when Elizabeth I, a fervent Protestant, was informed that her Dutch co-religionists were suffering appallingly at the hands of the ultra-Catholic Spanish. This could not be borne, she said. She raised an army and placed the expedition under the control of her lifetime favourite, Robert Dudley, Earl of Leicester. For the mission she elevated him

to the rank of her Lieutenant and Captain-General for the Nether-
lands, and shortly afterwards, in 1585, he set sail for Holland. Once
there he involved himself so successfully in the politics of the land that
he assisted in drawing up a new constitution, which may have pleased
his hosts but did not please his sovereign. That, however, is another
story.

Trouble lay elsewhere too, for nothing had gone right since Leicester
and his army had arrived in Holland. The army had been raised and
despatched so hurriedly that they sailed with neither supplies nor
money to buy any. Those sent on to Flushing were left in open boats
for ten days, and it was already late in October. The weather was
closing in, the men were inadequately dressed and many of them were
without food. Others arrived at Flushing to be refused bread and
clothing by the local population unless it was paid for: as there was
no cash, there were no sales. Even more took refuge in a church at
Middelburg where, according to Dame Edith Sitwell's exquisite book
The Queens and the Hive, 'their clothes, rotted by the rain, [were]
falling off them'. Some of England's most illustrious nobles were lost
in the combats that ensued, including Sir Philip Sidney of the de Lisle
family. Seeing a fellow officer without sufficient body-armour during
the battle of Zutphen he had taken off his own thigh-shields and
given them to him, only to receive a lethal shot himself immediately
afterwards. The Earl of Leicester, exhausted by the problems of keep-
ing his army going on nothing, fell ill and died shortly after returning
to England.

The English fared no better during the Napoleonic War in 1799,
when they landed to confront French forces; or ten years later, when
troops intended to reinforce Wellington—who was later to have vic-
tory at Waterloo—ended up on a fever-stricken expedition to Wal-
cheren. The tiny island had already made its mark.

* * *

While the First Canadian Army was responsible for opening the route
to Antwerp, the clearing of pockets of German resistance was
delegated to the 2nd Canadian Corps under General Simonds. The
operation was to be in three phases. South Beveland was to be sealed

off and cleared by the 2nd Canadian Infantry Division and the 1st Polish Armoured Division, who would then push for Bergen-op-Zoom and Roosendaal (*see map*). Next, the Breskens pocket would be cleared by the 3rd Canadian Infantry Division, and finally would come a seaborne landing on Walcheren Island by the 4th Special Service Brigade.

The Allied troop formations were, for the uninitiated, of confusing complexity. It is perhaps worthwhile detailing their composition, if for no other reason than to illustrate the enormous numbers of men, equipment and weaponry collected in a relatively small area. The 2nd Canadian Corps was composed of approximately 31,000 men, among them the 52nd Division otherwise known as the Lowland Division. The title is something of a misnomer, given that they were trained for mountain conditions. Their inclusion in the Walcheren campaign may well have been due to the original idea, later abandoned, of forcing the enemy to high ground and taking it by paratroop assault, in which case the 52nd would have provided ground support. Whatever the reason, the 52nd was destined not only to play a leading role in the battle, but also to be the first to assault the defences. The Lowland Division consisted of three brigades, the 155th, 156th and 157th; the 156th Brigade had two battalions, the 6th and 7th Cameronians, of which the 6th was home to Rifleman Khan.

The main German defences were sizeable. Naval personnel from the *Kriegsmarine* manned 30 coastal batteries with more than 50 guns of calibres ranging from 220 to 75 millimetres embedded in concrete; a large number of anti-aircraft guns, flame-throwers, rocket projectors and searchlights also faced seawards. The beaches were covered with booby-trapped obstacles, barbed wire several rows deep filled the shore, and there were mines. Every reinforced town bristled with weaponry. Flushing, the official history of the war records, 'had been turned into a fortress with several batteries around its perimeter and the streets furnished with every kind of weapon and obstacle that German ingenuity could devise'.

On 2 October, 1944, radio messages and air-dropped leaflets warned the civilian population that an invasion of the island was imminent. The following day the first phase of the operation began with a massive

aerial bombardment to breach the ancient dyke at Westkapelle and flood the fortifications. Pathfinders led the way and for the next two hours wave after wave of Lancaster bombers and Mosquitoes with fighter escorts zoomed over the target in precision-bombing runs, dropping 1,270 tons of high explosive on the dyke. Bombing had become a precise art: a breach appeared about a hundred yards wide, and the sea poured through. The aerial assault continued throughout the next 14 days, using more than 2,500 tons of bombs to complete the tasks that had been set. The one remaining raid, aimed at eliminating the radar stations and ammunition stores that had been rapidly moved to higher ground to escape the floods, would be the precursor of the invasion itself.

* * *

The Alsatian puppy was taken into the home of the Railton family of Tolworth in Surrey. They doted on him and, as he grew, it was obvious that he had an exceptional intelligence; he loved playing games, was alert and keen to be put through his paces. When appeals in the press and on the radio called for animals to be trained to serve with the forces, the Alsatian was offered.

It must have been strange for the family as they delivered him to the collection depot, where dogs of all kinds barked and jumped around, pulling on their leads, while the formal paperwork was completed. From the moment he was handed over to the reception clerk and fond goodbyes had been made, the dog faced a long haul of training and examinations with trials and tests that most of the dogs around him would fail. There were dogs whose speciality would be to guard and alert, or to act as messengers: others, with different training, were destined to detect buried mines, sniffing them out and lying, nose pointing directly to the object, five feet or so away until their handler came along to raise or defuse it.

Graduation meant assignment and the Railton dog became the latest recruit to the 6th Battalion of the Cameronian Regiment based in Lanarkshire. The dog and his handler, Corporal Muldoon, hit it off at first sight and from that moment they were to be inseparable. We do not know at what stage war dog 147 was officially named Rifleman

Khan, or indeed why the name Khan was chosen, unless it referred to an earlier battle, for the records of the dog have proved remarkably elusive.

* * *

Three Royal Navy warships, the *Warspite*, *Erebus* and *Roberts*, sailed into position to give covering fire for the Westkapelle landing of the Special Service brigade group sailing from Ostend. At the same time scores of Buffaloes carrying amphibious Weasels, tracked assault vehicles of American manufacture, had sailed from Terneuzen to Breskens under extensive smokescreens. The move had been preceded by an aerial bombardment to soften up the target, with Bomber Command and the Second Tactical Air Force concentrating on the enemy's batteries and the remains of the fortifications. At six a.m. on the morning of 1 November the Flushing landing commenced; four hours later, in full daylight, the sea landing at Westkapelle began.

The causeway carried both the road to Walcheren and the railway that linked Middelburg to Flushing. It was about 1,200 yards long and some 40 yards wide, 'with sodden reedgrown mud flats at either side'. More, it was as 'straight as a barrel' and offered no protection whatsoever to the invading forces. On 31 October units from the 2nd Canadian Infantry Division attacked and won the eastern end of the causeway, capturing 150 surprised prisoners, most of whom, it was later learned, were on special rations due to stomach problems or stomach injuries. The position was held by about two thirds of the 70th German Infantry (Mager) Division, who were drawing convalescent rations. Although this bridgehead meant that South Beveland was liberated from enemy occupation, it still did not deliver the vital causeway into Allied hands. The western end was particularly well fortified and the German defenders were well dug in. They held the high ground, too, flanking positions on Walcheren's main enclosing dyke. From there, enemy fire covered all movement along the causeway, which was lined by wide ditches with water at least armpit deep. Any thought of getting across with tracked vehicles was out of the question: the causeway would have to be taken by infantry assault.

The first attempt on 31 October was met with withering artillery,

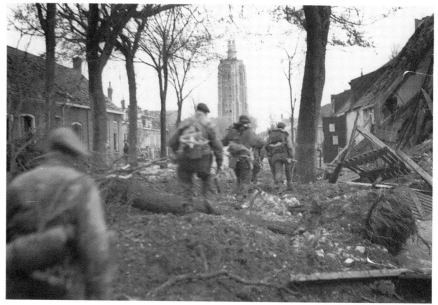

Commandos advancing through the ruins on Walcheren. *Photo: Imperial War Museum.*

mortar and machine-gun fire. A second assault was made in pitch darkness but with no better results. The next morning a third attempt was made after the laying down of artillery fire, but still the western end stayed firm and Allied losses began to mount alarmingly. Indeed, the 2nd Canadian Infantry Division was taken out from the Scheldt and rested, as it had suffered 3,600 casualties in just five weeks.

The situation on the causeway was reassessed. It would have to be outflanked by crossing the Sloe Channel in boats, then wading ashore along a mile-long stretch of the mud banks via a path marked out by sappers. In their defensive preparations the Germans had laid hundreds of mines along the banks of the canal, most of which had been dislodged during the flooding caused by the Allied air raids. As a result the most hazardous job of all had been for the sappers to feel their way forward to provide a safe line through which the troops would pass.

The night of 2/3 November was dark and cold. The wind blew in gusts from the canal, rocking the assault craft as the men of the 6th Cameronians clambered aboard. It was just 03.30 when they pushed off at high tide. They immediately came under intense fire from entrenched enemy positions, and the night was lit with thousands of tracers as the armada of small boats headed for the opposite bank. Shell and mortar fire screamed down upon them. The distance they had to cover was not far, but every inch seemed an agony as the bombardment continued, the white and red and yellow of the explosions reflecting on the water. Mortar and artillery shells smashed into the Sloe. Machine-guns raked the choppy waters where the assault craft rocked.

Rifleman Khan sat still, crouched down in the boat, close to his handler, Corporal Muldoon. It was most unusual for the Cameronians to have a dog with them, especially one which was not a pet but a 'professional', but this one was about to prove his worth. There was not much room in the confines of the assault craft and men, equipment, ammunition and radio equipment were stacked close together, making the journey even more difficult as the craft pitched from side to side. Everyone knew this was their most vulnerable time. They were pinned down, sitting ducks in the glare of the artillery fire and searchlights. There was little they could do in their own defence until they reached the farther bank.

All these thoughts must have been going through their minds when an artillery shell hit the landing-craft and cut it almost in half. Those nearest to the impact were thrown first high in to the air then fell heavily into the Sloe, where great spouts of ice-cold water shot into the air. Others were deafened temporarily by the ear-shattering explosion as their boat disintegrated. They thrashed about in the water, pulled down by the equipment on their backs, trying desperately to keep hold of their rifles. Arms rose above the water and plunged in again in awkward, jerky movements as men tried to find a stroke that would pull them forwards, away from the stabbing searchlights that were directing the machine-gun fire. Those who were not wounded were swimming, slowly and methodically, towards the bank.

If it had been a terrifying experience for a human, it must also have

been for Rifleman Khan. He too was thrown into the air on the impact and landed with a smack in the water. His head immediately bobbed up and, paddling frantically, he turned his body round in the water to fix the light he could see on shore: the light that was coming from the enemy's bombardments. With a jerk, he set himself on course and paddled for all he was worth. He reached the bank and his paws immediately sank into the mud, up to four feet deep in places, which was to entrap many men loaded down with the equipment they had struggled to save. Some of them were destined to stay in it for up to four hours, under constant machine-gun fire, until they were pulled out by rope. Rifleman Khan was luckier; he was lighter and faster. As if he had always known how to adapt to the mud, he almost ran along it, searching for his handler. He gained higher, firmer ground and hunted for Corporal Muldoon again: one man, one form, among so many passing him in all directions.

Then he stopped, and his ears lifted. His tail, still dripping water, remained straight out behind him. Among all the noise of combat— men exchanging orders or hauling equipment, small-arms fire, the enemy's heavy machine-guns, artillery and mortars—he had heard and distinguished just one voice. He peered out into the canal, lit up like day by the searchlights, and spotted his handler thrashing around in the water in a desperate situation. For Corporal Muldoon could not swim and had already taken in too much of the murky water to survive for long.

Rifleman Khan did not hesitate. He dashed down through the mud into the water, and paddled for all he was worth, his head and line of vision barely above the surface, until he reached his handler. He clamped his teeth hard onto Corporal Muldoon's tunic just behind and to the side of his neck, and pulled. At first there was no movement. The dog pulled again and Corporal Muldoon relaxed, leaving the momentum to his four-legged friend. The swim back to the shore was long and arduous, and the enemy's fire was unrelenting, but at no time did Rifleman Khan tire. He battled on, his paws pounding the black water. When they reached the mud bank the dog shook himself and Corporal Muldoon coughed up the grime he had taken in, but still the dog continued to pull his handler along until he reached firmer

186

Rifleman Khan with his handler, Lance Corporal Muldoon. *Photo: Imperial War Museum.*

ground where, by now exhausted, he at last let go. Corporal Muldoon could so easily have lost his life—many did in that short time, including the company commander Colonel Sixsmith—but he was saved due to the exceptional courage of a dog who had concentrated hard under impossible conditions and used all his strength to bring his handler back to safety.

Rifleman Khan's nomination for the Dickin Medal came just over four months later, on 27 March, 1945. The citation reads: 'For rescuing L/Cpl. Muldoon from drowning under heavy shell fire at the assault of Walcheren, November 1944 while serving with the 6th Cameronians'.

<p style="text-align:center">* * *</p>

The liberation of the Netherlands and Belgium was fiercely opposed by the German occupiers. Every step of the way was hard fought and scores of dogs were involved in the fray. The story of Rifleman Khan is perhaps one of the most stirring, but several other dogs made their mark in the same campaign. Ricky, a short-legged Welsh sheepdog, had, like Rifleman Khan, been loaned to the nation by his owner at the beginning of the war. His training, however, was different, for he had a speciality: the ability to detect an explosive device and calmly lie nearby pointing his nose towards it until his handler came along. This training was intense and many dogs were rejected before the end of the course. They had to be more sure of foot than others, and calm and disciplined. As Ricky was being trained, so was his handler, and when the courses were complete they left for France together after D-Day. Ricky's war was a long one, for he continued his work through France, into Belgium and then to Holland.

Holland was a particularly difficult combat zone, for if the German forces failed to halt the Allies there, the doors would be open to Germany itself. They put up fierce opposition in Nijmegen and Arnhem. Roads were mined, derelict buildings were booby-trapped and the V-bomb rocket bases at Zutphen poured V-2s on to Britain in the declining months of the war. But it was especially along the banks of the rivers that mines were laid, where they were hard to detect in the loose shingle that descended to the water.

It was 3 December, 1944, a bitterly cold day, when Ricky was set

to work along the banks of the Nederdeent River. He located one mine beneath the shingle, then a second and soon afterwards a third; he found them in thickets and, in one place, in the mud. Farther along the bank others were probing for mines, but one was triggered and exploded. The leading officer was killed on the spot and Ricky, who was close by, was injured. He was thrown sideways down the bank and lay there for some time, unmoving. When help reached him it was clear that he had been hit in the head by shrapnel: he was bleeding profusely and his sight was in danger.

Yet neither these injuries nor the shock of the explosion held Ricky up for long. He was soon back on his feet, shaking himself down and getting back to work. Throughout the ordeal he had remained calm and collected: had he reacted otherwise from pain or disorientation, he could well have triggered other mines and killed many sappers working nearby. Ricky stayed in service and continued to work until the end of the campaign. The citation for his Dickin Medal, which came two years after the end of the war, in March 1947, reads: 'This dog was engaged in clearing the verges of the canal bank at Nederdeent, Holland. He found all the mines but during the operation one of them exploded. Ricky was wounded in the head but remained calm and kept at work. Had he become excited he would have endangered the rest of the section working nearby.'

12

Rob of the SAS

The citation is awesome to behold. It reads: 'War Dog 471/322. Special Air Service. Took part in landings during North African Campaign with an Infantry Unit and later served with a Special Air Unit in Italy as patrol and guard on small detachments lying-up in enemy territory. His presence with these parties saved many of them from discovery and subsequent capture or destruction. Rob made over 20 parachute descents.' Yet Rob started off as an ordinary collie prancing mischievously around his home farm in Shropshire. After his exceptional deeds he returned there among the family he loved.

* * *

No chapter in this book seemed easier to research and put together than the story of Rob, the SAS dog, but none has proved harder to compile. For a long time Rob's exploits with 2 SAS remained, like those of the SAS itself, classified top secret. His handlers in the field had either died in combat or after the war and there was a perplexing lack of authoritative documentation. Countless articles have been written about Rob's achievements but all have centred on the same themes, the citation for the Dickin Medal, the letter received from the then War Office describing his heroism, particularly in Italy, and the accounts of how he was raised by his loving owners in Shropshire. But still there was no background to the missions in which he took part. Historians writing about animals in combat have been unable to probe his whole story and some points will no doubt remain secret forever.

Yet Rob was probably the most decorated animal in British history, and remains the only dog to have been recommended for an award by the War Office. He was to be decorated eight times, the two most

important awards being the Dickin Medal, presented by Philip Sydney VC, the late Lord de Lisle and Dudley, and the RSPCA's red collar and silver medallion inscribed 'For Valour'.

Identifying how and why Rob obtained such decorations has been arduous, and at times I despaired. But gradually, with the stirling and unselfish assistance of Miss Heather Bayne whose childhood was blessed by Rob's presence, the picture has emerged. As a result, the exceptional courage of his deeds, which earned him the respect of a nation and praise throughout the world, can be revealed for the first time.

<p align="center">* * *</p>

It was May 1943 and the first significant victory for the West had just been achieved—Axis forces were out of North Africa. Churchill sped across the Atlantic to an urgent meeting with President Roosevelt to discuss where the Allies would turn next. The Tunisian campaign was the last of the many battles for North Africa, which had already seen the triumph of Montgomery's Eighth Army and a massed tank assault, but after the Americans and British linked up in early April there was no doubt about the outcome. On 12 April the remnants of Axis forces surrendered with the fall of Bizerta. The North African campaign had been hard fought and Axis losses had been heavy: according to Churchill, 950,000 soldiers killed and captured, 2,400,000 gross tons of shipping sunk, 8,000 aircraft destroyed, 6,200 guns and 2,550 tanks lost. But Allied losses had been heavy too. Statistics apart, it was vital for the eventual outcome of the war that the enemy should be deprived of North Africa, with its strategic sea lanes and access to oil supplies. Success there was a turning point in the war.

After Bizerta came a lull and Allied forces rested up, enjoying a brief respite. The victory—so good to taste after so many reversals— was won by a combination of efforts: the leadership of General Montgomery of the Eighth Army, whose final artillery bombardment was the largest in history; the successful coordination of inter-Allied British, French and American forces; and the arrival on the scene of new and novel special forces, the Long Range Desert Group and the Special Air Service, or SAS. The SAS was the brainchild of one of

the great visionaries of our time, David, later Sir David, Stirling, whose simple slogan from the very beginning was *Who Dares Wins*. He rejected totally the theory that war had to be fought according to rule books, but he had to fight hard for acceptance of his concept of small groups operating deep behind enemy lines. If SAS operations in North Africa were to fall short of Stirling's aspirations, he nevertheless proved his point. Stirling was captured, however, and held, despite repeated escapes, at the well-known German prison camp for officers at Colditz Castle. But the SAS continued, with Stirling's brother William—'a much better shot than I ever was', as Sir David told me some years ago—creating and leading the 2nd SAS.

Immediately after victory in Tunisia, 2nd SAS was stationed at Sousse, where they had a training base and considerable stores' supplies. But objects were going missing with alarming regularity and the quartermaster, Captain Tom Burt, knew he had to do something about it. He needed a guard dog, and a well-trained one. After making enquiries he found that once the battle was over all military dogs had been concentrated in one spot, a dog holding section some 180 miles away at Constantine in Algeria. As his commanding officer was away sick, it was something that he had to get on with himself. He applied for two dogs from the centre and they duly arrived. One was rejected because it had a skin ailment which could well degenerate. The other Tom Burt accepted immediately. Instinctively he knew that this was the dog for the SAS. Tattooed inside his spotted ear was his official war dog number—471/322. His name was Rob: he was, as his owner Mrs Bayne described, 'an ordinary cattle collie, born and bred in Shropshire. He was mostly black with a white face, one ear white with black spots, white waistcoat and "stockings" and a long black bushy tail with a white tip.' He was just two months short of his fourth birthday and in absolutely top condition. Rob had also caught the eye of Captain Burt's batman, Sam Redhead, who became so attached to him that later he even tried to enrol into the paratroopers in order to be with him. (That was not to be, but after the dog's SAS adventures the two were reunited.)

Rob showed his worth immediately, proving that he could differentiate between friend and foe and recognise those who were stealing.

With him on guard duty, it was not long before 'Italian prisoners walked sideways past him and pilfering Arabs became honest men overnight'.

The more Captain Burt saw of Rob, the more he was convinced that the dog was capable of service of a different nature, capable in fact of becoming as near to a soldier as possible: more, an SAS soldier, where stealth, silence and the ability to work alone if necessary are key. He had been most impressed by the dog's behaviour whenever he had taken him in the unit's jeep on forays around camp. Rob was clearly in his element, bracing himself at every pitch and turn, his eyes alert and eager, his tongue lolling out. And, importantly, he did not bark uncontrollably to register his joy. It was now that one of the leaders of 2nd SAS took an interest in Rob and saw his potential as a 'para dog'. It has been said that this was Roy Farren, who was close to Bill Stirling and later led several parties behind the lines in Italy.

Rob, Britain's most decorated animal war hero. *Photo: Imperial War Museum.*

When I broached the subject, however, Mr Farren did not recall it. Rob had many handlers, particularly during the early stages of his induction into the SAS, and all of them were killed within the following 18 months. It was certainly one of those who smuggled Rob on to a plane to see how he would adapt to the aircraft's droning noise, its vibration and jerky movement.

That happened the very next time 2nd SAS held a practice parachute drop. All the vital signs for which Rob was being watched and assessed proved that he had passed the test; what was more, it was obvious that he had enjoyed every minute. Whether he would react in the same manner when he was actually dropped, and whether he would keep silent during the descent, remained to be seen, but before that could be tested there was a big problem to overcome. Where, in the desert, could one find a harness to suit a dog? Fate, as so often, had a card to play. Close to the British base where 2nd SAS were practising parachute drops while awaiting new orders was an American base. There, a special effort had been underway for some time to collect dogs that could be dropped with airborne forces. The programme had its own drawbacks and frustrations for the Americans: they were rejecting dogs after trial drops because the animals enjoyed the experience so much that they barked all the time. This was not the conduct either they or the SAS were looking for. The Americans were keen to know more about the dog for which the SAS had asked the loan of a harness.

The harness borrowed by 2nd SAS weighed a formidable 93 pounds. It was strapped securely around Rob, leaving adequate movement for his legs and paws. He lay comfortably at the feet of his handler during the take-off and preliminary run as the plane gathered height. Then the despatch door was opened and the drops began, one after the other. Without any fear, Rob waited his turn. His parachute's rip-cord was attached to the line then, suddenly, he was out, hitting the airstream and descending, 800 feet above the ground, his handler right behind him. The force of the air pushed his fur back and up, and his ears must have been standing upright on his head. Yet Rob showed no sign of fear when the 'chute opened, jerking him sideways and upwards at terrifying speed.

He landed correctly and was speedily released from his harness by the other members of the team who rushed to see how he had fared. With the permission of the commanding officer, Rob's inclusion in the 2nd SAS was made official and his training commenced in earnest. The Americans asked for their harness to be returned and at the same time asked how the dog had done in his trial drop. When they learned of his excellent results they asked if they could have him allocated to their kennels. The SAS had found their Rob, however, and were not about to be deprived of him. The harness became a permanent loan.

Rob was to have another 17 practice drops in North Africa. He was trained to perfect two roles, to lie still on landing and wait until his handler came to release him, and then to act as liaison and round up

Salvo, who made a record number of drops with the Parachute Regiment, wearing the American-designed harness used by Rob. *Photo: Imperial War Museum.*

his patrol in darkness or daylight and bring them together. Rob loved it, and according to those who had been with him, 'he would have been first through the open doors [of the aircraft]' if he could.

When the call came for the 2nd SAS to move out, Rob was a fully fledged 'sky dog' included on the 'Very Secret List'. He and 2nd SAS were destined to go into Italy in small groups on special missions well behind enemy lines. Around this time, the Bayne family received a brief note from the War Office. Rob, it said, 'was fit and well and doing a splendid job of work'. That is all they were prepared to divulge and it would remain that way until well after the war.

* * *

It came as no real surprise to the Bayne family that their Rob had excelled. All his puppyhood could be said to have pointed towards it. Rob was born in July 1939, the larger of two pups. The mother, Jess, owned by Mr George Hulme of Colemere, was a farm dog described in an article by Mrs Bayne as a 'maid of all work'. She was cattle-dog, sheepdog and pig-dog. She was particularly clever at rounding up the truculent snorting pigs, from whom she took no nonsense. Rob was still only a ball of fluff when he was sold for five shillings to Mrs Bayne, quite a sum at a time when the average wage packet was only three pounds. From the very start, Rob was spoiled. He ate from the best china, was cuddled and played with and slept in a soft armchair. As he grew, he went out with his master and hopped on the tractor, his tail swinging with pleasure, his legs splayed to take the roll of the bouncing machine. While Mrs Bayne talked to Rob and encouraged him, finding new ways to extend his intelligence, her husband taught him how to drive cows, round up the pigs and keep the chickens off the garden. Rob soon showed how gentle he was, too. When chicks were lost in beds of nettles, he knew exactly how to dig his nose inside and pick them up between his teeth without injuring them, then deposit them in their coop. Mrs Bayne recalls how, when her son was born, there was no jealousy on Rob's part, but rather the contrary. He took it as his duty to care for the child, and instead of sleeping in his usual soft chair or in an alcove behind his master's chair, every night he could be found lying across the doorway to the nursery.

Soon after the outbreak of war, the War Office had broadcast a plea for pigeons to be volunteered for service with the forces. Now, as 1942 commenced, the appeal was extended to dogs. A positive deluge was offered of animals of all sizes, shapes and varieties. One woman, whose husband and son were already abroad with the army, submitted her dog, her last treasure. If her loved ones were out there fighting, she said, so should the dog be, as her personal contribution to the effort. Whether that particular dog made it or not we do not know, but the selection process was severe. Already the authorities were aware which breeds were to be preferred. The most likely to succeed were Alsatians, Labradors and poodles.

Rob was offered to the War Office with the proviso that, if he was accepted, it would be for the duration of the war only. Rob was so much part of the family that when it was all over his place was back on the farm. Three months went by before he was called to the dog training school, now under War Office control, at Northaw, Middlesex. Rob passed out from his exams in record time, just nine weeks, after succeeding at every test at the first attempt. Part of the training involved observing the dog and analysing his or her reactions, for each had a penchant for one discipline more than another. In Rob's case he not only passed as a guard and patrol dog, but had been seen to excel in liaison work in which he could carry messages between handlers on the move. This ability, and the strength of character that permitted him to avoid all distractions, were to save the lives of many men. At Northaw handlers were trained along with the dogs, so when Rob had completed his course he left the station with his handler and departed almost immediately for the front in North Africa with an infantry regiment. It was there, some time later, that Captain Burt of 2 SAS came upon him.

* * *

The campaign in North Africa in which Rob had played his part was the first military step towards his major adventure in Italy. The conquest of Tunisia in May led to a successful Anglo–American landing in Sicily in mid-July. This stung Benito Mussolini, and when he was called before King Victor Emanuel on 25 July he knew it was the end

of his empire and his dreams. He was deposed, led away a captive, and an interim government under the aged Marshal Bagdolio took over with the task of trying, secretly, to negotiate a settlement with the West. The only problem was that Hitler would have none of it, for two reasons. First, he felt he had a duty to rescue Mussolini and reinstate him as head of government; secondly, he could not allow the physical and strategic threat to Germany caused by the collapse of his major Axis ally to continue. Within two days Hitler had convened a meeting with his chiefs of staff to restore the situation. From that discussion, four operations emerged: Operation *Eiche*, or Oak, to rescue Mussolini; Operation *Student*, which called for the occupation of the Italian capital, Rome; Operation *Schwarz* would see the total occupation of Italy and Operation *Achse*, or Axis, envisaged the capture and destruction of the Italian fleet, which had been a significant force even if inadequately directed. He ordered the immediate closing of the Alpine passes on both the French and Italian borders and diverted eight full divisions from France and southern Germany to Italy under the command of Army Group B and its famous leader, Erwin Rommel. Hitler was again stung into action when the Allies landed in the toe of Italy on 3 September.

The next few weeks saw a true Italian drama take place, of which the Allies, in particular the special forces and intelligence services, made excellent use. The Duce, as Mussolini was called, had been moved from one open prison to another, more to keep him from falling into the hands of the Communist partisans than for any other reason, and was finally lodged high in the Abruzzi mountains. British SOE, the Special Operations Executive monitoring the situation, knew that the volatile partisans could be armed and trained to oppose German forces whom they accurately perceived would not be long in arriving. Hitler's intelligence services, particularly Admiral Canaris' *Abwehr* and Himmler's SS, tried all avenues to find out where Mussolini was. In the end they traced him and in a well-executed snatch, SS General Otto Skorzeny swooped down in a Friesler Storch two-seater plane and flew him to the safety of Germany. Shortly afterwards, on 15 September, Mussolini was reinstated by force as head of a puppet government and Germany took on responsibility for Italy's security.

The partisans were furious that the dictator had returned. They plotted Mussolini's overthrow and achieved it, more for reasons of political expediency linked to intrigues with Soviet Intelligence's double game than for altruistic reasons.

There has been considerable commentary on what lay behind the speedy and gruesome execution of Mussolini and his long-standing mistress, Clara Petaci, yet the event has never really been examined in depth—except by such noted historians as Christopher Hibbert. It is a strange story with even stranger implications, for while the Soviet Union was certainly the ally of the Western powers in a common struggle, it was already infiltrating Western intelligence and resistance organisations and even, as in the case of the British special agents and the American OSS (Office of Strategic Services), betraying them to the Germans in order to achieve strategic gains and intelligence. Much of this was masterminded by Leopold Trepper, a Russian who headed 'Red Orchestra', a secret resistance network in occupied Europe. Many of the communist-controlled *maquis* and resistants operating in France, Germany and Italy had links with Trepper. At the time of Mussolini's execution by Italian communist partisans, efforts were being made by the West to capture Mussolini. It was into this turbulent situation that the SAS and Rob were sent ahead of the main invasion of troops.

Rob was said to have made three parachute drops into Italy hundreds of miles north of the advancing allies, or two drops and (according to several articles) one arrival by sea. While it is possible to identify two drops, with Lieutenant McGregor in September 1943 and with Major Widdrington in January 1944, there is still considerable doubt about the sea landing and to a large extent this has to be viewed by eliminating the evidence. There was one key issue that helped in this search: we know that Rob led a team back to safety after a particularly hazardous mission, after they had been deemed to be lost. It was for this that Rob was immediately recommended for his award for valour.

The first SAS drop in Italy—for details of which I draw heavily on Anthony Kemp's excellently researched work *SAS at War*—came within a few days of the Allied landing on the toe of Italy in July 1943. It was a hurried and ill-prepared mission, given that it had been

cancelled several times and reinstated at the last moment before take-off. Captain Pinckney and his ten men lost most of their radio equipment when it was smashed or went astray on landing. They were short of food and highly vulnerable, hundreds of miles from the nearest friendly forces. Most of those who dropped were able to get back to base after accepting that the mission was futile, but it took a considerable time and they were feared lost. The drop caused many recriminations, and although lessons were learned that were later put to good use, there were no more drops until September.

Operation Speedwell began on 7 September. Its objective was to cut the rail links in the north of Italy that fed the Bologna, Florence and Genoa–La Spezia lines which were taking reinforcements for the German forces going up to the front. One 'stick' was led by Captain Pinckney and Lieutenant Tony Greville-Bell with five men; the other was led by Captain Dudgeon and Lieutenant Wedderburn, again with five men. Captain Pinckney was lost immediately upon landing and the unit was taken over by Greville-Bell, who then split the group into two. The second group was led by Sergeant Robinson, who set off with two men to attack the Bologna–Prato line. They laid their charges and effectively derailed a train, without realising, as Kemp points out, that in the meantime Italy had already surrendered. They were soon out of food and all three men were taken sick on the long return by foot, with occasional hops on trains, back to British lines in Frosinone. It had taken them 54 days to get back, nearly six weeks.

In the meantime Greville-Bell, who had suffered a damaged back and two broken ribs, carried on with his mission. He kept a detailed report on day-to-day procedures from which we see that he and his men blew up several trains and tunnels, and cut power supplies. They came across partisans and tried to help them get better organised. This was an extremely delicate time, for the SAS could not be sure how the partisans would react—they were often hostile. Greville-Bell noted how well supplied they were with arms and ammunition. Not only were the SAS obliged to keep constantly on the move southwards to avoid German patrols, but they suffered from lack of food, too. After two full months Greville-Bell and his faithful Sergeant Daniels, to whom he had delegated much of the responsibility since his injury,

were lost in a blizzard and both suffered snow blindness. Almost a fortnight later they reached German lines and had to find a way through them. With extreme caution and luck they succeeded. Their return was celebrated as one of the great feats of SAS endurance.

While the Speedwell missions were proceeding, four groups of SAS were embarked upon an American cruiser for a landing at Taranto, on a mission to find out what the Germans were up to. Another, led by Lieutenant Alastair McGregor, had been dropped into Chieti by parachute. He had an exceptionally busy time in Italy, often working in a manner he had not expected, amassing groups of Allied prisoners of war and helping them to reach Allied lines as German forces increased their grip on the country. His first coup of this kind came when he linked up with a French force and released 180 internees from a concentration camp in Metaponto, after having stolen a train to help him. At this point he met up with B Squadron 2 SAS, which had landed from the American cruiser. The second occurred in October when 300 prisoners of war were sent down the line.

The drop on Chieti was, according to Kemp, hair-raising, for they were despatched too early, while it was still light, and on the wrong dropping zone. As they landed they saw German cars coming straight for them, but were whisked away and hidden by Italian peasants. McGregor resumed his escape-chain activity and from the time of his landing to 12 October he sent 300 to safety. While he awaited the expected arrival of the Allies in the region—it took longer than thought—he devised a route through which to pass a further 300.

It is worthwhile examining Kemp's research into McGregor's missions:

As the 8th Army was expected in Chieti by 20th October there was no hurry to return, so McGregor then devised an overland route and sent down a further three hundred escapees. But then the Army failed to arrive on time and many of the ex-prisoners resigned themselves to settling down for the winter, often in comfortable billets which they had secured for themselves with Italian families. The new menace appeared on the scene in the form of an SS unit dedicated to recapturing the roving bands of

allied soldiers and airmen. McGregor therefore decided to divert attention by attacking the Germans with his tiny force. His original intention was to mount a mobile ambush using a truck with a machine gun mounted on the back, the poor man's substitute for an SAS jeep with twin Vickers. In the end he had to make do with an Italian Breda and a small 8-cwt truck which was commandeered from an unpopular fascist. Unfortunately the truck broke down so they had to conduct ambushes on foot on an almost daily basis.

The Germans caught up with his tiny band at last but, after a ferocious shoot out, McGregor and McQueen—the surviving private from McGregor's original three—managed to get back to British lines. They had been on their mission for almost four months. Upon getting back McGregor was surprised to find that he had been posted 'missing in action'.

Interestingly, Mrs Bayne received a letter from Lieutenant McGregor's mother as a result of an article she read about Rob after the war. Mrs McGregor, in saying that she would send the article to her son who lived abroad, remarked that he had been forever speaking of Rob and Rob's courage and exploits. On the strength of this evidence, there can be little doubt that Rob was with McGregor during these missions.

But now we come to Operation Pomegranate. By January 1944 the whole of Italy was under German occupation and their forces were conducting a skilful action using to the full the natural barriers that the many mountain ranges offered. In order to assure the best chance for the planned Allied assault on the beachheads at Anzio, it would be necessary to knock out the German reconnaissance aircraft based at San Egidio. A six-man team was chosen to do this, led by Major Widdrington and Lieutenant Hughes with four other ranks. They dropped on the night of 12 January east of Lake Trasimeno, and marched towards their target by night, lying low during the day. They had trouble crossing the Tiber and as a result were obliged to split up, the two officers remaining together while the four others carried on in a different direction, both teams heading for the same objective.

The four privates found the aerodrome site heavily patrolled and its perimeter difficult to penetrate. Once through the patrols they quickly realised that the two officers had been there first and the task had already been completed. They had to get out now, quickly, back to Allied lines.

Widdrington and Hughes had penetrated the airfield and placed Lewis bombs on the seven aircraft they found, primed them and made ready to leave. While they were doing so, a bomb exploded and, as Kemp describes, Widdrington 'was killed outright and Hughes was severely wounded. When he [Hughes] came round he found that he was blind, that his trousers had been blown off and that his legs were covered in blood.' Hughes was subsequently caught and told he would be handed over to the dread Gestapo as soon as his wounds had been looked at in hospital.

In hospital he learned that an order had been issued by Hitler through Field Marshal Kesselring's HQ that all parachutists were to be killed, and were to be handed over to the *Sicherheitsdienst* (SD) for despatch. Up to that point, with only a few exceptions, all massacres of Allied forces had taken place inside Hitler's concentration and extermination camps, and not in prisoner-of-war camps. The order's existence marked a deterioration of Germany's position and was a factor for which Kesselring in particular was held responsible in the Nuremberg war crimes trials. Lieutenant Hughes' documents were altered by a compassionate German doctor in order that he be classified as a prisoner-of-war, so he escaped the 'special treatment' of the SD.

So which of those exploits effectively won Rob his awards? From the indications given in many of the articles written after the war by those who knew Rob, we can assume that he was involved in the prisoner-of-war rescue operation led by McGregor, and no doubt this was one of the reasons, if not the main one, why the dog later took part in a post-war fund-raising campaign for returned PoWs. He would certainly have arrived back in Allied lines before McGregor, and there would have been nothing unusual about that: he would have been needed to assist in the escort of the freed prisoners. Rob could not therefore have been on the Greville-Bell mission that commenced a

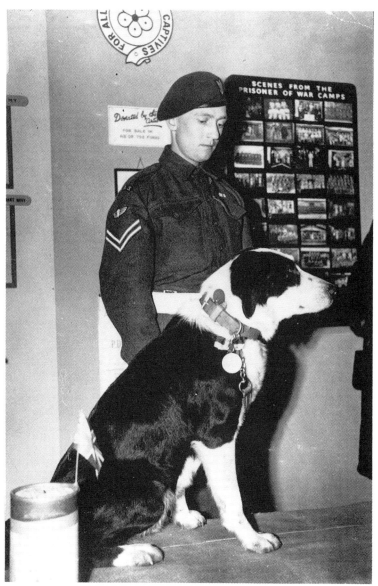

Rob taking part in a PoW fund-raising campaign after the war. *Photo: courtesy the PDSA*.

week before the McGregor drop and lasted well after the McGregor mission was completed.

That leaves two other points to be considered: the mention of Rob landing in Italy via 'a cruiser' and Major Widdrington's mission. The available evidence records only one SAS team landing by sea from an American cruiser, coinciding with the surrender of Italy in early September 1943, by which time McGregor's team was already in Italy, even if only by a day or so, having been dropped at Chieti. Later, as we have seen, some of the sea-landed SAS met up with McGregor, but there is no evidence that Rob came with them. When and where he entered the country by ship, if at all, must remain a mystery.

That leaves us with Widdrington's mission between 12 and 24 January 1944. Of Rob's presence with Widdrington on that occasion there can be no doubt, given the testimony of Widdrington's mother after the war. In a letter written to the Bayne family after Mrs Widdrington had seen an article about Rob's exploits in a newspaper, she described how her son had often written and spoken of the dog's courage and fortitude while on active service in Italy. She concluded with the words that she should say 'no more than that because [her son] had died'.

Rob, with the rest of SAS, was withdrawn from Italy and returned to North Africa prior to departure for Britain. But although the regiment left for England as planned, Rob did not. No one, naval or civilian, would accept the dog on board or transport him by any other means. Captain Burt pleaded and pressed and made quite sure that everyone knew that this was not an ordinary dog, but an SAS dog and a hero at that. No amount of inducement would change any minds, and Rob stayed behind alone. Eventually a Norwegian freighter captain took pity and agreed to carry Rob back to Edinburgh, where he was immediately placed into six months' quarantine. One wonders whether, during that time, Rob met up with Voytek the Polish bear, who was probably in the same quarantine zone.

Rob had been in quarantine for about five months when a plea was made by the SAS for his release: he was needed on a very special mission. The quarantine authorities had other ideas, however, and refused. There was an appeal, because Rob was known to possess skills that few other dogs had demonstrated; it was rejected. So the

SAS units left without him. That mission went first to Belgium and then to Holland, where most of the men Rob had known were killed at Arnhem. When the dog's quarantine was over, he was released into the custody of the devoted Sam Redhead.

On 8 February, 1945, at a crowded ceremony in London covered by the BBC Overseas Programme, Rob received the Dickin Medal from Major Philip Sydney VC, later Lord de Lisle and Dudley. Shortly afterwards, Rob was awarded the Red Collar of the RSPCA, their highest award to an animal, in recognition of his splendid courage. To this collar with its shining medallion, Mrs Bayne has recorded, was added the Dickin Medal and six war ribbons. He wore these with obvious pride during parades and several functions for charity, including raising money for the Returned Prisoners of War Fund, for which he toured Colchester, London, Manchester, Wolverhampton and Ellesmere.

With the war drawing to a close and the sad news percolating of the deaths of so many of Rob's former SAS colleagues, Sam and Rob were stationed at Rednal from where they made their last drop together above the hills of Llangollen. This was tantalisingly close to where the Baynes lived, and had they been warned they might perhaps have had their only chance of seeing their beloved Rob on active service.

Shortly afterwards the War Office notified Mr Bayne that the dog would soon be released and that travel arrangements would be made, but this was quickly followed by a second letter requesting permission to retain Rob for a further period of service. This, as Mrs Bayne no doubt accurately assessed, was due to moves to disband the SAS. While the struggle for the regiment was raging, the SAS did not feel they wished Rob, who had now become their mascot, to leave. He stayed until the official disbanding of the regiment six months later— but the SAS was almost immediately re-created in the form that we know so well today.

Rob was returned home on 27 November, 1945, under military escort. It was an embarrassing return for the escort as the Dickin Medal was missing from around the dog's neck—the War Office later obtained a replacement for him. How Rob would adapt to the calm

of life on the farm had been puzzling the Baynes for some time, especially as there was now another little one around: during the three-and-a-half years of Rob's absence a daughter, Heather, had been born to the Bayne family. They need not have worried. Rob settled in straight away and even appeared to recognise some of his old haunts. Mrs Bayne later remarked that he was no longer any good as a cattle-dog because instead of rounding them up from behind, he wanted constantly to lead from the front.

It turned out that Rob had little work. The exigencies of war had seen the pig numbers dwindle, and Rob was more or less pensioned off, with the responsibility only of caring for the children. This he did with dedication, sprawling across the landing at night to guard them. He still had a trick or two to play from his experiences of the war, however. On one occasion, shortly after his return home, he woke the whole house with his incessant barking. When the door was opened, he sped out into the darkness. Mr Bayne, grabbing a torch, followed, calling his name and calling him to heel, but when he came across Rob he was rounding up a bunch of yearlings that had broken out from their shed. On another occasion Rob started barking again: this time he warned of a valuable cow that was about to be strangled to death. She had slipped in the cowshed and fallen into a position where the chain was tight around her neck. It was so tight that it had to be sawn off to save her.

Rob spent the rest of his life roaming the lovely fields and valleys of Shropshire with the two young Bayne children. His entire life had been spent where he had been loved. In January 1952 his infirmities, no doubt due to the extraordinary pressures that war service had demanded of him, caught up; in his best interest, he was gently put to sleep. The PDSA immediately offered a place for Rob in their own pet cemetery, where he would have lain with other war dogs of renown, and the family considered the suggestion. But there seemed to be something right about having Rob buried at home, and that is where he lies today. Above his grave stands a marble headstone on which is simply inscribed: 'To the Dear Memory of Rob, War Dog No. 471/322. Twice VC. Britain's First Parachute Dog who served 3 and a half years in North Africa and Italy with the 2nd Special Air

Rob at home with the Bayne family in Shropshire. *Photo: courtesy Miss Heather Bayne.*

Service Regiment. Died 18 January 1952 aged 12 and a half years. Erected by Basil and Heather Bayne in Memory of a Faithful Friend and Playmate.' Rob's story is as fascinating as it is moving, as exciting as it is humbling, and a constant reminder that an animal asks so little and gives so much in return.

13

THEY ALSO SERVED

One aspect of animals' presence on the battlefield has not been covered in the previous chapters: how they fared in times of chemical warfare gas attack. Because it remains as important an issue today as it has ever been, it needs to be specifically mentioned. We tend to think of poisonous gas primarily in connection with the First World War where, it should be remembered, both sides used it against each other, but the use of chemical weapons is not new, not something that simply cropped up in that conflict or that suddenly alarmed everyone during the Gulf crisis of 1990. It goes back as far as 2000 BC when stupor or hypnosis was induced by arsenical and alkaloid 'smokes'. Its use was referred to in Leonardo da Vinci's 15th-century *Notebooks*, which he copied from the *Histories* of Polybius. Chinese scientists wrote of toxic projectiles in the 11th century, the Moors used poisoned arrows in Spain in 1483, and sulphur was resorted to by the allies at Sebastopol during the Crimean War. During the First World War chemical weapons were first used on 22 April, 1915, by the Imperial German Army against French forces at Ypres. An intelligence bulletin from the French Tenth Army stated: 'According to prisoners taken from XV Corps, there is, along the whole front in the neighbourhood of Zillebeke [Belgium], a large supply of iron cylinders, 1.4 metres long, which are stored a little in the rear of the trenches in bomb-proof shelters or even buried. They contain a gas which is intended to render the enemy unconscious or to asphyxiate him.'

This was the chlorine that swept low over the ground and filtered into the trenches of the front-line forces. The attack was soon followed up by the first launching of a crude mustard gas which left approximately 5,000 dead and 10,000 injured. Before the end of that war, all nationalities were to suffer the effects of diverse chemical-warfare

agents: Russia alone lost almost 100,000 men, with a further million and a quarter injured. Gas was also used between the two world wars, in Ethiopia by the Italians and in China by the Japanese. By the time the Second World War came along, new and highly toxic nerve agents had been developed.

This concentrated the mind on the problem not only of quickly providing protection for the troops in their trenches where—because the gas wafted over the lines low to the ground—they were most vulnerable, but of the safety of the animals as well. For no army could do without its silent soldiers. Horses having played such a decisive role throughout the centuries and in the field in the First World War in their thousands, most nations realised that an army veterinary service was no less important than a casualty centre for the troops. Together with scientists—in Britain, from the research centre at Porton Down—veterinary surgeons made a great effort to find medication or antidotes for gas, to perfect decontamination procedures and to supply some form of mask to protect the animals' lungs and eyes. It was a daunting task, but it was done.

The first horse mask was produced in Germany. The chemically treated nosebag was filled with wet straw and absorbents that covered the horse's nose and mouth. The English version drew the bag tightly around the horse's head to prevent points of filtration. The American model may well have protected the horse, but in so doing it totally exhausted the animal and was soon abandoned.

Dogs—used for carrying messages, to locate wounded on the battlefield, to haul ammunition and food supplies, and to lay communication wiring along the front line—were also provided with masks. These comprised an impregnated cloth pierced with holes for the eyes and ears, above which the dog wore goggles. Surprisingly, both horses and dogs adapted better to gas masks than soldiers did. There were problems, of course. The horse remained vulnerable above its hoof, where the fetlock is fragile, and on its underside. Decontamination by instant washing with soapy water whenever a horse had been in a gas attack became an urgent imperative. In the case of dogs, gas could lead to severe injuries. One dog was caught in a mustard-gas attack as he crossed a field with an urgent message. Despite what must have

A British messenger dog with burnt paws as a result of crossing a field during a mustard gas attack in 1916. *Photo: Imperial War Museum.*

been hideously painful burns, he nevertheless continued his course and delivered his note. He recovered from his injuries.

For our gallant pigeons there was nothing that could be done. The risk that they would be caught in a toxic cloud while in flight was high at certain times and in certain places—Verdun, Ypres and on the Somme. Verdun for example, became a military fixation simply because it was there, because it was a proud city defended by 15 fortresses. Of these, by far the most important were Fort Douaumont, which dominated the hills overlooking the countryside about six miles north-east of Verdun, and Fort Vaux three miles farther east. For the French the town was already a *cause célèbre*. Great names were to be found among its defenders: General Philippe Pétain, who became a postwar hero only to be condemned to death after the Second World War for collaboration with Hitler's Germany; and a young officer who was to go on to reach the height of national and international power, Charles de Gaulle. The more the French defended Verdun, the more the German generals felt it had to be taken. Desperate for results, the Germans resorted to chemical weapons. An attack with flame-throwers and phosgene was launched and both Fort Douaumont and

211

Fort Vaux fell. As the pressure mounted on Fort Vaux, its commander, Commandant Raynal, tried desperately to hold a link open with Verdun. His very last pigeon—the others having been shot or lost by other means—was coming in with a message that was vital for him. It was spotted while still some way off, and could be seen to be labouring, clearly in trouble. The pigeon managed to land in the loft, but died before the message could be removed from his leg. For this outstanding effort, the pigeon was awarded the highest French decoration for valour in the field, the illustrious *Légion d'Honneur*. Both forts were later retaken and Verdun relieved: the struggle had cost half a million lives.

* * *

The threat from chemical weapons was realised only periodically: despite their potential, they never became a regular method of waging war. It was soon understood by all the belligerents that a change of wind direction would mean gassing their own troops. But animals remained in constant and deadly danger from many other sources, bullets, bombs, explosive shells and illness. Pigeons suffered a relatively high mortality rate, and so did the hundreds of dogs laying field-telephone cables along the front line. Sturdy Labradors and Alsatians, they were trained from the Shoeburyness kennels where messenger dogs also received instruction. Their responsiveness to orders, their sense of direction and their ability to continue with their duties under fire were imperative to their missions—and the only factors that would, eventually, give them any protection from being killed. If they worked efficiently, they stood a good chance of survival. Sadly of course, many of them were killed, as the enemy knew precisely what the cable-laying dogs were achieving and did all they could to prevent it.

The horror of the front line in the First World War is well documented. Rain turned the battlefields into quagmires, bogging down equipment, and it was heavy going for the troops as the mud slowed them down in fields raked by machine-gun fire. Trenches were often waterlogged, adding to the misery of the soldiers huddled there, waiting for a respite from the cold only to face a fiercer enemy when they

had to go over the top. Communications between one flank and another and HQ were tenuous and often ineffective. The telephone cable was constantly being cut as one side ceded a few yards at colossal human cost, only to retake the same ground later at an equal price. When the front moved, new telephone lines had to be laid. A cable dog knew its job well, knew that the heavy cable that spun from a reel strapped to its back had to be dropped, that it must avoid the hundreds of craters dug by continuous artillery shelling from both sides, churning subsoil on to topsoil. Each dog also knew that the cable must be free from snags which would gradually sever it, and understood that it was essential to lay as far forward in the front line as possible.

A full reel of cable weighed at least ten pounds and was strapped to the dog's back on a solid harness tied firmly on the underside. The first half of the journey was the most dangerous, for only after that could the dog pick up speed and weave and wend his way though the obstacles back to the relative safety of the trenches. Weighed down, he was highly vulnerable to enemy fire. The valour of these animals is largely unsung and unknown and their constancy, efficiency and sacrifice brings a lump to the throat, for it is certain that without them

A dog carries apparatus for laying telephone wires on the Western Front. *Photo: Imperial War Museum.*

213

and their achievements the tragedy of the trenches of the Great War would have been even more severe than it was. The need for their skilled work was visible everywhere, at Passchendaele, Ypres, the Somme, Gallipoli. . . .

Ypres lies on the French–Belgian frontier about 50 miles from the Dunkirk coast. It was the scene of huge losses for the British as well as the French. One of the soldiers participating in that battle, Ronald Garrett, was so touched by the horses he watched galloping into battle—and there were several thousand—that 37 years after the event, in February 1953, he wrote of it in *The Legionary*. One can imagine the scene from his description. The bedraggled wounded— some of them blind, their heads swathed in bandages, their hands resting on the shoulder of the man in front, others being physically supported by their colleagues—moved slowly along the cobblestone roads of Ypres, familiarly known as 'Wipers'. They had come from Kitchener's Wood, named after the famous commander Lord Kitchener, and were heading for the casualty centre. A coal wagon thundering down the road ran into a wall and brought it crashing and splintering down in their path. At the same time, coming towards them from about 300 yards away in the opposite direction, were teams of 'fine equine soldiers' rushing headlong towards the debris, 'their hooves clattering furiously' over the cobblestones, veering to one side to avoid colliding with the wounded or the wreckage. They neither stopped nor were deterred from their objective. 'The horses,' Garrett recalled, 'held their heads well forward, their nostrils aflame with snorts of war amid the shouts of artillery-men thrusting the gun carriages forward with all possible speed. Who could have been so filled with the fury of war, the fires of courage and the will to do and dare as those equines as they bore themselves, their human fellow-soldiers and the engines of death into fields of carnage?' He felt that it had always been this way, horse and man together in combat: at Agincourt, Poitiers, Malplaquet, Waterloo, St Julien, Mons and Ypres, at the Somme, in the snows of the Crimea and amid the waste of the Charge of the Light Brigade. Horses have long been at the heart of a nation's defences, notably in Poland with its magnificent Ulany, the cavalry divisions, and in Russia, with its feared Cossacks. The noble horse has

carried the world's greatest generals and leaders, pulled gun-carriages, strained at the weight of hauling loads through mud and mire. It has the longest history of all animals for its allegiance to mankind and it is fitting that man, in return, has an enduring bond with the horse.

* * *

Strange occurrences in wartime can lead to the success or failure of a mission and none can be stranger than the attack of bees in an area not far from Mombasa in Kenya, where German and British forces were in pitched battle. It is debatable whether the outcome would have been any different had the bees not intervened, but they certainly assured a British loss.

The episode took place at the outbreak of the First World War, when both Britain and Germany had extensive African interests. It was not a combat of light arms as is often imagined in the African bush—far from it. Heavy machine-guns were employed by both sides. The hives, caught in the crossfire, were ripped to pieces by the heavy-duty ammunition and the bees were out and on the rampage, looking for revenge. The British commander, General Aitken, was suddenly confronted with an entirely new problem other than the enemy. The bees made straight for the British lines and the stinging began.

The bees concerned were said to be not ordinary bees, not just any bees, but a species that were to the European bee as the leopard is to a tabby. A puncture from one of their stings was likened to being injected with an acid-tipped needle. The men howled in pain and shock and dived for the beaches, where the confusion was such that officers were firing on their own men. The general, seeing the way the fight was going, charged into the fray with his staff officers and re-engaged the enemy with temporary success. But his men, grunting and groaning, were collapsing around him. Some leaped into the sea to escape the torment and quench the fire in their skin. Others performed strange contortions on the ground. Many were covered with stings, their faces and arms swollen to double their size. One officer, as Charles Miller describes in *The Battle for the Bundu*, was comatose from a bullet wound but was stung back to consciousness by the insect's injection. And most of the troops were convinced that the bees had been trained

215

by the Germans, so dedicated were they to attacking only one side in the combat.

* * *

From the Second World War we have already seen many examples of exemplary animal courage, but one more story needs to be told. Again it concerns a horse, but a horse with a difference, for it had two mighty owners: Field Marshal Lord Montgomery of El Alamein and his legendary opponent, Field Marshal Erwin Rommel. Montgomery, then a general, won an outstanding victory when he retook Tobruk during the Alamein offensive from Rommel's famed Afrika Korps. In so doing he assured a turning point, one of the first, in favour of the Allies.

It had not been an easy triumph. Earlier, when Rommel and Italian forces had seized Alamein, British forces had been thrown back into Egypt, Malta was pounded by the *Luftwaffe* and control of the Mediterranean hung in the balance. Montgomery's well-known opening salvo was the largest single bombardment of the war, rivalled only when the Russians opened their successful counter-offensive against Axis forces in 1943. More than 1,000 artillery guns were fired simultaneously, lighting up the sky, their deafening roar ending the eerie silence that had suggested something big was afoot. Rommel, one of Germany's finest strategists, was highly respected for his professionalism and moral values, but after a fierce battle that commenced in August 1942, during which he was injured, the German and Italian forces were routed and Rommel returned to Germany to recuperate. Whether or not there is any truth in the suggestion that he took part in the abortive von Stauffenberg plot to kill Hitler, he was certainly under suspicion from the Gestapo, who eventually took him away and persuaded him to commit suicide. They did not wish, he was told, to put on trial and execute an officer who had won the admiration and affection of the German people as well as the enemy. To protect his family, Rommel took his own life; he was subsequently, if hypocritically, given a full state funeral. It is a strange and fascinating story, much of which remains unknown, but it is perhaps a sign of Montgomery's respect for his opponent that he acquired Rommel's white

Field Marshal Montgomery riding the white Arab stallion that formerly belonged to Rommel. *Photo: Imperial War Museum.*

stallion and rode and cared for it with pride. The horse had been a particular favourite of Rommel, and according to a member of his family, Manfred Rommel, had been ridden in combat situations early in the war, later becoming a ceremonial horse.

*　　*　　*

Animals in some form are nearly always to be found on regimental insignia carried into battle. The animal represents all that the regiment feels about itself and sees in itself: the forcefulness of the ram, the strength of the bear, the tenacity of the roaring lion, and the prowess of the eagle. No nation has more insignia sporting the eagle in all shapes and forms than the United States. This is the story that lies behind one of them—Old Abe of the 101 US Airborne Division.

Old Abe's story goes back to 1861 and the American Civil War, when a Chippewa Indian known as Sky Chief captured an eaglet on the Flambeau River in Wisconsin. He sold him shortly afterwards for the price of a bushel of corn. The bird was sold again for five dollars and presented to the Eau Claire Eagles, or C Company of the Eighth

217

Wisconsin Regiment. By now a grown eagle, the bird was taken into battle by a sergeant who was responsible for his care, perched on a shield between the national and regimental colours. The eagle, dubbed Old Abe, flew to the end of its tether as the guns roared and screamed at the Confederate lines. The whole brigade, thrilled by the bird's reaction, yelled their enthusiastic support. They had the impression that while the eagle was with them all would be well, as if an extra and unseen force was watching over them. Old Abe went through no less than 36 battles in his role of guardian, so it was a miracle that he was only wounded twice; first in the assault on Vicksburg and later at the Battle of Corinth, where the Confederate general Sterling Price, hearing that the eagle was in the vicinity, offered a sizeable reward for his capture or death.

There has probably never been a battle in which animals were not somehow involved, some as participants in the conflict, others as pets. Of the latter, most had to be smuggled onto the field, for the rule book in any 20th-century nation forbids pets in combat or even in the barracks in peacetime. Those who managed to secrete an animal in their pack or otherwise were, as a rule, permitted to keep it, for it was recognised that an animal could provide an essential morale booster at times when nothing else would. Often the animals concerned showed considerable courage and initiative but remained without award. In those cases we can only be grateful that somewhere someone jotted down the facts for posterity.

Mustard was a bright golden cocker spaniel, otherwise referred to as 'the pilot', who had served with the US Air Force's Air Transport Command. In fact, he had virtually lived in his aircraft and notched up an impressive 500 hours of flying plus no less than ten round trips across the United States. In flight, Mustard spent most of his time in the cockpit with his master. On the ground, he would often be seen sitting on the wing just under the aircraft's emblem painted on the fuselage, waiting for passing airmen to come along and pat him or stroke his head. So much had Mustard become part of the base and of flying schedules that when he notched up his 500th flight it was decided to mark the occasion with something special. In a ceremony organised as well as any official function, Mustard was awarded a

218

badge of honour. It was no ordinary badge, but one that had been specially made from a bone, tied round his neck on a wide piece of ribbon. Mustard was not immediately sure what to think about this: did he wear it, play with it or eat it? He no doubt thought that compromise would be the best thing. He dug a hole and buried his badge of honour, only to retrieve it hurriedly when he returned from his next flight. No matter where he had been, or for how long, whether it had rained and made the ground sodden or not, Mustard knew where the bone was and dug it up.

Ask any Australian about his country's animal war heroes and he will at once mention Gallipoli Murphy, whose story was told in Chapter Six, and Horrie the Wog Dog. Horrie was irreverently called the 'Wog Dog' because his owner acquired him in an Arab market while based in Egypt during the Second World War. Private J.B. Moody was determined not to abandon him when the order went out for embarkation. Luckily, Horrie was a small dog, a terrier. Slipped into Moody's huge backpack and forewarned by a wagging finger not to cause trouble, Horrie had his first taste of a sea voyage during the cramped journey to Greece, then to Crete and finally more or less back to home ground, to Palestine.

During the very first trip, Horrie's presence was revealed to Moody's commanders. There was a tense moment or two while a decision was made as to his fate, but Horrie's outrageous character was endearing, and he was not only permitted to stay but was to go on to become, surely, one of the most photographed dogs of the entire conflict. He was photographed in every conceivable state and position.

Horrie howled at the music that was played by his soldiers outside their tent, his nose well into the air, his mournful cry lingering. He stood over trenches looking down, as if supervising the energies of the diggers. He rode on camels, sitting in front of Moody as if this was a perfectly normal method of travel for a dog. All work stopped in the Gaza Strip's pounding heat while a makeshift shade was constructed for him, beneath which he would sleep while the others toiled. His little white snout peered out from a Vichy French tank in Syria, barking down to his cobbers below. He was cuddled by just about everyone on board HMS *Defender* when he was rescued from the sea

after his own ship, the *Costa Rica*, had been torpedoed. He was the self-appointed guard outside the men's tent and, most of all, he was renowned for 'bashing the spine' in approved Aussie-soldier style— lying on his back on a thick wedge of blankets, his eyes shut in slothful sleep, four paws in the air. And, naturally, Horrie had his own uniform, with two stripes for his rank of corporal. . . .

Then there was Smudge, the white-furred rabbit and mascot of the 383 Wireless Unit of the RAF. When the unit received orders to embark for France, then Belgium, there was no thought of leaving Smudge behind. But quite how they managed to get him on the transport with them is difficult to imagine, as rabbits are hardly the most controllable of animals and tend to slip through the hands when being chased. Smudge's life in the fifth year of the war, May 1944, was a luxurious one. He had total freedom to roam the sergeants' mess wherever the unit happened to be stationed; he slept contentedly by the open fire and spent his waking hours standing on his hind legs, begging for food.

In the story of Voytek we have already seen how much of an individual a bear can be, even in the middle of a raging battle. There was another bear, greatly different from Voytek, with Orde Wingate's Chindits in Burma. As Voytek swung from a crane to everyone's

Horrie the Wog Dog, pet of Australian troops in the Middle East during the Second World War. *Photo: Australian War Memorial neg. no. 076877.*

amusement at Monte Cassino, so Joey the sloth bear used to go around on bicycles with the men of the RAF HQ special force.

Gnup was in the Far East, too. He was an Indian mole rat, and just about the most unlikely mascot or pet one can imagine. What is even more surprising is that Gnup was the adored one of the pest destruction advisory unit of the Royal Army Service Corps in Rangoon. Gnup weighed just one ounce at birth and was adopted immediately by the unit. Nine months later he weighed nine ounces, exceptionally heavy for his species.

Faith might have been interested in Gnup given the opportunity, for she was a cat, a tabby and a devoted mother. She lived with her newly born kitten in St Augustine's Church on one of the long main roads that linked London to the south, a route regularly followed by the *Luftwaffe*. Being bombed was nerve-racking for anyone, but for animals it must have been more fearsome still. On 6 September, 1940, Faith was uneasy, and restless. She lifted her kitten from her basket, taking hold of it firmly by the loose skin across its back, and carried it gently down three flights of stairs, where she placed her charge in safety. The vicar made repeated efforts to return the kitten to its basket at the top of the house. Faith would have none of it, simply taking hold of her kitten again and repeating the performance. Finally she was allowed to settle in on the ground floor.

The day after Faith had shown such anxiety, the *Luftwaffe* launched its largest aerial attack of the war in an effort to demolish London. Two waves of bombers totalling 350 aircraft followed the snaking River Thames up to the city and dropped their loads on industrial and waterside areas on both sides of the river. Docks, warehouses and barges went up in flames. As the attack progressed, the targeting became less discriminate and civilian targets were hit. The raid continued for 12 hours, from day into night. Two days later the vicarage received a direct hit in a similar raid. The roof and walls seemed to explode in one fearful, searing roar of destruction and flame. Soon flooding was added to the terror as the fire brigades poured water into the ruins. When it was all over, however, Faith was found alive with her kitten, still guarding over it.

Just what made 311 Battery of the Royal Artillery stationed in North

Africa choose Charley the monkey as their mascot is anyone's guess. He had a reputation so bad that his previous American owners had thrown him out. The monkey was impish, frustrating and definitely had character, even if it was arguably bad. It was fortunate for Charley that the British were not far off when the Americans showed him the door.

The new owners did not have to wait long before finding out why Charley was always in trouble. The whole of the monkey's life seemed to be one long, continuous fight against authority. He would suddenly appear where he should not be; he scrounged from everyone, including visiting officers. He was untidy and inquisitive; he left a long line of debris in his wake as he ploughed through the tents. Things were worst when he entered a tent while its occupants were out: he would chew whatever he could find, tear up paper and be a source of general mayhem. The men soon learned to batten things down. It was not long before a question mark hung over the monkey's head. What was the point of keeping an animal that could not be controlled? But Charley had such a way with him that he melted doubters' hearts. For all his frustrating naughtiness, he provided endless hours of hilarity and everyone was attached to him. He represented the lighter side of life and kept everyone on the hop: a compelling combination. He remained with the unit to the end.

Along with Montgomery's famed Desert Rats and Rommel's Afrika Korps, Joe the goose was also in the battle for Tobruk with an RAF maintenance unit. Joe travelled hundreds of miles with them between their base in Alexandria and Italy, but it was during a crossing of the Mediterranean that he caused an uproar. What made him suddenly decide to fly away from the ship is not known, but as soon as he did it was evident that he was in trouble. Everyone turned out to scan the sky, the horizon and the waters. For two hours they searched, getting more anxious as the minutes passed. Even when Joe was eventually spotted the problem continued: getting hold of him and hauling him back on board was anything but easy. When the task was achieved, he was welcomed and fussed over. Restored to fitness, he continued his adventures with the unit.

Animals have always been alongside man on the field of battle, but

historians have been less than generous in recognising the enormous contribution those animals—particularly the trained working ones— made to the eventual outcome of battles which then affected the course of a war. Hannibal would not have achieved his epic crossing of the Alps without the use of elephants, and elephants went on for a further two millennia to assist in times of need: they helped remove trees and other obstacles in the dense jungles in the fight against the Japanese in the Second World War, for example. Other battles were won or lost on the amount of cavalry a side could put into action. Even bullocks were put to good use, and who can forget the memorable role played by the camels of Lawrence of Arabia in his long struggle to unite the Arabs against the Turkish armies?

<p align="center">* * *</p>

Of the 53 Dickin Medals awarded, three went to horses—Olga, Upstart and Regal—and all for the same reason. The trio belonged to the Metropolitan Police, and their duty was to stand rock still while their rider directed traffic and civilians to shelters as bombs dropped. In all three cases, the horses were in danger from falling debris, fires caused by bombing and shrapnel; yet with people milling round them, some in panic, the horses stood their ground, unflappable and undaunted.

The RSPCA also have awards for gallantry which span a wider period than the PDSA's Dickin Medal. Such awards are important: the role of an animal in combat, whether a pet smuggled into camp or an animal highly trained for a purpose, is one that needs to be known and recognised. No animal is trained to be courageous. It can be trained to perform a given task, but courage comes only from an inner conviction and an individual decision to rise above fear to protect a loved one. Assessing what makes an animal take such a course involves another, parallel, issue. In the midst of war, often when things are going badly, the human being finds the resources to laugh, to love a creature who cannot fend for itself, and to cherish it. That must surely be one of the most precious and lasting testimonies of the relationship between animals and man. That animals do not seek more for themselves makes them heroes unique to history.

REFERENCES

CHAPTER ONE; BOBBIE AND THE BATTLE OF
MAIWAND
Britain and her Army, Corelli Barnett. Allen Lane, 1970,
pp. 315–17.
Maiwand, 27th July 1880, Colonel A.J.W. Harvey. Official
History of the Royal Horse Artillery, Archives. National
Army Museum, London.
My God—Maiwand, Leigh Maxwell. Leo Cooper, 1979,
p. 178.
Official Archives, Duke of Edinburgh's Royal Regiment,
Salisbury, Wiltshire.
Queen Victoria's Journal, 17th August, 1881. The Royal
Archives, Windsor Castle.
The 66th Regiment of Foot. Official Archives, Duke of Edin-
burgh's Royal Regiment, Salisbury, Wiltshire.

CHAPTER TWO: CHINDIT MINNIE
The Lancashire Fusiliers, 1939–1945, John Hallam. Alan
Sutton, 1993.
Interviews with Brigadier Calvert, commander of the 'White
City' mission, and Mr G.S. Beaumont, pilot of one of the
aeroplanes ferrying Chindits and animals into the dropping
zone.
Members of the Chindits Old Comrades Association. My
grateful thanks for their help in compiling this chapter.

CHAPTER FOUR: VOYTEK OF MONTE CASSINO
'La Bataille de Cassino', in *Historia Magazine*, Paris, p. 1632.
Soldier Bear, Geoffrey Morgan and W.A. Lasocki. Gryf Publi-
cations Ltd., London, 1970.

CHAPTER FIVE: IRMA, BLITZ DOG
Designed to Kill, Major Hogben, MBE. Patrick Stephens,
1987, pp. 158–9 and 165.
Mr Charles E. Fricker, MBE.
The MoD Defence Animal Centre in Melton Mowbray and
Mrs Griffin's diary which is kept in their museum.

CHAPTER SIX; GALLIPOLI MURPHY
The Anzacs, Patsy Adam-Smith. Thomas Nelson (Australia)
Ltd., 1978. The Face of a Hero.
Glorious Deeds of Australia in the Great War, E.C. Buley.
Quoted by Sir Irving Benson in *The Man with the Donkey*
(see below).
History of the 20th Century, World War I, J.M. Winter.
Hamlyn, 1993, pp. 72–4.
*The Man with the Donkey: John Simpson Kirkpatrick, The
Good Samaritan of Gallipoli*, Sir Irving Benson. Hodder &
Stoughton (no date).
Verbal description of Gallipoli at the National Army Museum,
London.
World War I—Dardanelles Campaign. Official Australian
History, p. 378.

CHAPTER SEVEN: SEBASTOPOL TOM
The Camp of Sebastopol, Lt.Col. E.B. Hanley. National Army
Museum, London.
Heroes of the Crimea, Michael Barthorp. Blandford, 1991.
Inside Sebastopol (collection of writings). Chapman & Hall,
1856.
The Last Hours of Sebastopol. National Army Museum, 1857.

CHAPTER NINE: WINKIE: PIGEON POST
Captain of the Queen's Flight, Len Rush. Bloomsbury, 1987.
Furred and Feathered Friends, James Gilroy. Trafalgar Pub-
lishers, London, 1946.
The Homing World Stud Book, 1963.
The Oracle Encyclopaedia. George Newnes, London, 1895.
Vol.III, p. 271.
Pigeons in Two World Wars, A.H. Osman, W.H. Osman and
C. Osman. The Racing Pigeon Publishing Company,
London, 1976.
S.O.E. in France, M.R.D. Foot. HM Stationery Office,
London, 1966.

CHAPTER TEN: STUBBY AND FLEABITE
Furred and Feathered Friends, James Gilroy. Trafalgar Pub-
lishers, London, 1946.
History of the 20th Century, World War 1, J.M. Winter.
Hamlyn, 1993, p. 136.

CHAPTER ELEVEN: RIFLEMAN KHAN
History of the Second World War—Victory in the West, Vol.2,
pp. 81–119. HM Stationery Office, London.
The Queens and the Hive, Edith Sitwell. Macmillan, 1962.

CHAPTER TWELVE: ROB OF THE SAS
Benito Mussolini, Christopher Hibbert. Longmans, 1962.
Mauthausen, History of a Death Camp, Evelyn Le Chêne.
Methuen, 1970.
The Rise and Fall of the Third Reich, William L. Shirer. Secker
& Warburg, 1974, pp. 999–1003.
The SAS at War, 1941–45, Anthony Kemp. John Murray,
1991.
Shropshire Magazine. Article by Mrs Bayne.

CHAPTER THIRTEEN: THEY ALSO SERVED
Ronald Garrett in *The Legionary*, Vol. 27, No. 7, p. 19, 1953.
The Battle for the Bundu, Charles Miller. Macdonald & Jane,
London, 1974.
Chemical and Biological Weapons – Threat of the Future,
Evelyn Le Chêne. Mackenzie Institute for the Study of Ter-
rorism, Canada, 1989.
East Germans, Brian Gardner. Cassell, London, 1963, p. 31.
Gas Attack: Chemical Warfare 1915–date, William Moore. Leo
Cooper, London, 1987.
Insignia and Decorations of the US Armed Forces. National
Geographic Society, Washington DC, 1944.
They Also Serve, Dorothea St. Hill Brown. Winchester Publi-
cations, 1957.